ROBERT CAPA

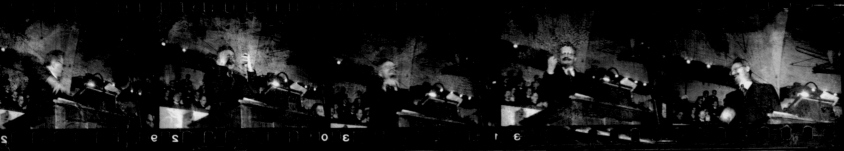
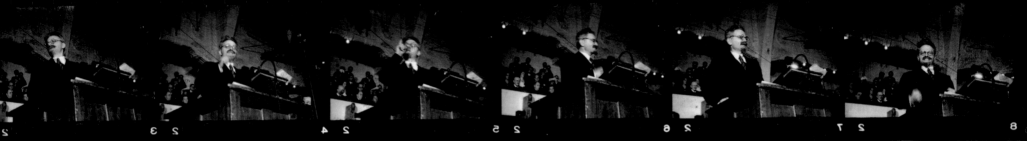
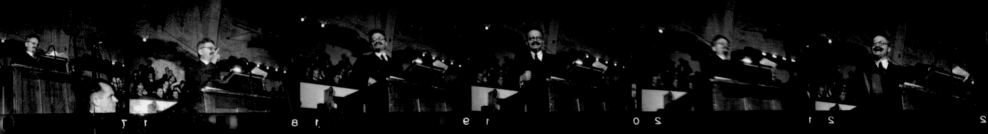

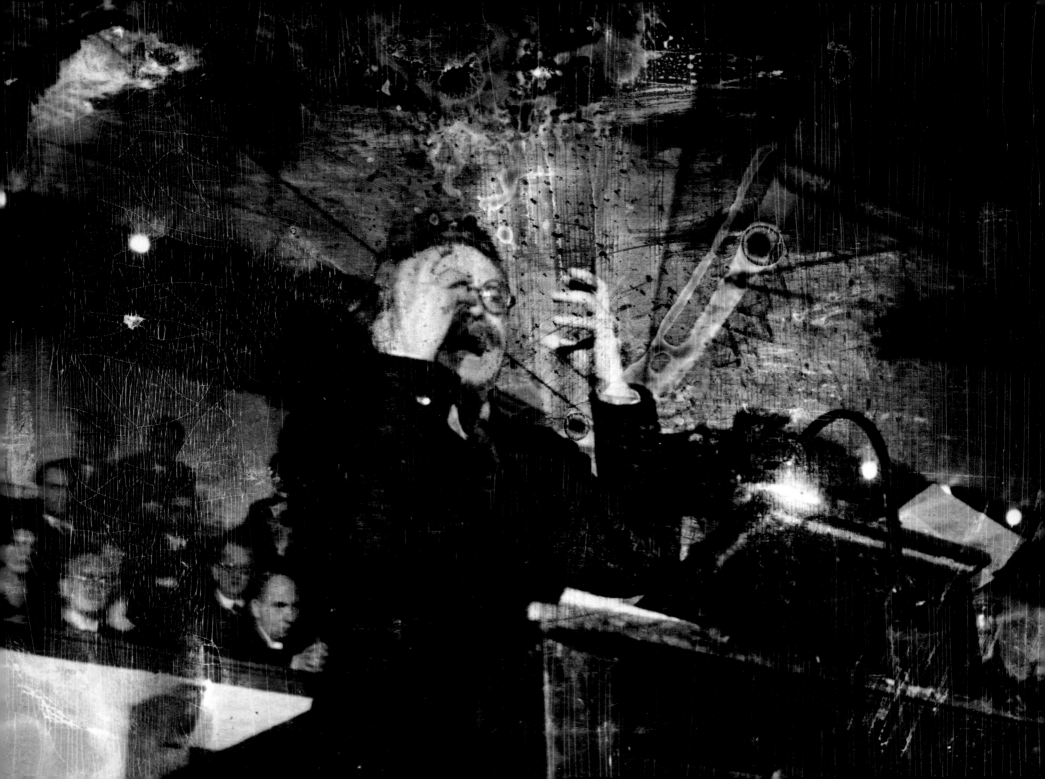

ROBERT CAPA PHOTOGRAPHS

FOREWORD BY HENRI CARTIER-BRESSON

REMEMBRANCE BY CORNELL CAPA

INTRODUCTION BY RICHARD WHELAN

APERTURE

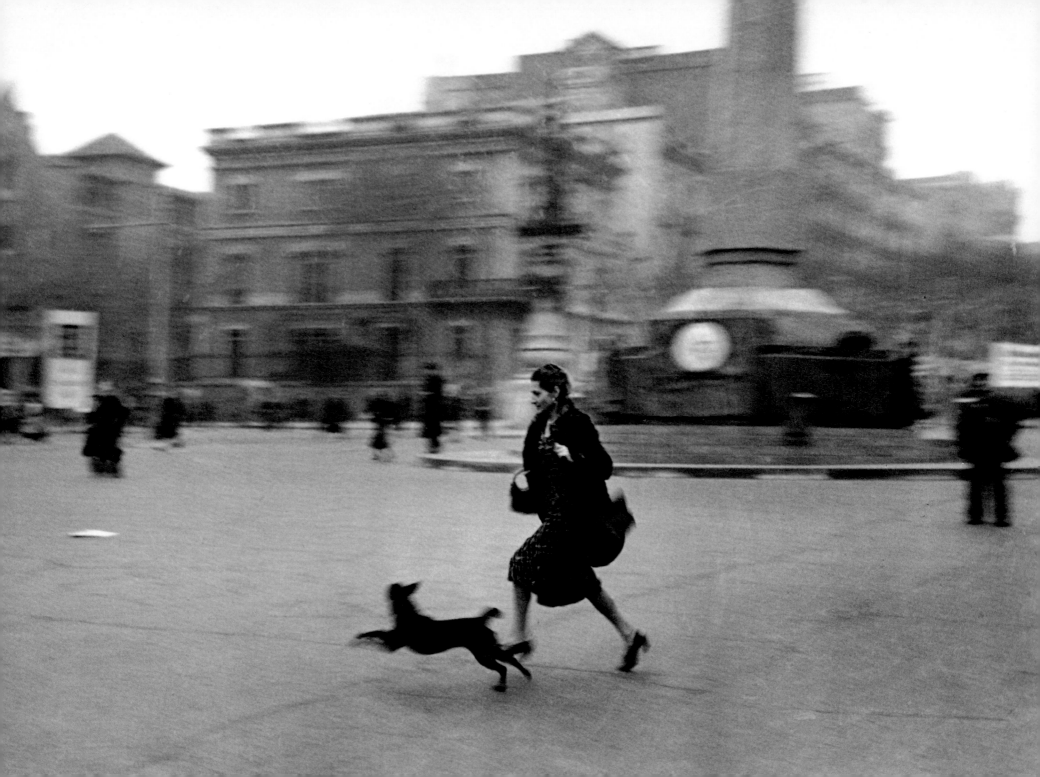

*Capa pour moi portait l'
habit de lumière d'un grand
torero, mais il ne tuait pas.
— grand joueur, il se battait
généreusement pour lui-même
et pour les autres dans un
tourbillon. —
La fatalité a voulu qu'il soit
frappé en pleine gloire.*

Henri Cartier-Bresson
18.1.96

For me, Capa wore the dazzling matador's costume,

but he never went in for the kill;

a great player, he fought generously for himself

and for others in a whirlwind.

Destiny was determined that he should be struck

down at the height of his glory.

—HENRI CARTIER-BRESSON

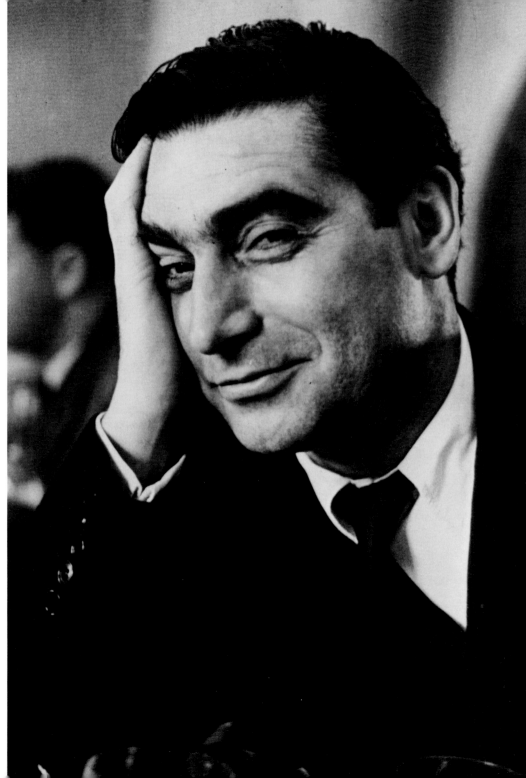

Previous pages:
Leon Trotsky lecturing
Danish students on the history
of the Russian revolution,
Copenhagen, Denmark,
November 27, 1932. Capa's
coverage of Trotsky's lecture was
his first published story.

Running for shelter during air raid,
Barcelona, January 1939

Feria, Seville, 1935

Right:
Robert Capa in Paris, 1952.
Photograph by
Ruth Orkin.

My brother Robert Capa
was born with a language not useful beyond the borders
of a small country, Hungary.
Yet he managed to travel all over the world
and to communicate his experiences and feelings through
a universal language, photography.
The advice Bob used to give to other photographers was:
"Like people and let them know it." That is what he always did.
Five years older than myself, Bob inspired
and encouraged me, and he showed me the true meaning of brotherhood.
My brother's life and work constitute a testament to challenges met,
and gambles won—except at the end.
What he left behind is the story of his unique voyage and
a visual testimony affirming his own faith in
humankind's capacity to endure and occasionally to overcome.

—CORNELL CAPA

INTRODUCTION by Richard Whelan

In December 1938 the prestigious British magazine *Picture Post* published eight pages of images of the Spanish Civil War by twenty-five-year-old Robert Capa and proclaimed him "The Greatest War Photographer in the World." Forty years after his death, many people feel that Capa's extraordinarily powerful and moving coverage of five wars entitles him to retain that title. But Capa cannot be categorized simply as a war photographer, for, as this book shows, many of his images capture, with warmth and wit, the joys of peace. Some of his photographs manifest a lyricism as tender as that in the work of his friend André Kertész, and others are of moments as decisively constellated as those captured by Henri Cartier-Bresson, another friend. Increasingly we view Capa's complex photojournalistic documentation as rivaling the work of more consciously artistic photographers in sensitivity, emotional power, and visual impact.

Nevertheless, war photographs remain at the very heart of his work. Besides documenting the Spanish Civil War (1936–39), Capa spent six months in China during 1938 to photograph resistance to the Japanese invasion, and later went on to cover the European theater of World War II (1941–45), the Israeli War for Independence (1948), and the French Indochina War (1954). While photographing French maneuvers in the Red River delta, Capa stepped on an antipersonnel mine and was killed on May 25, 1954. He was forty years old.

Capa hated war for what it did to the individuals who were caught up in it—as he himself was. Although he was a very brave man who adapted well to the rigors of military life in the field, he was fundamentally a pacifist and often used to say that he looked forward to being unable to find employment as a war photographer. It is fitting that he is buried in a Quaker cemetery.

As much as Capa detested conflict, he felt passionately that if war had to be the reality of the moment, it was essential for the side of justice to win. And so, to gain political support for the Spanish government, he made photographs that

revealed not only the courage and determination of its soldiers against great odds but also their fortitude in miserable conditions. By showing them shivering in foxholes and eating soup in the rain, he emphasized that these heroes were ordinary men and women, and thus led those who saw his pictures to identify with them. By focusing on the faces and gestures of his subjects, Capa allowed viewers to experience a sense of involvement, as if they themselves were suddenly present in the midst of the war. It may well have been this sense of the situation's immediacy that roused many who were immune to ideological arguments to contribute money to the cause or to take part in political demonstrations.

One of Capa's most famous photographs shows a Spanish government militiaman who has just been shot. When it was first published, in September 1936, no one had ever seen such a picture. Earlier photographs of war had almost invariably been rather static and distanced. Even as recently as World War I the standard camera had been the medium-sized bellows-extended Graflex, using four-by-five-inch plates. Not only did it call attention to itself, making candid shots nearly impossible, but it was also a burden with which the photographer could not easily maneuver in dangerous situations. By contrast, Capa's 35-mm Leica was inconspicuous and gave him maximum mobility. With it he threw himself into the maelstrom of war as no one had been able to do previously.

Capa is probably best known for his so-close-you-can-feel-the-ground-shake photographs of battle, but the other side of his coverage of war documents the sufferings of innocent civilians, especially children. Capa was present as bombs were dropped on residential neighborhoods in Madrid, in Hankou, and in London. But he rarely photographed the dead or the grievously injured; instead, he focused more often on the survivors going on with life despite numbing losses and staggering destruction.

Whether his photographs show soldiers or civilians, the pictures are characterized by intimacy and immediacy, by compassion and empathy. Capa could easily bring these qualities to his work, as he himself had experiences parallel to

much of what he photographed. He was a political exile from Hungary and had fled Germany to escape Nazi anti-Semitism. In Berlin and Paris he had learned what it was to go hungry. His beloved Gerda Taro, whom he had helped to become a photojournalist in her own right, was killed by a tank while she was covering a battle in Spain in 1937, and he himself constantly risked his life by photographing in the front lines of combat. By the time he documented the Israeli War for Independence, he knew that many of his relatives had been killed at Auschwitz. He could empathize all too easily with the subjects of his photographs.

The horrific tendency of modern warfare is to dehumanize. Soldiers are able to use their terrible weapons of mass destruction only because they have been trained to conceptualize their victims not as individuals but as a category—the enemy. Capa's strategy was to repersonalize war, to emphasize that those who suffer its effects are individuals with whom the viewer of the photographs cannot help but identify. Confronted with overviews of a battle, or of vast movements of refugees, one may feel simply overwhelmed and paralyzed. But the natural impulse of anyone who sees a photograph of an individual in pain or in need is to reach out and help.

Capa always understood, as he put it, "If your pictures aren't good enough, you're not close enough." He recognized that only by recording individual gestures and facial expressions could he convey a sense of the actuality of war. As his friend John Steinbeck wrote, Capa "knew that you cannot photograph war, because it is largely an emotion. But he did photograph that emotion by shooting beside it. He could show the horror of a whole people in the face of a child."

The paradox is that, although Capa made his photographs in order to help the side in whose cause he passionately believed—the Spanish anti-Fascists, the Chinese, the Allies in World War II, the Jews in the Israeli War for Independence—his sympathy extended to individuals on both sides of the conflict. Capa was essentially a stateless person himself and thus had a kind of neutrality, as well as a sense of the complexity of reality.

His sympathy is clear, for instance, in his photographs of very young German soldiers who were taken prisoner by the Americans in Italy; the pictures and their captions emphasize that these naive and often apolitical boys were taken from their schools or farms and thrown into combat without adequate training or equipment. Many of their comrades had already been slaughtered. Although these young soldiers were "the enemy," they were also—as individual human beings—victims of the horrendous forces of war.

Similarly, Capa's famous 1944 photograph of the young woman of Chartres whose head has been shaved as punishment for having had a baby by a German soldier transforms her into a Madonna tormented by demons. By pure coincidence (Capa had no interest in painting), that photograph echoes traditional representations of the Massacre of the Innocents. The resemblance, though unconscious, seems perfectly in keeping with Capa's intentions, for his sympathies seem to be with the victim and her baby.

Ultimately, the great power of Capa's photographs derives from his own personality. By all accounts, he was an extraordinary man—extremely generous, incisive, and amusing. He despised all cant and pretentions, and he never called himself an artist. For one thing, he thought it was a very impractical and even inconvenient label. In the 1930s, he advised Cartier-Bresson, whose interest was in Surrealist photography but who wanted to be published in the pictorial press, "If you call yourself an artist, you won't get any assignments. Call yourself a photojournalist and then do whatever you like."

Capa had the spirit of a true artist: he did his work with great intelligence, passion, skill, sensitivity, wit, and grace. To his coverage of five wars and interludes of peace, he brought not only a deep commitment to improving the human condition but also an unfailing eye for graphic impact. Although his photographs remain the definitive visual records of such momentous events as the siege of Madrid, the Japanese bombing of Hankou, and the Allied landings on D-Day, many of Capa's images have a timeless and universal quality that transcends the specifics of history.

FRANCE 1936–1939

When Capa arrived in Paris in the fall of 1934, he hoped to find success as a photojournalist. Instead, at first, he found hunger, which was mitigated only by the camaraderie of the community of refugees in Montparnasse. Soon he met Gerda Taro, a young German who became his lover and, in effect, his business manager, advising Capa to take his work more seriously. As he increasingly savored the charms of Paris, he fell in love with the city and with the French people—so much so that in 1938 Christopher Isherwood wrote that Capa was "more French than the French."

During the spring and summer of 1936 Capa covered the tumultuous Parisian parades, rallies, and sit-in strikes surrounding the election of the coalition of Liberals, Socialists, and Communists known as the Popular Front, formed to combat the rising threat of Fascism. Capa's photographs of these events began to make his reputation.

When not documenting upheaval, Capa focused his camera on nonpolitical subjects ranging from a society of wounded World War I veterans (the Gueules Cassées, or "bashed faces") to an exposition of new inventions, most of them destined for oblivion. This body of work constitutes a marvelously quirky portrait of Parisian life in the late 1930s.

Page 14:
Delegates at
the peace rally held to
commemorate the
twentieth anniversary
of the World War I Battle of
Verdun, July 12, 1936

Left:
At a horse show, Paris,
ca. 1936

Opposite:
Paris, ca. 1936

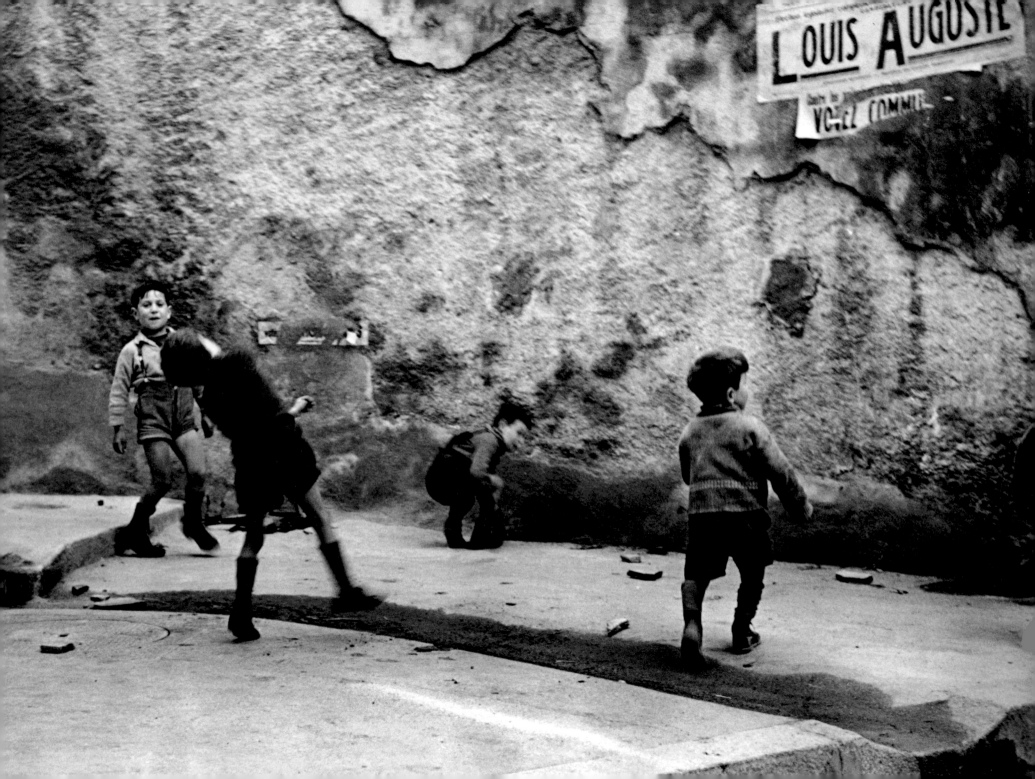

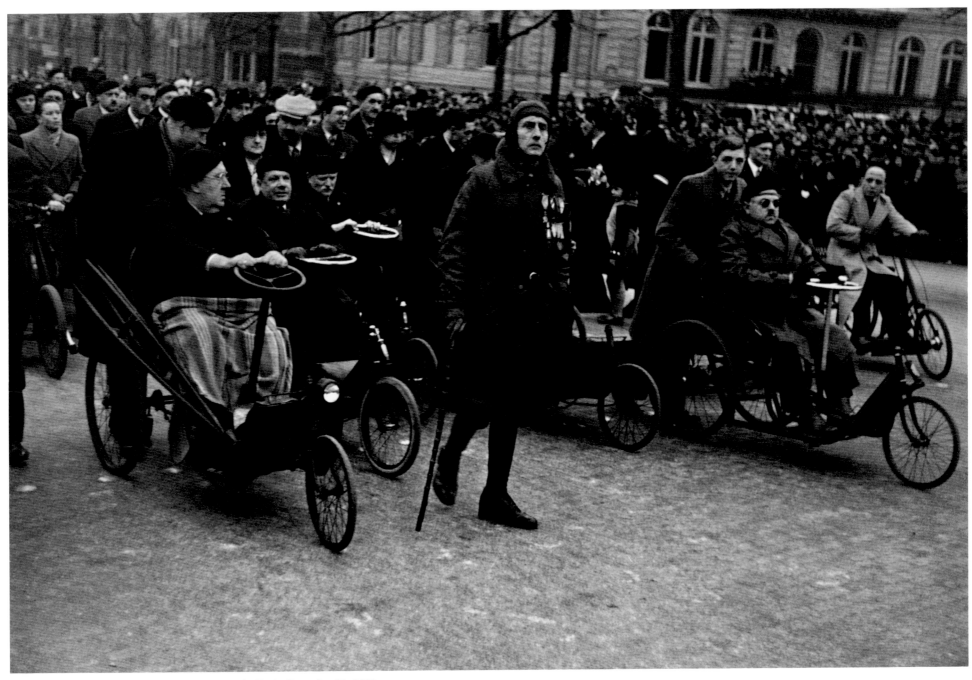

Veterans of World War I in the Armistice Day parade, Paris, November 11, 1936

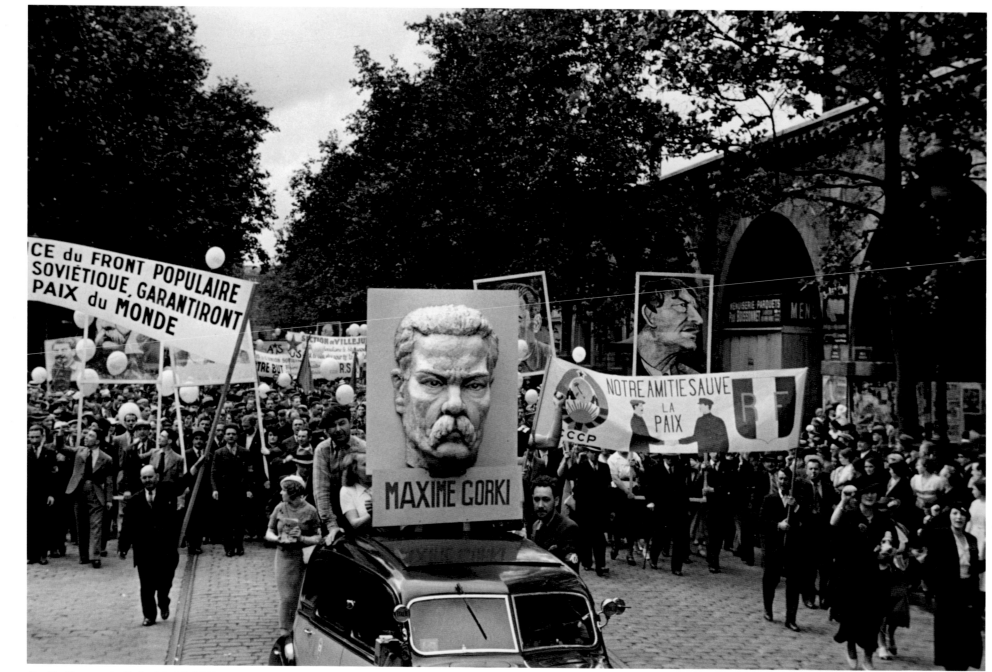

Bastille Day parade, Paris, July 14, 1936

19

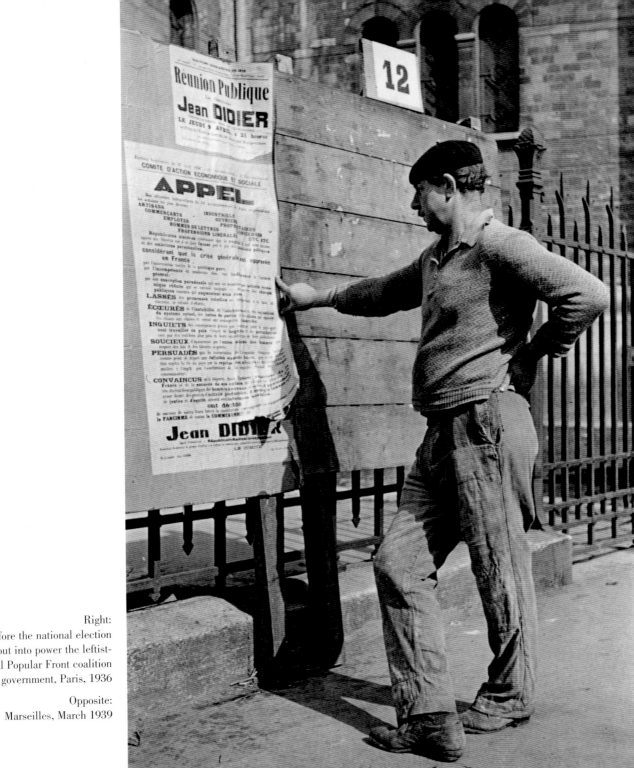

Right:
Before the national election
that would put into power the leftist-
liberal Popular Front coalition
government, Paris, 1936

Opposite:
Marseilles, March 1939

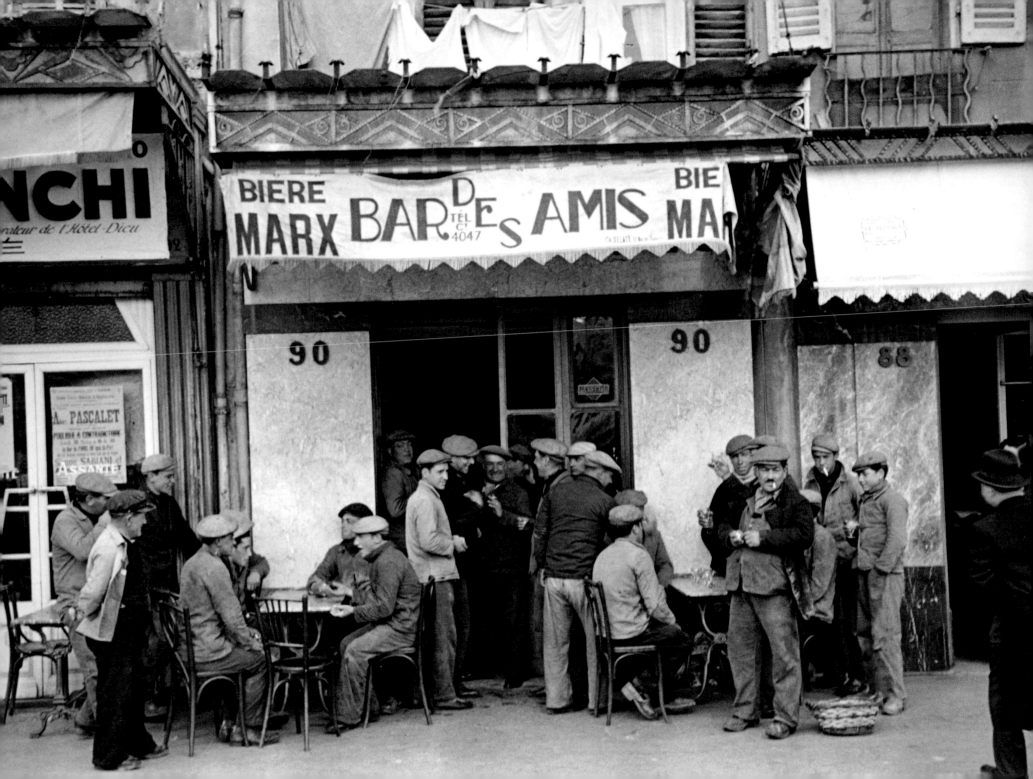

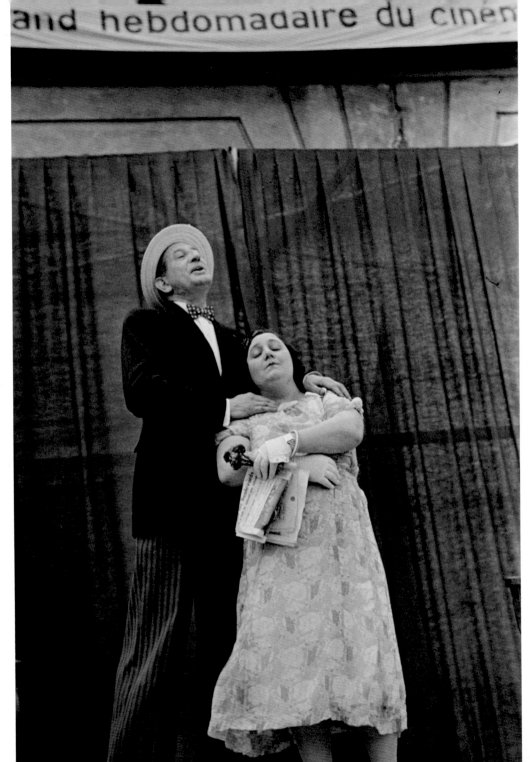

and hebdomadaire du ciné

Left:
Paris, Spring 1936

Opposite:
Bastille Day, Paris, 1936

22

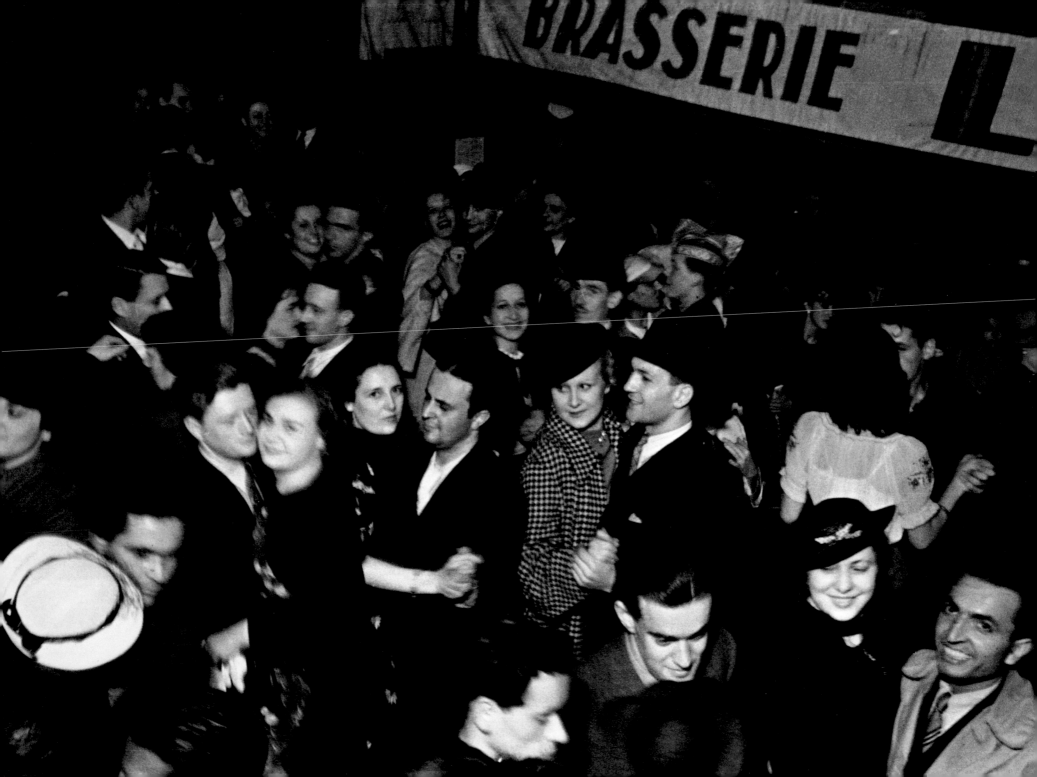

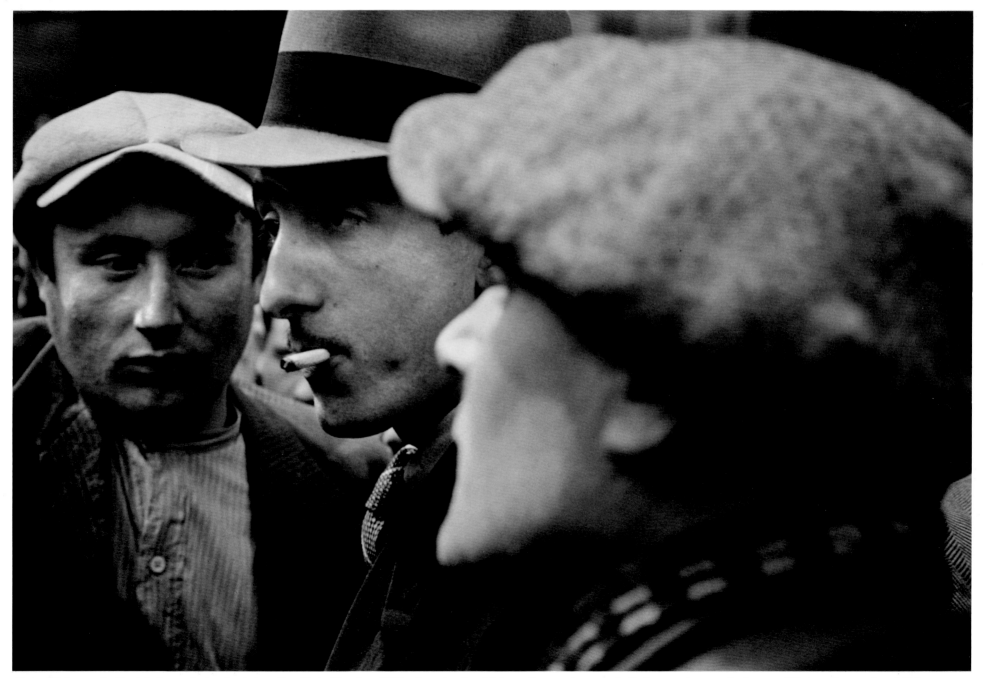

Above: Workers at the Renault factory during the sit-in strikes, Paris, May–June 1936 Opposite: Spanish journalist wrongly accused of being an agitator at the League of Nations, Geneva, June 1936

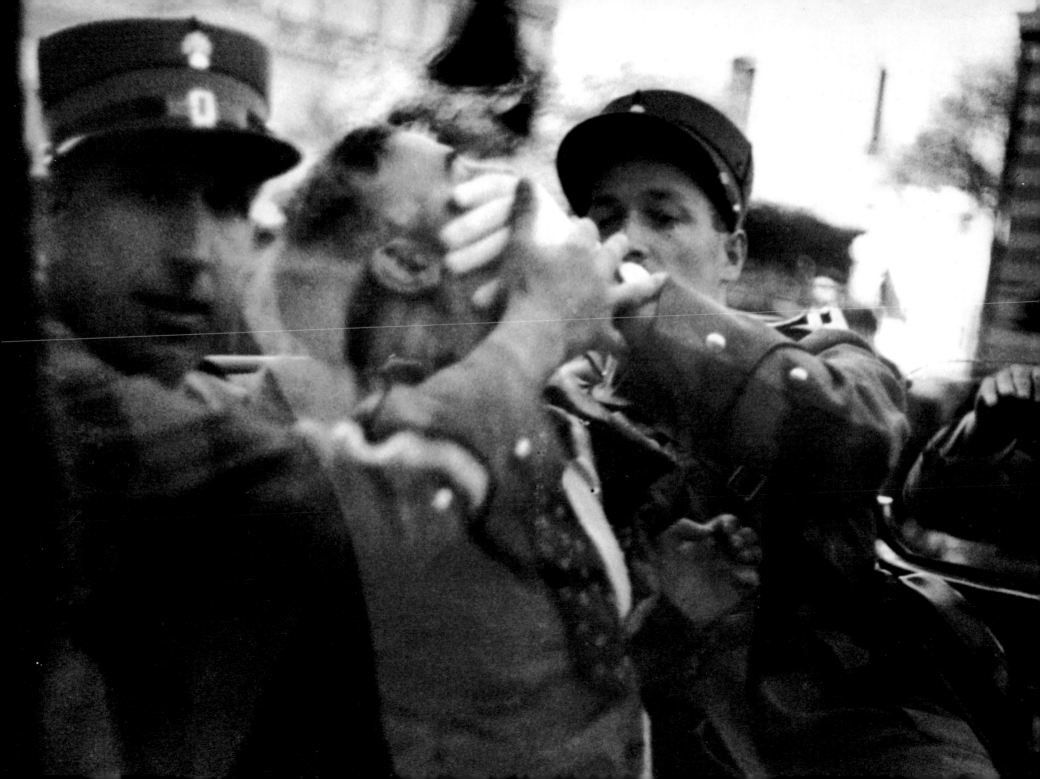

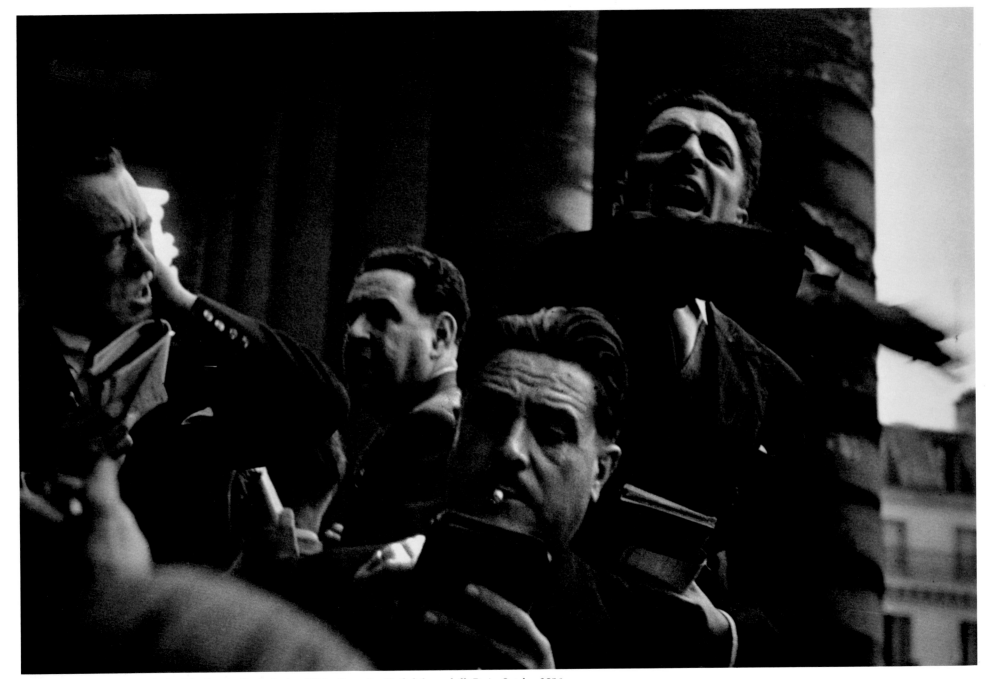

Above: Curb traders on the porch of the Bourse, Paris, Spring 1936 Opposite: Civil-defense drill, Paris, October 1936

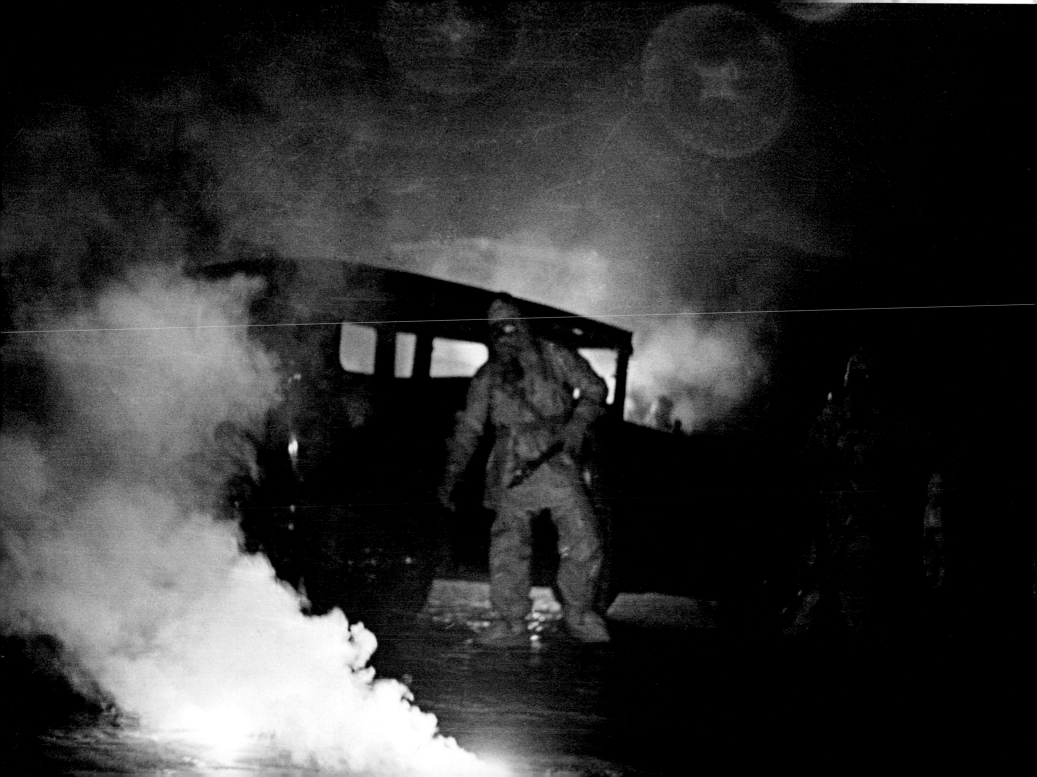

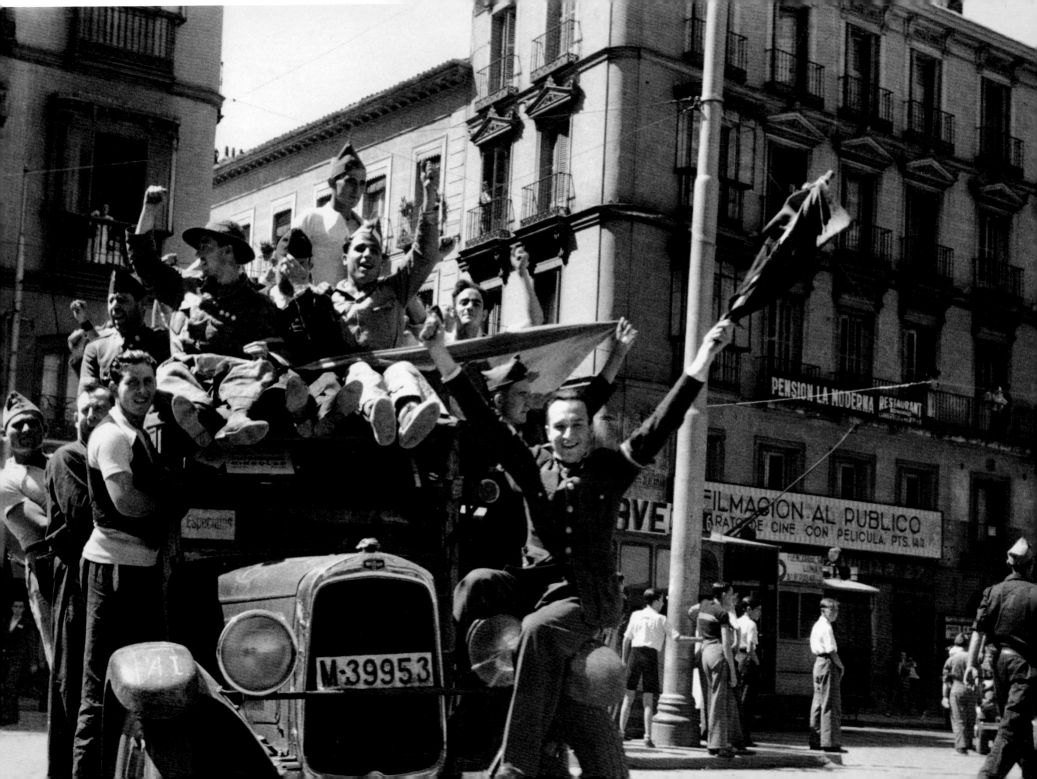

SPAIN 1936-1939

In July 1936 an alliance of monarchists and Fascists, led by Generalissimo Francisco Franco, began a civil war to overthrow the legitimately elected government of Spain, which united liberals and leftists. On his first trip to cover the war, Capa (together with Gerda Taro) photographed fighting in the south and in the northeastern provinces of Catalonia and Aragon.

In early November 1936 Fascist troops began attacking Madrid, which was saved by the arrival of large numbers of foreign volunteers, the International Brigades. When the French newspaper *Regards* published Capa's first pictures of the siege of Madrid, the issue's cover proclaimed his photographs of the "crucified capital" to be "prodigious." He made many trips to Spain, and spent much time in Madrid, which was heavily shelled and bombed. "Nowhere is there safety for anyone in this war," he wrote. "The women stay behind but the death, the ingenious death from the skies, finds them out."

After Gerda Taro was killed by a tank, in July 1937, Capa went to New York to visit his mother and brother, and during 1938 he spent six months in China. After his return in October 1938, he was based in Barcelona, which was suffering under bombardment as Fascist troops were advancing rapidly. Some of his most moving photographs document the exodus from the city to the French border late in January 1939. Madrid held out until March, when its fall completed the Fascist victory.

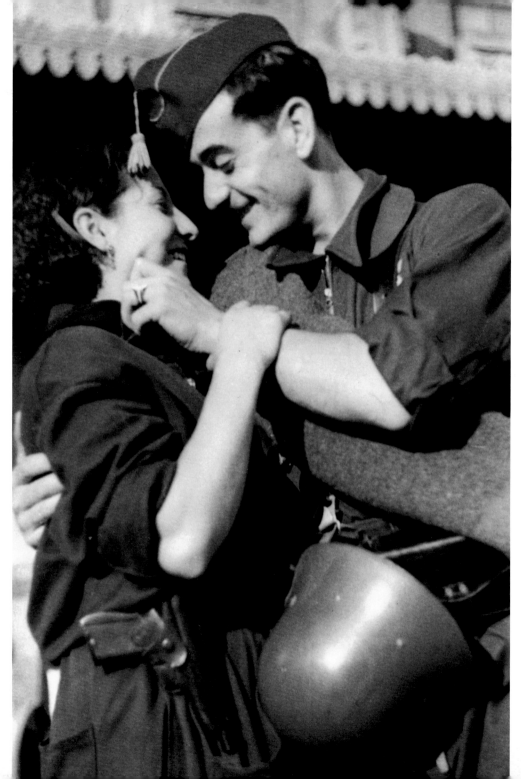

30

Page 28:
Madrid, August–September 1936

Left:
Barcelona, August 1936

Opposite:
Barcelona, August 1936

UHP

JURAD SOBRE ESTAS LETRAS HERMAN

ANTES MORIR QUE CONSENTIR TIRANO

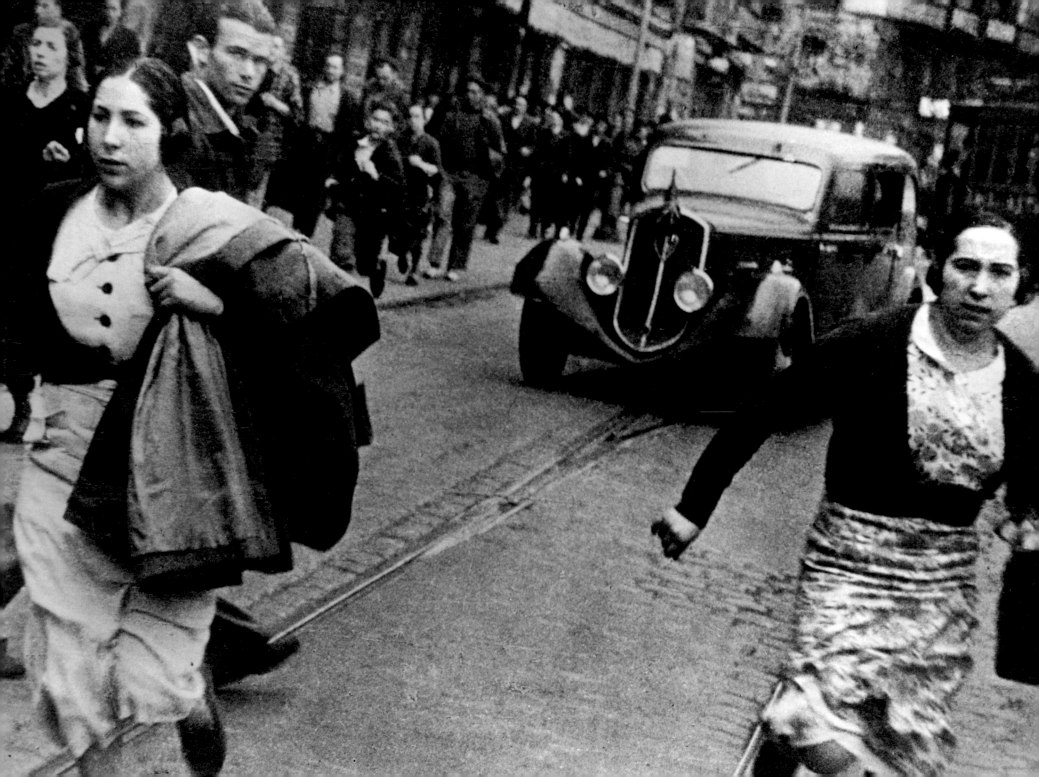

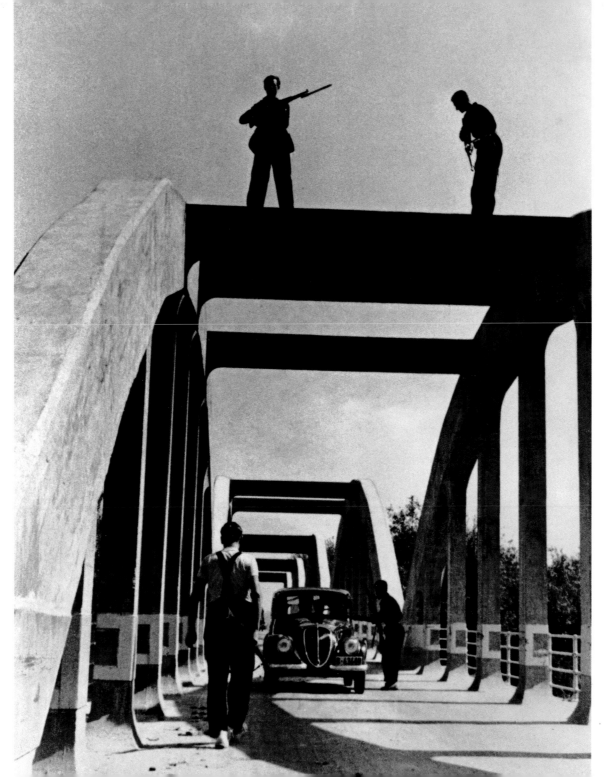

Opposite:
During a Fascist air raid,
Bilbao, May 1937

Left:
Near Barcelona,
August–September 1936

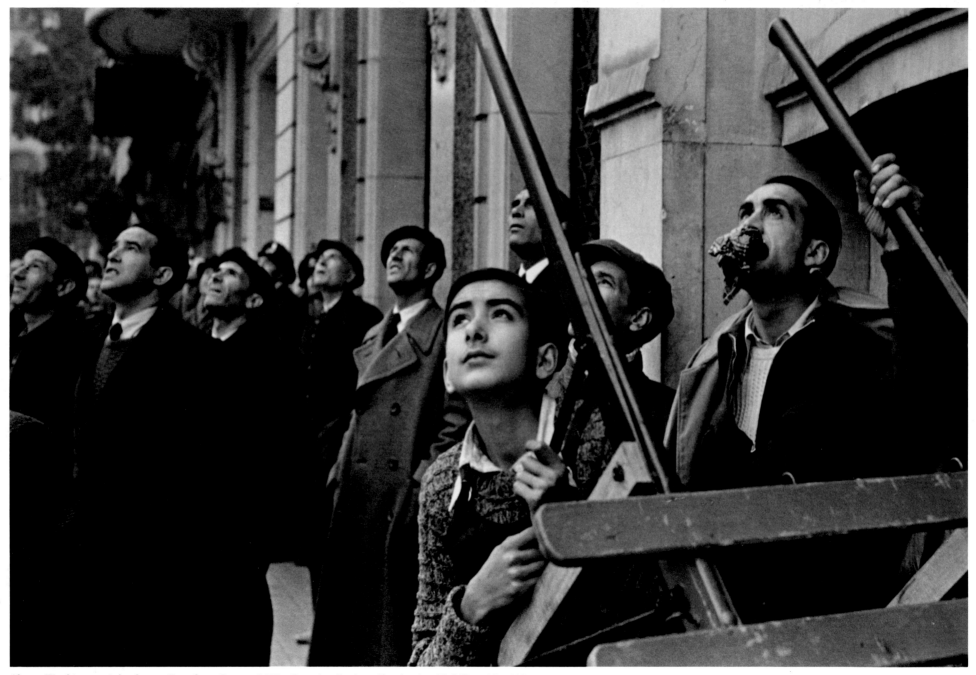

Above: Watching an air battle over Barcelona, January 1939 Opposite: During a Fascist air raid, Bilbao, May 1937

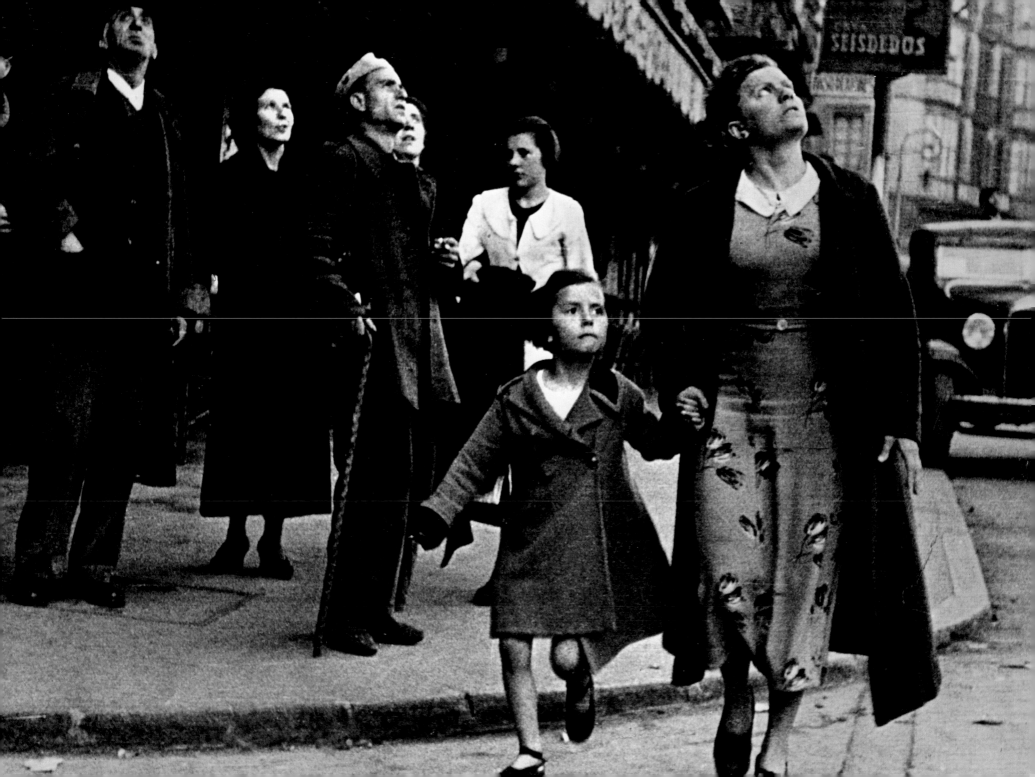

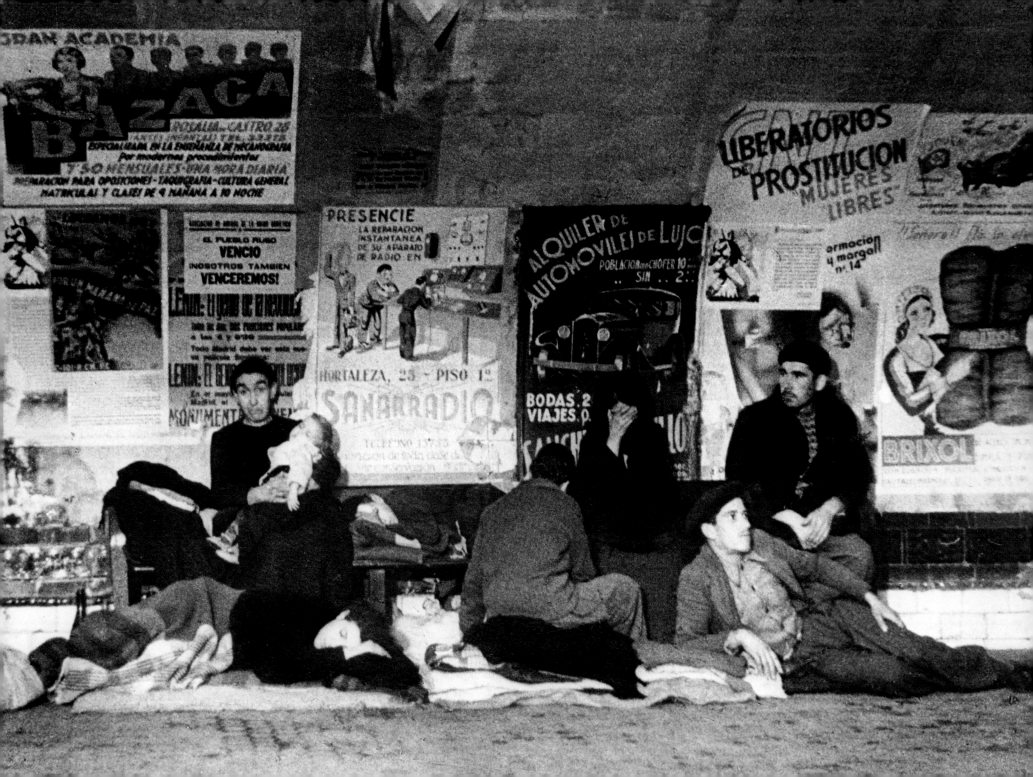

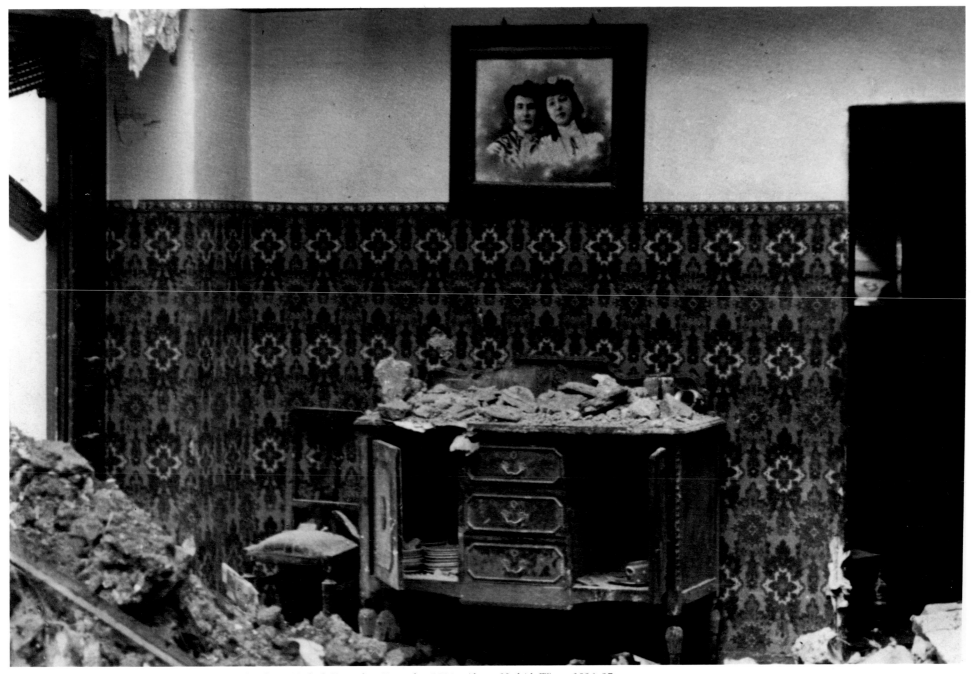

Opposite: In a subway station, seeking shelter from bombing, Madrid, November–December 1936 Above: Madrid, Winter 1936–37

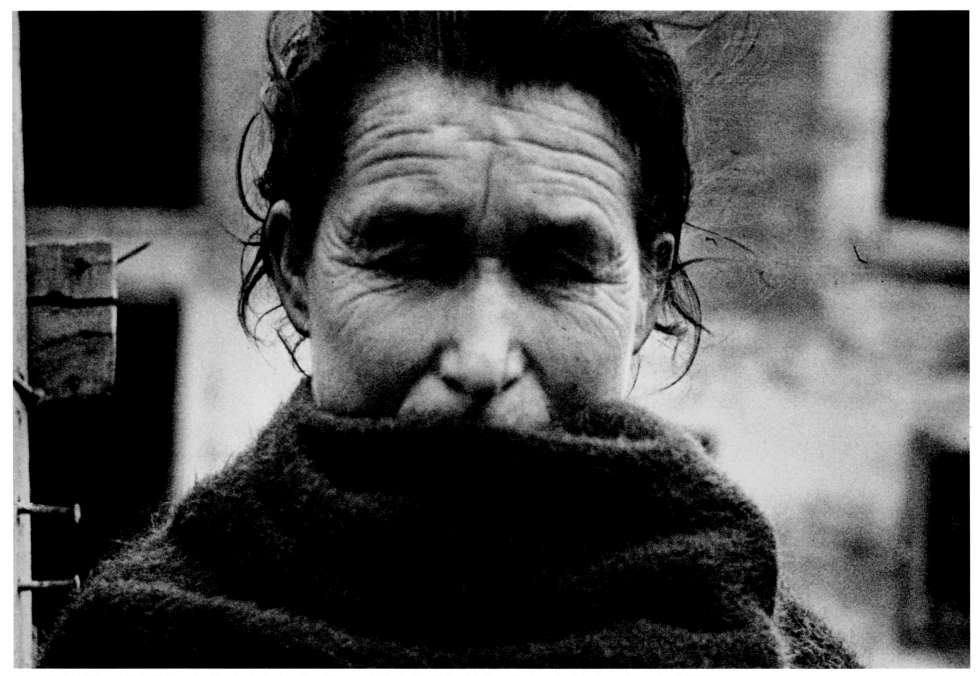

Above: Madrid, Winter 1936–37 Opposite: The death of a Loyalist militiaman (Federico Barell Garcia), Cerro Muriano (Córdoba front), September 5, 1936

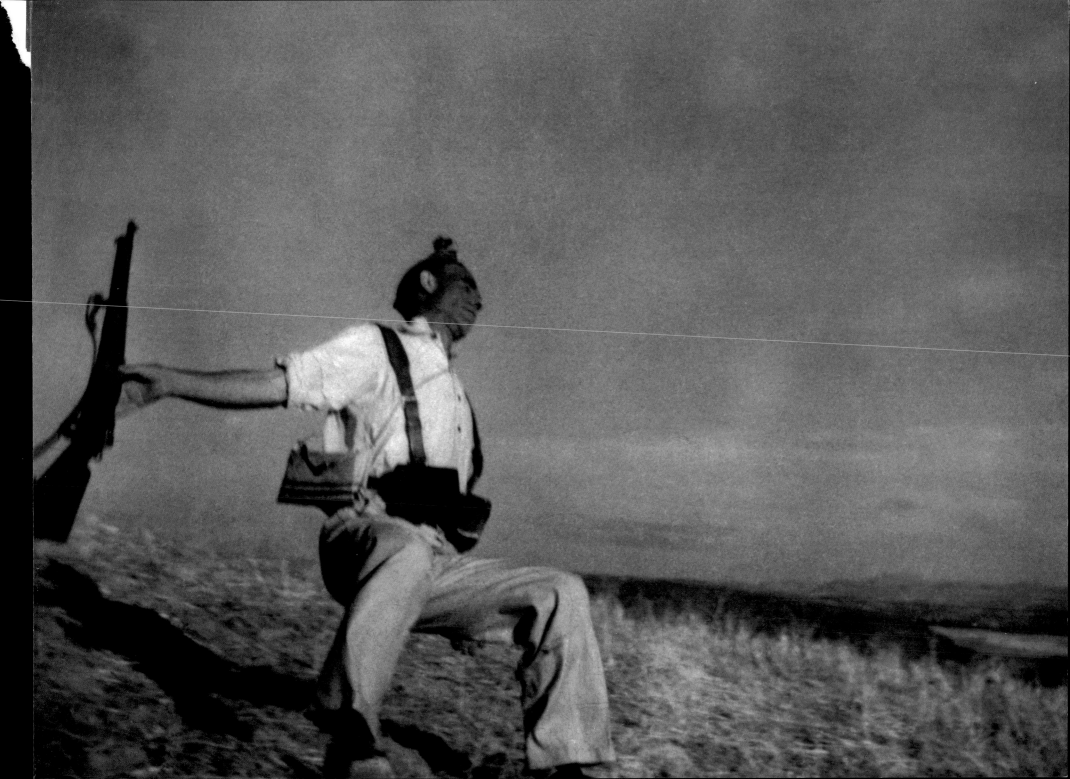

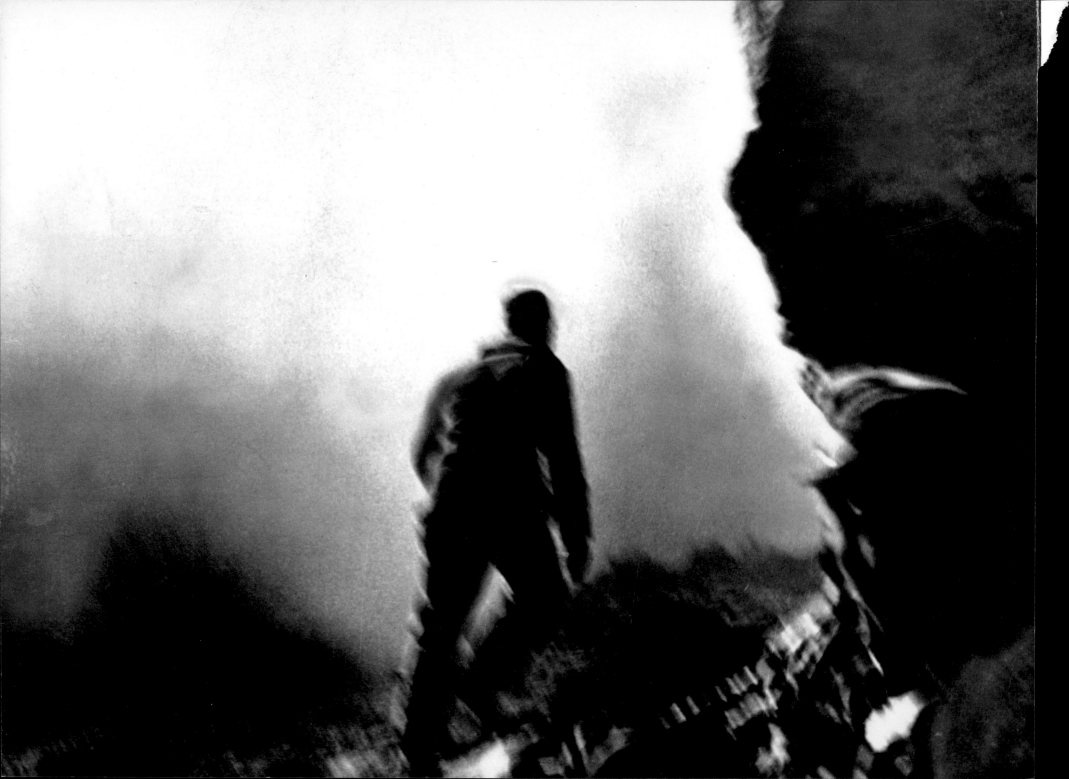

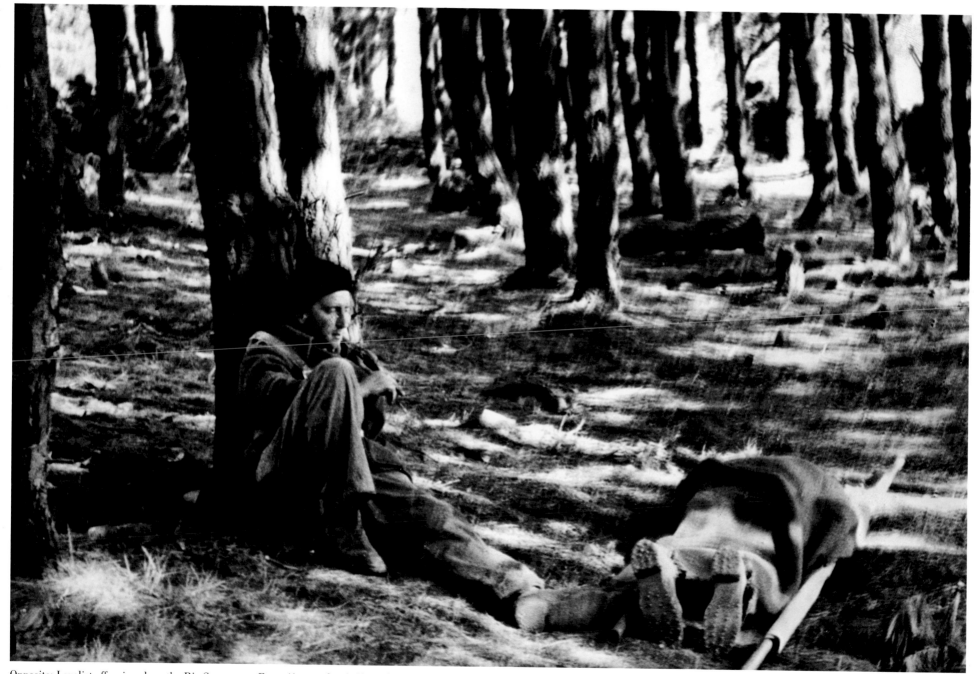

Opposite: Loyalist offensive along the Rio Segre, near Fraga (Aragon front), November 7, 1938 Above: Loyalist soldier during the battle of Mount Solluve, Bilbao front (Basque region), May 1937

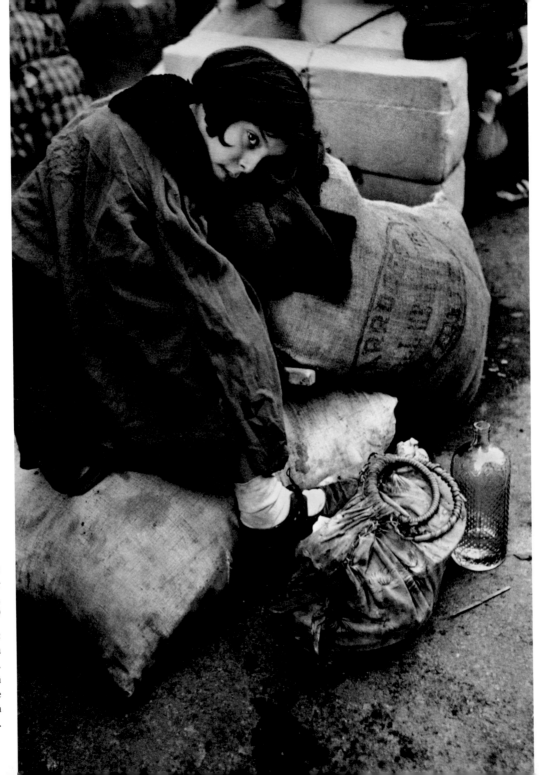

Right:
At a refugee transit center
during the evacuation of the city,
Barcelona, January 1939

Opposite:
On the road from Tarragona
to Barcelona, January 15, 1939.
Before they could reach
Barcelona, many refugees were
killed by strafing from
Fascist planes.

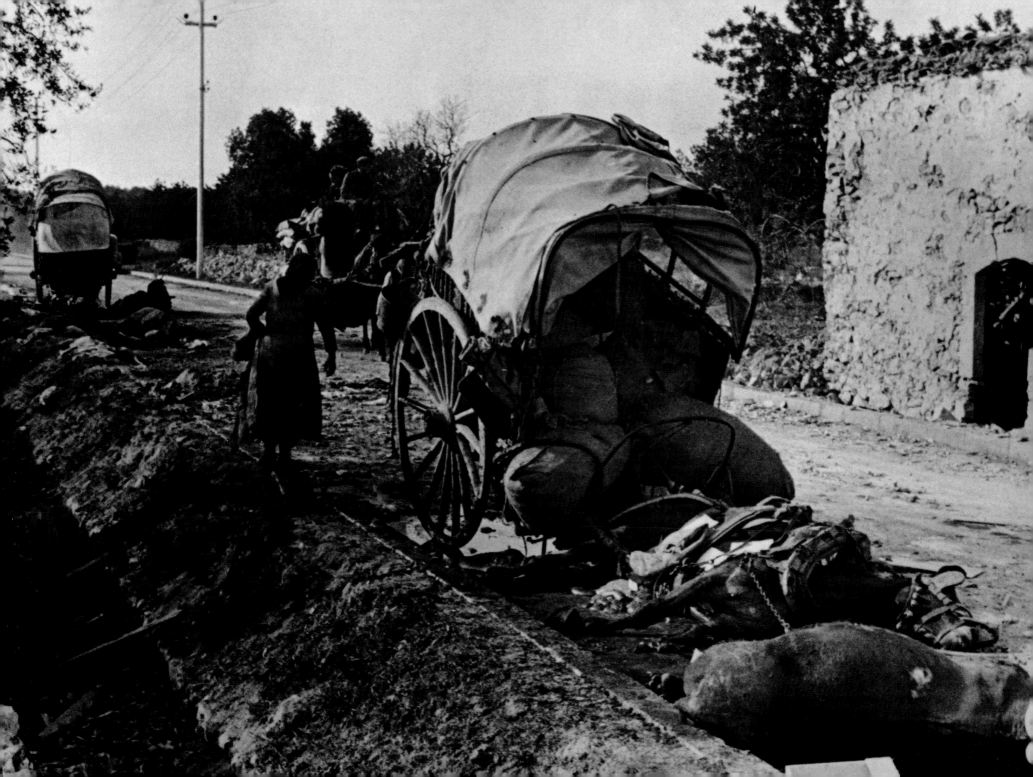

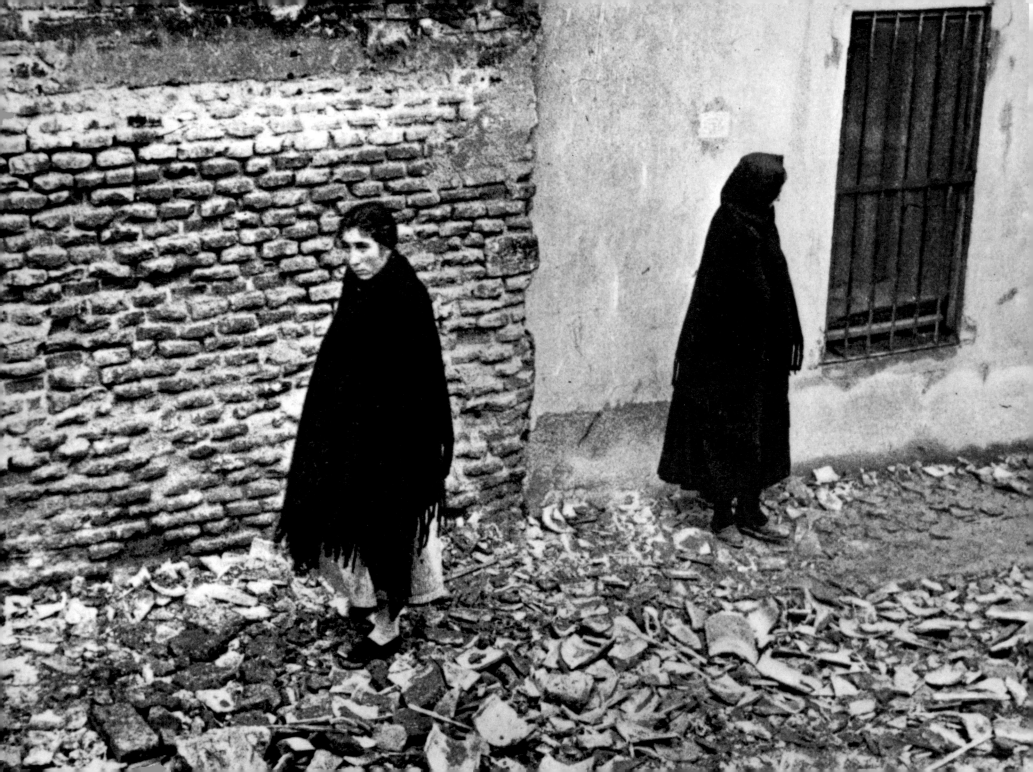

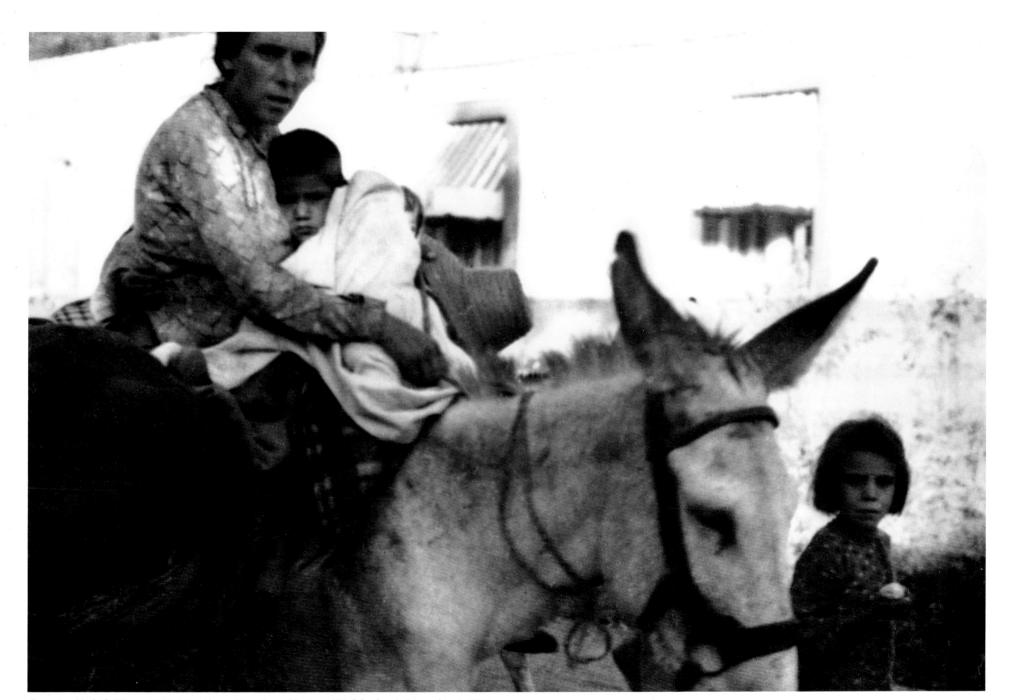

Opposite: Madrid, Winter 1936–37 Above: Near Cerro Muriano (Córdoba front), September 5, 1936

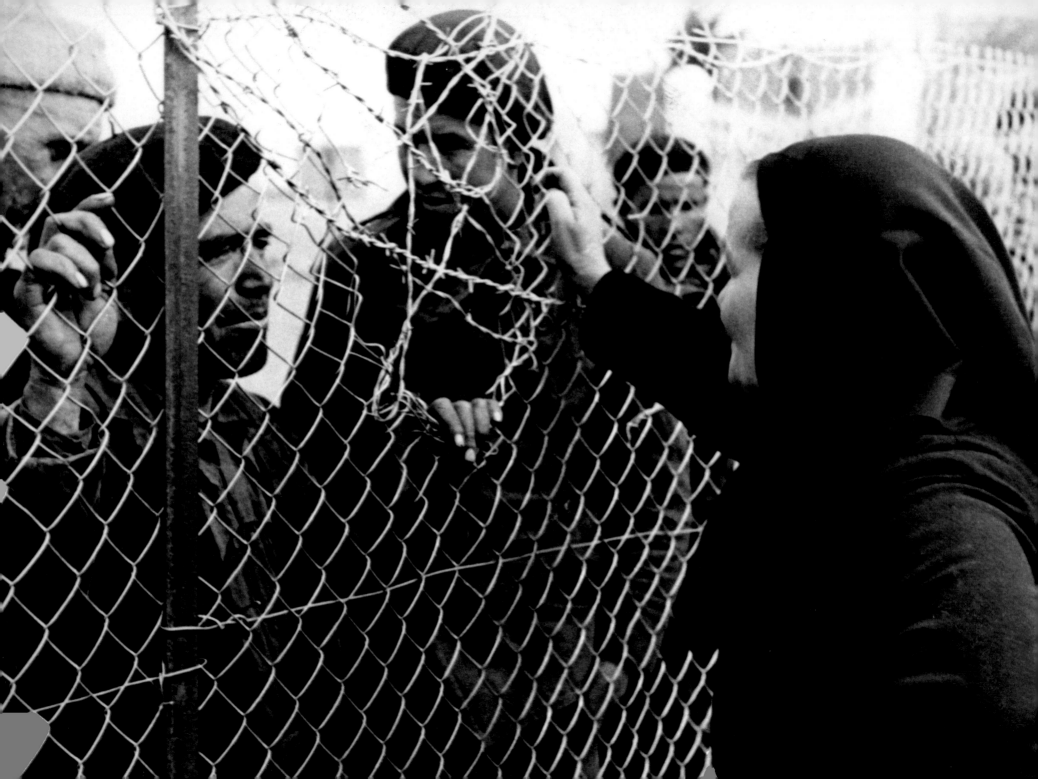

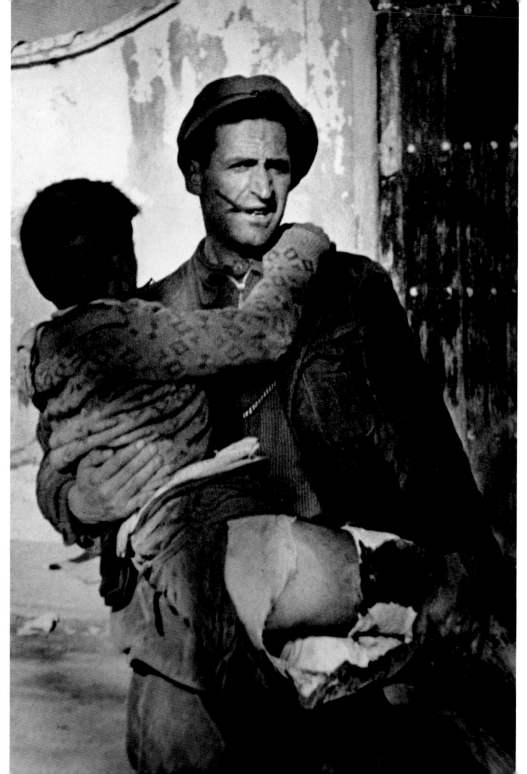

Opposite:
Internment camp for Spanish
Loyalists who had
crossed the border into exile,
Argèles-sur-Mer, France,
March 1939

Left:
Civilian casualties,
Teruel (Aragon front),
December 21, 1937

47

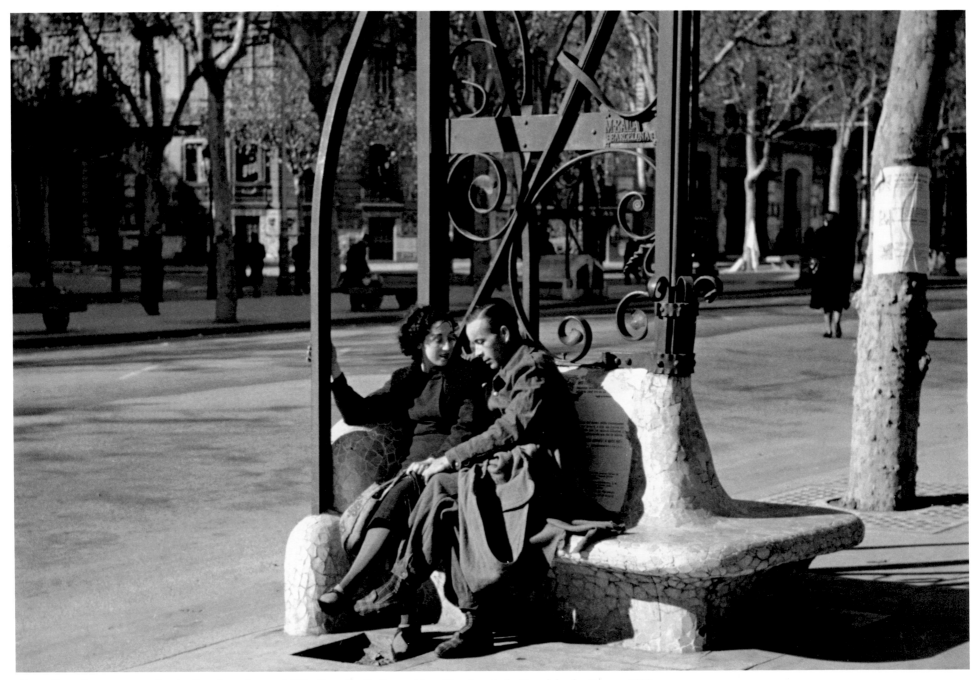

Above: Preparing to evacuate the city, Barcelona, January 1939 Opposite: On the road from Barcelona to the French border, January 1939

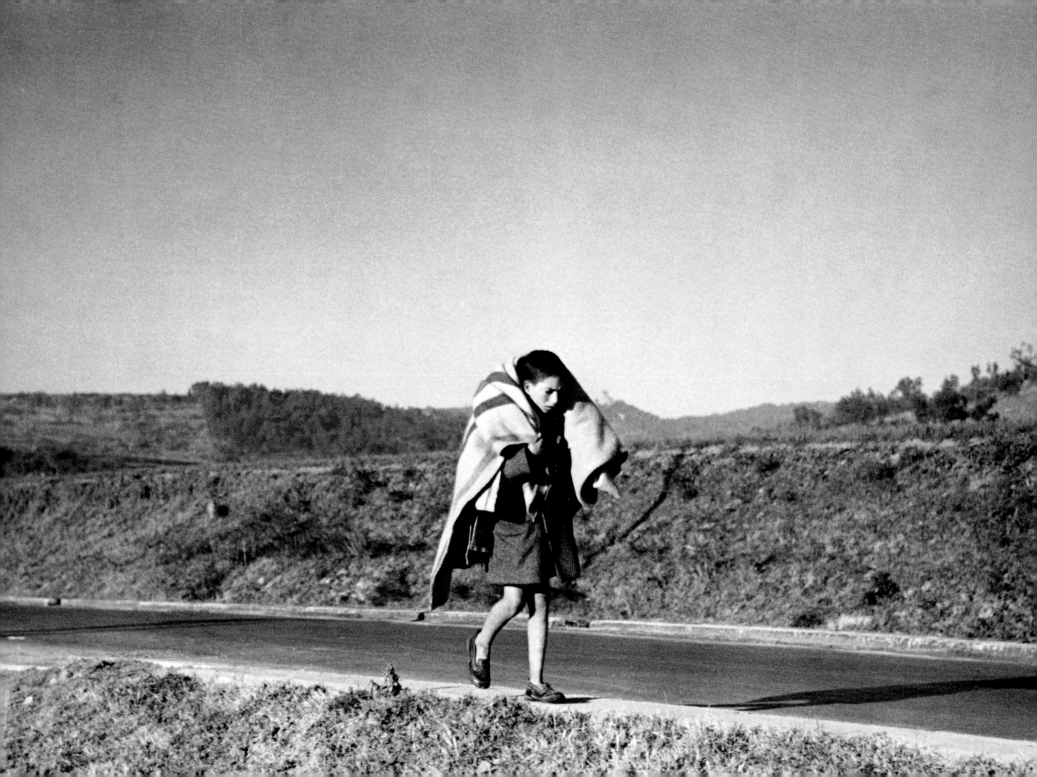

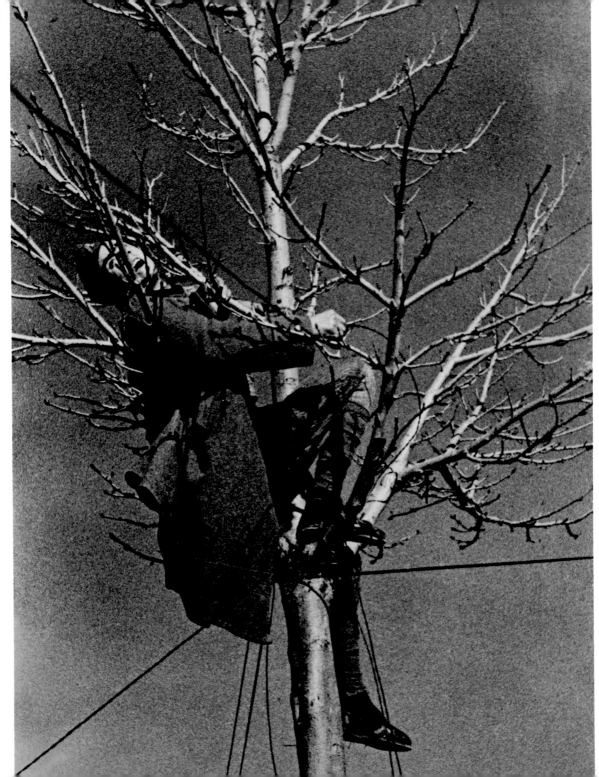

Left:
Loyalist soldier killed
while stringing telephone
lines, Teruel (Aragon front),
December 1937

Opposite:
Loyalist soldiers in the
Civil Governor's palace—the
last major bastion of Fascist
resistance in the town,
Teruel (Aragon front),
January 1938

Following pages:
Exiled Loyalist soldiers
being transferred from one
French government internment
camp to another, between
Argèles-sur-Mer and
Le Barcarès, March 1939

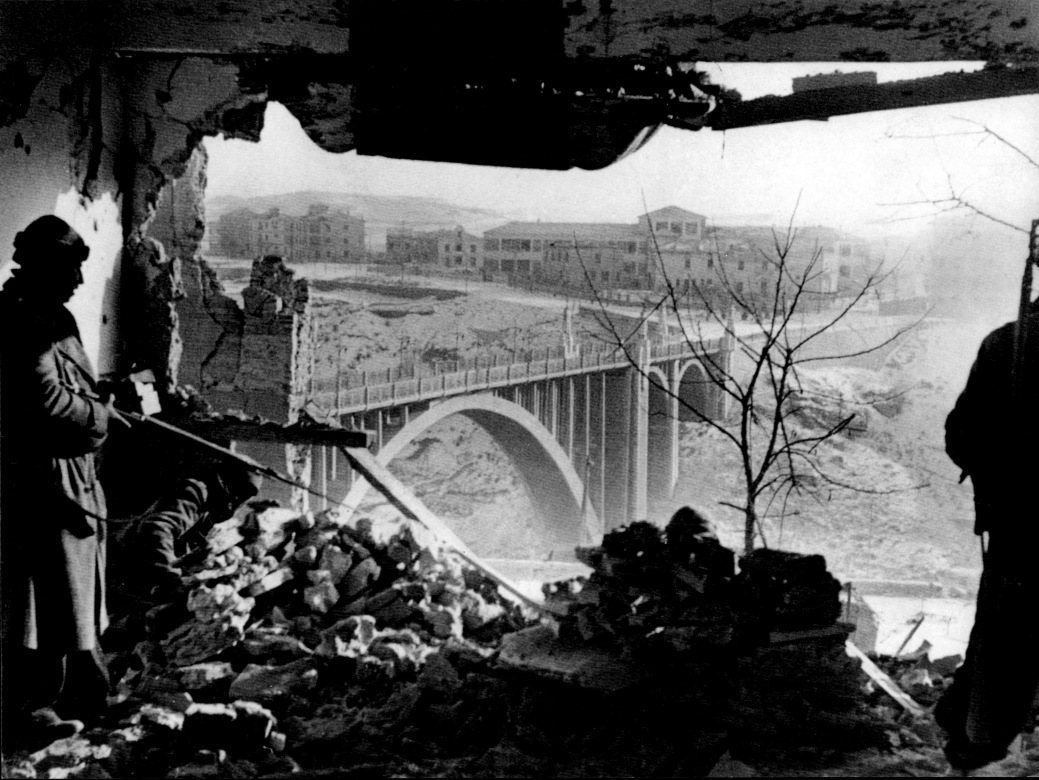

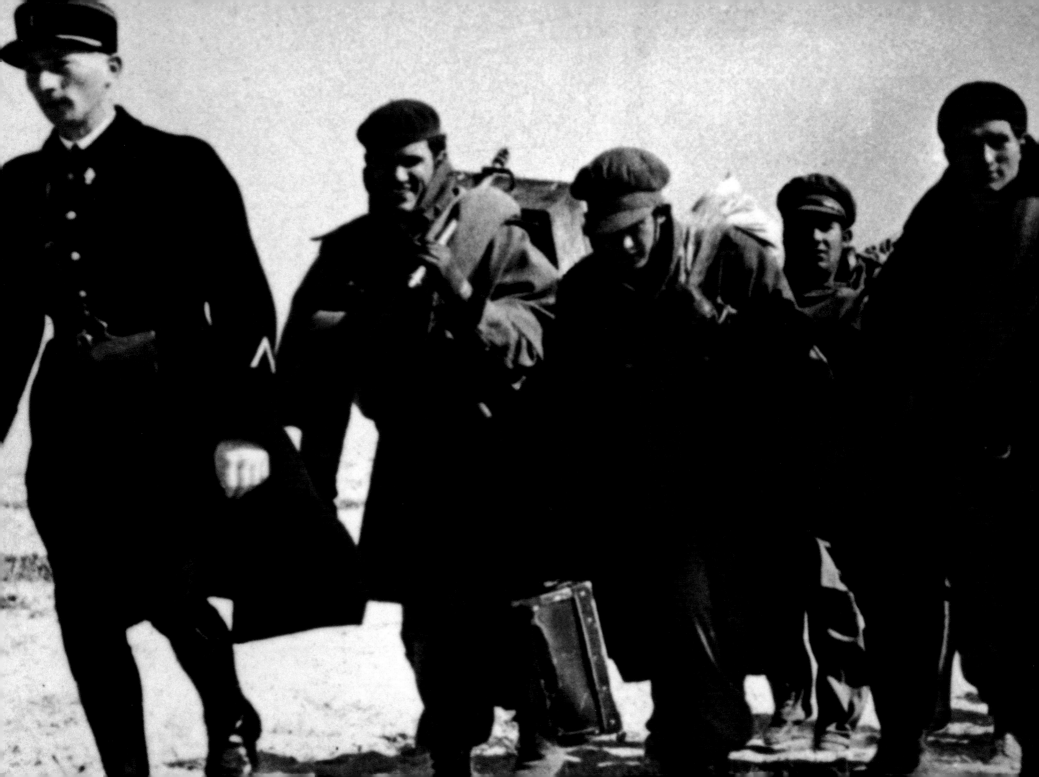

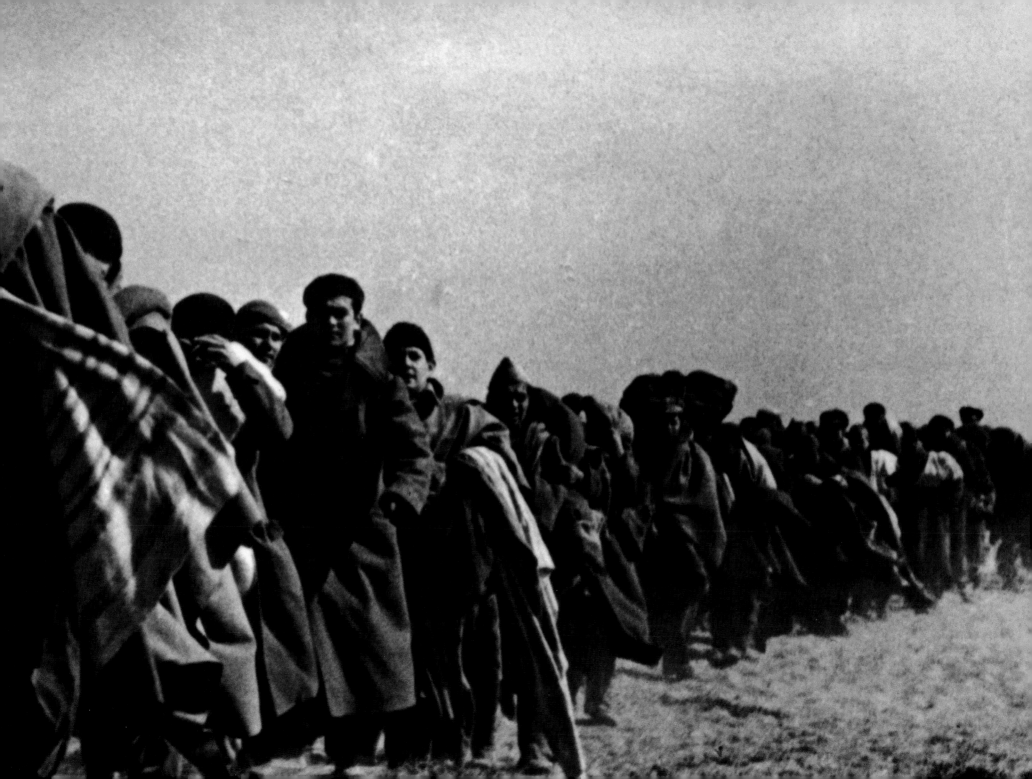

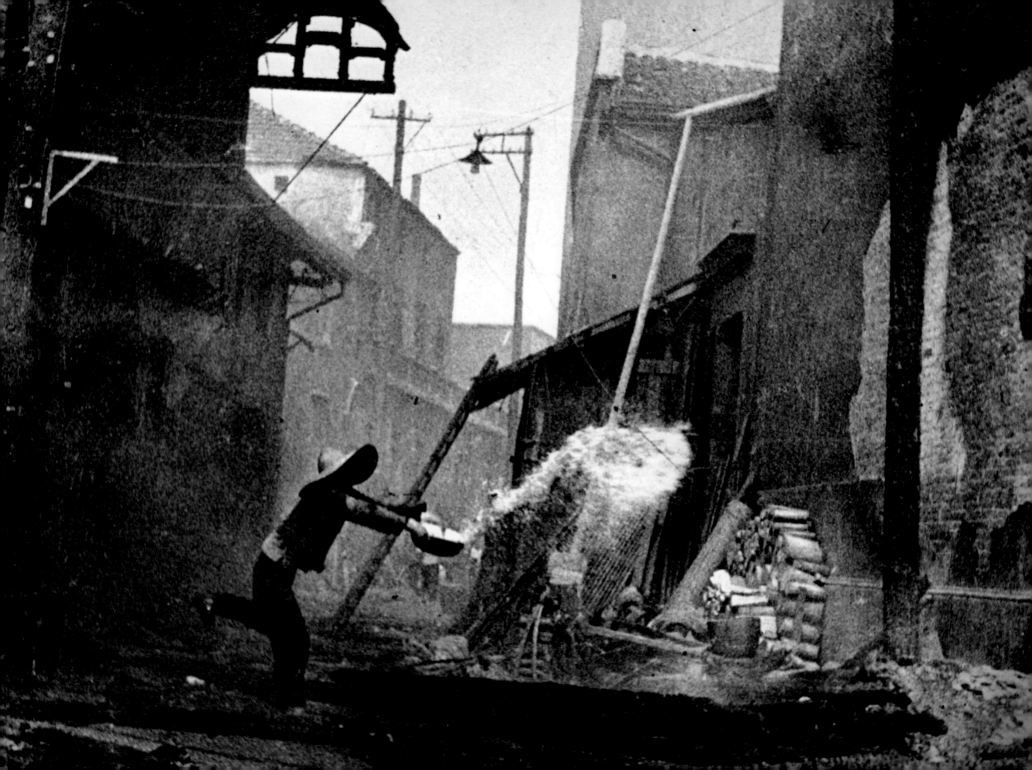

CHINA 1938

Japan, which was allied with Germany and Italy, invaded China in July 1937 hoping to win formal recognition of the de facto Japanese sovereignty in Manchuria. The fighting forced Jiang Jienshi (Chiang Kai-Shek) to form an alliance with his arch-enemies, the Communists. Many people—including Capa—therefore viewed the war in China as the eastern front of the struggle against Fascism, of which the Spanish Civil War was the western front. Many of Capa's images of China echo images he had made in Spain; his photographs of both conflicts show that war reduces nations to the lowest common denominator of violence and suffering.

Early in April 1938, soon after Capa arrived in China with filmmaker Joris Ivens, he photographed the battle of Tai'erzhuang, hailed as the first frontal defeat the Japanese army had ever suffered. Thereafter, he spent much time in the temporary capital, Hankou, which was being severely bombed. Some of the most powerful photographs of his career, both emotionally and graphically, document the aftermath of the Japanese air raids.

Capa accompanied Ivens to Xi'an and Guangzhou, and he photographed the devastating flood that resulted when Jiang Jienshi ordered the dikes of the Yellow River near Zhengzhou to be dynamited in order to stop the Japanese advance. Capa had hoped to visit Mao Zedong and his Communist forces in their western outpost of Yenan, but Jiang's government thwarted the photographer's efforts to get there. He left China late in September of 1938, shortly before Hankou fell to the Japanese.

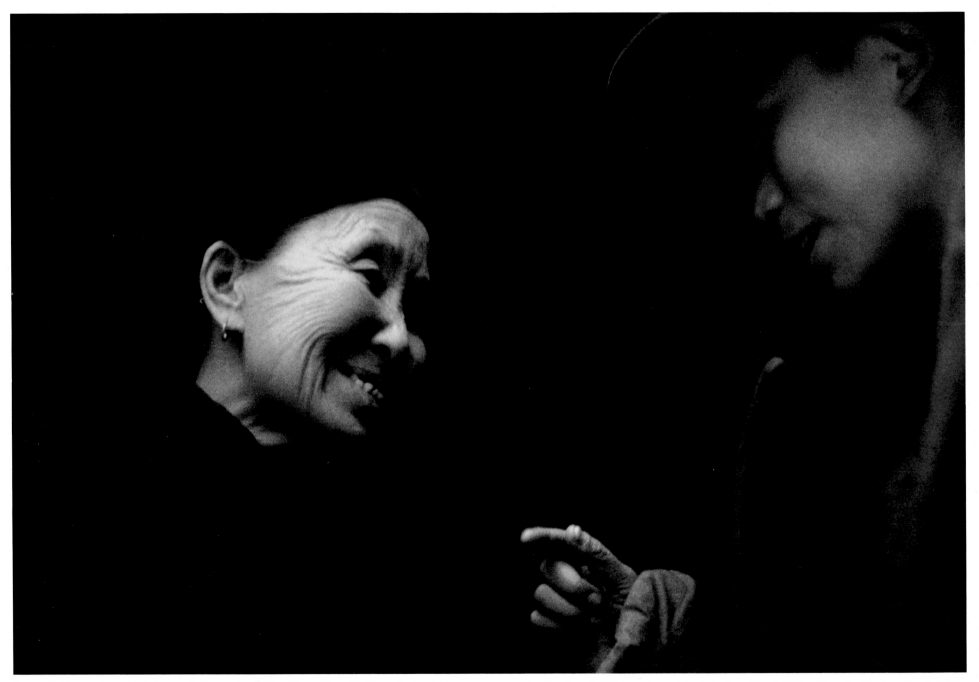

Page 54: After an air raid, Hankou, July–September 1938 Above: Mme. Ma-Tso, a leader of Chinese women, with Mlle. Jan, the "Chinese Joan of Arc," Hankou, March 1938 Opposite: Hankou, March 1938

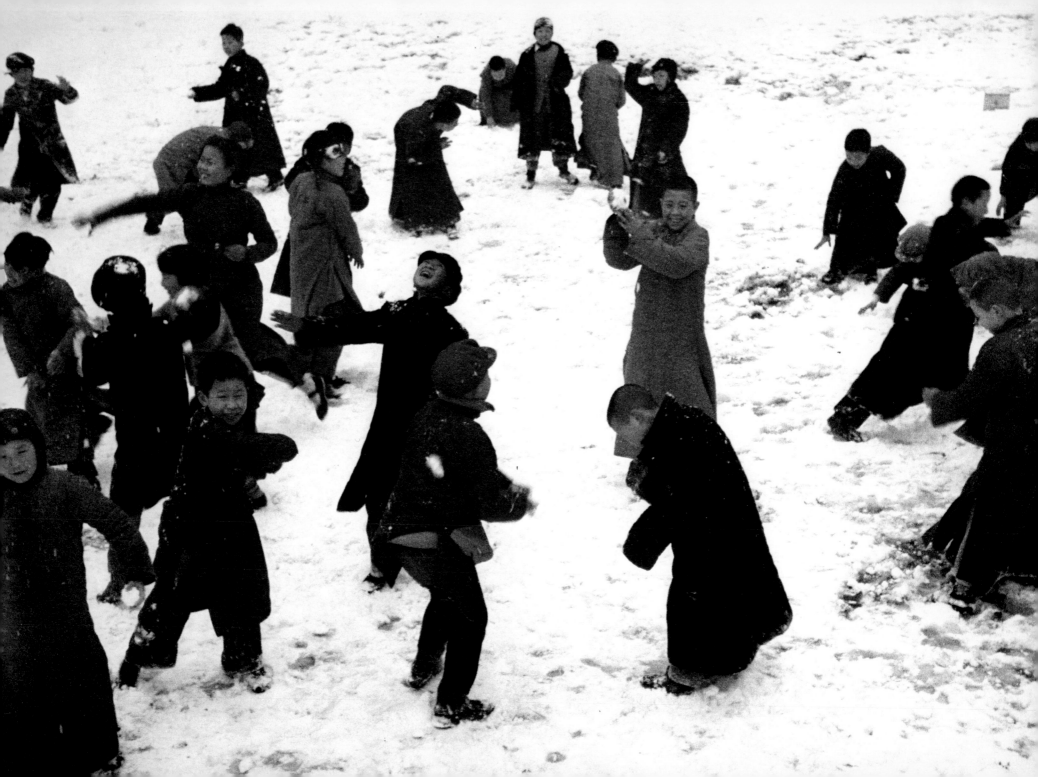

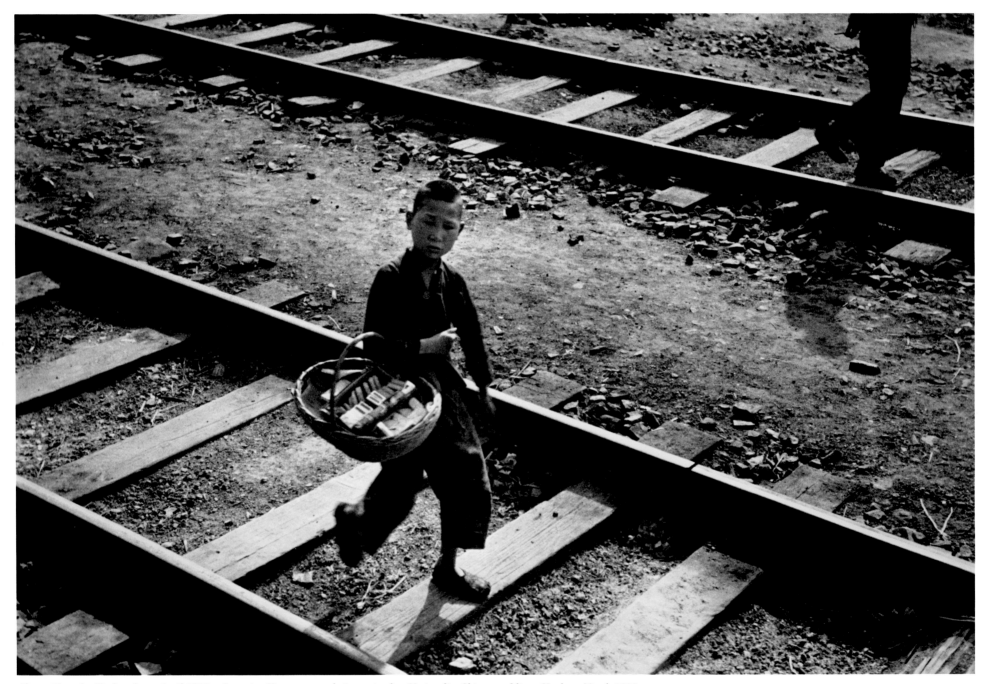

Above: Near the Xuzhou front, April 1938 Opposite: Young women being trained as Nationalist Chinese soldiers, Hankou, March 1938

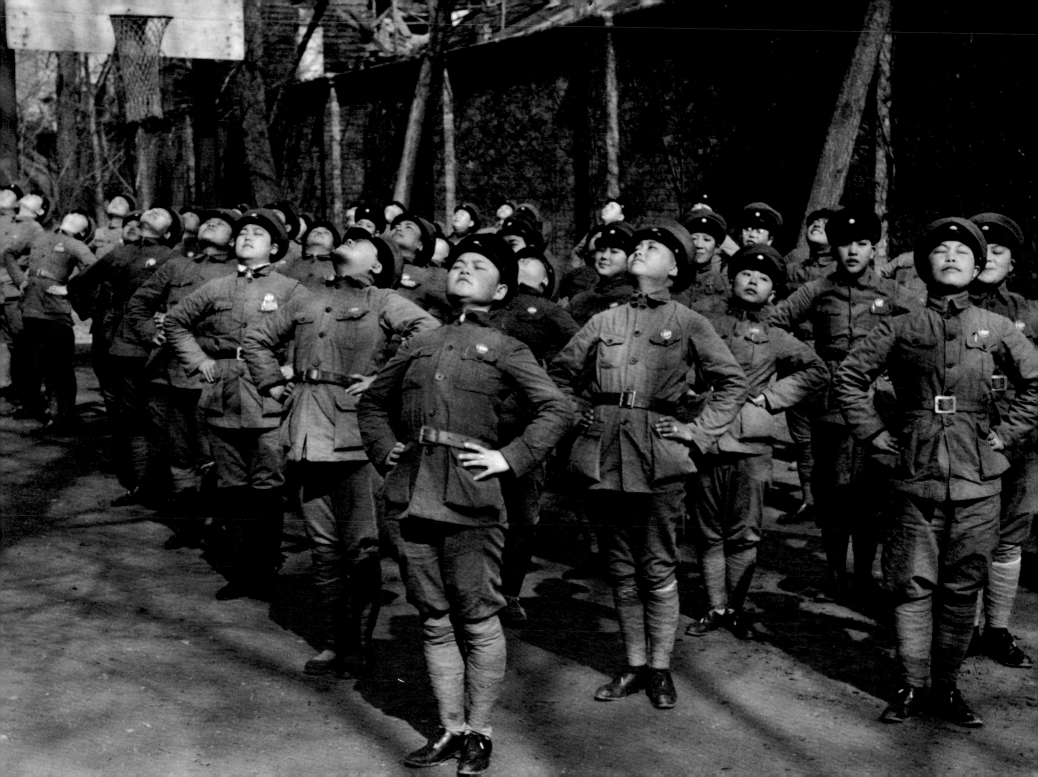

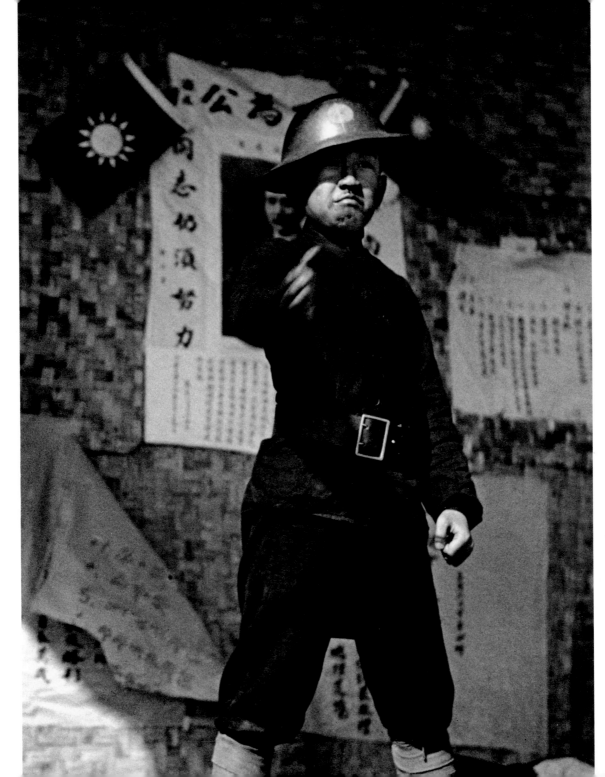

Left:
Student propaganda play
celebrating Chinese
resistance to the Japanese
invasion of China,
Hankou, March 1938

Opposite:
Chinese soldiers being
ferried across the flooded
Yellow River, near
Zhengzhou, June–July 1938

Following pages:
Watching as Chinese
fighter planes shoot down
twenty of the Japanese
bombers attacking the city
on Emperor Hirohito's
birthday, Hankou,
April 29, 1938

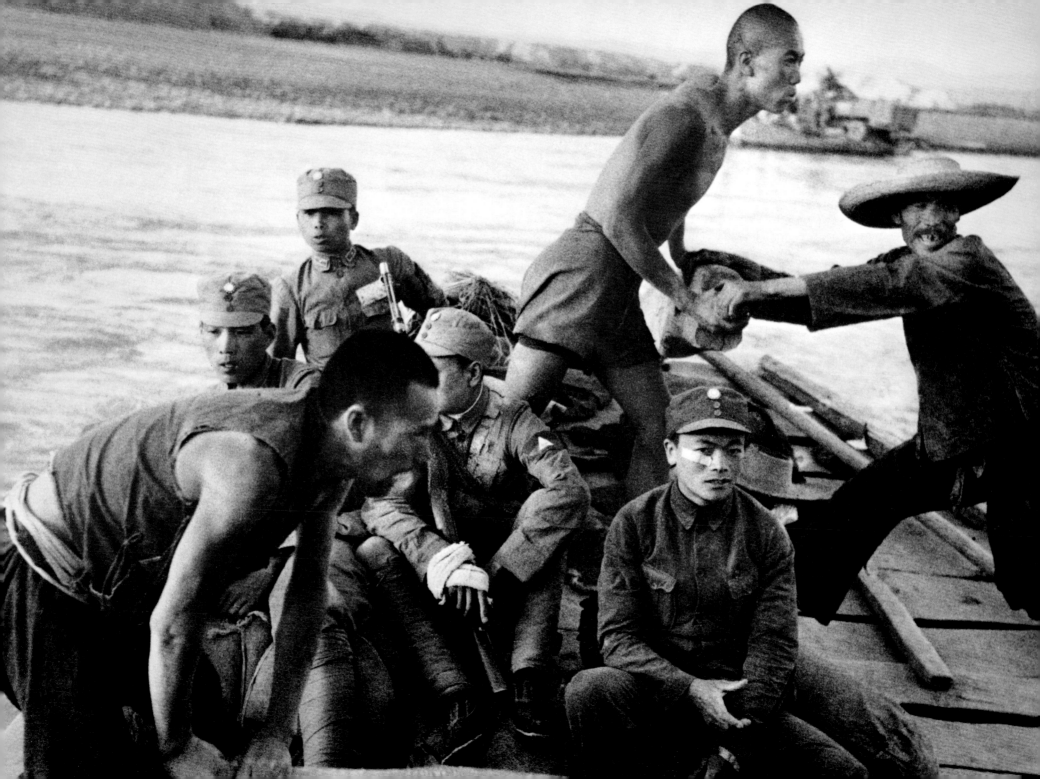

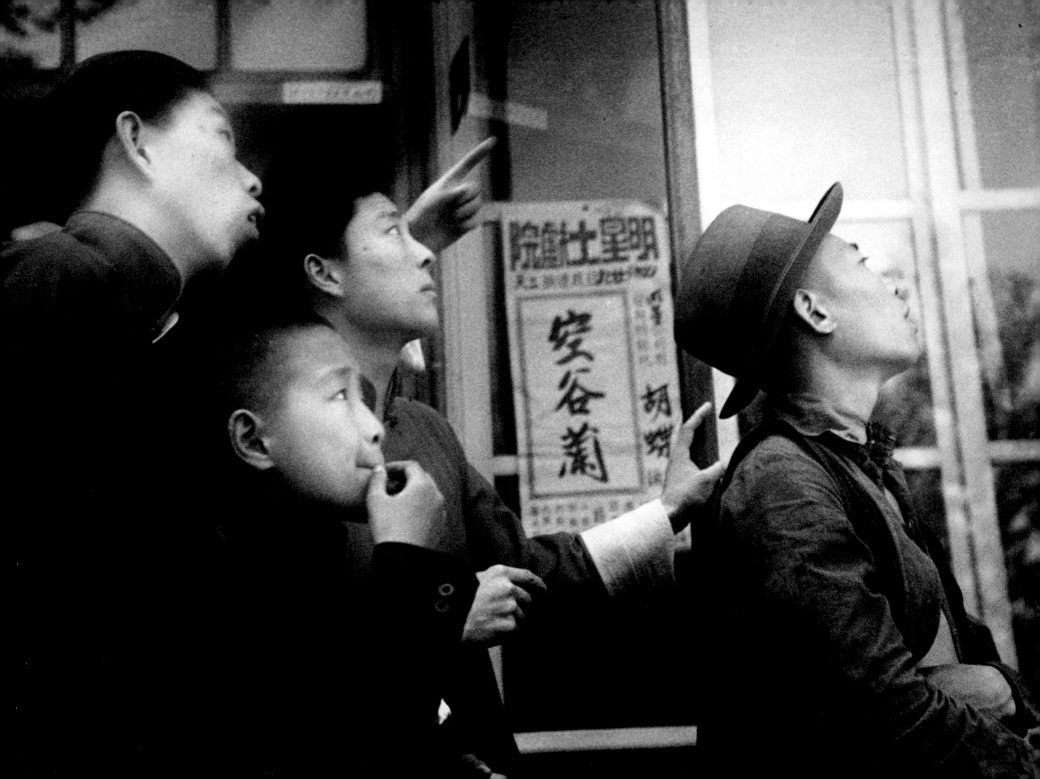

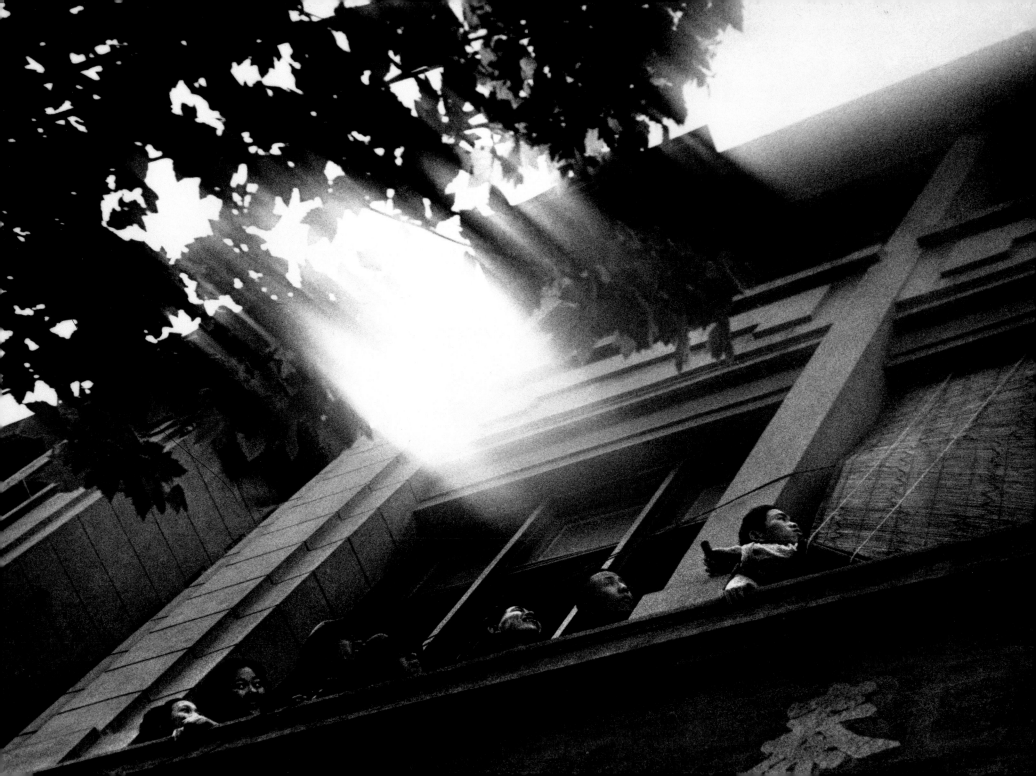

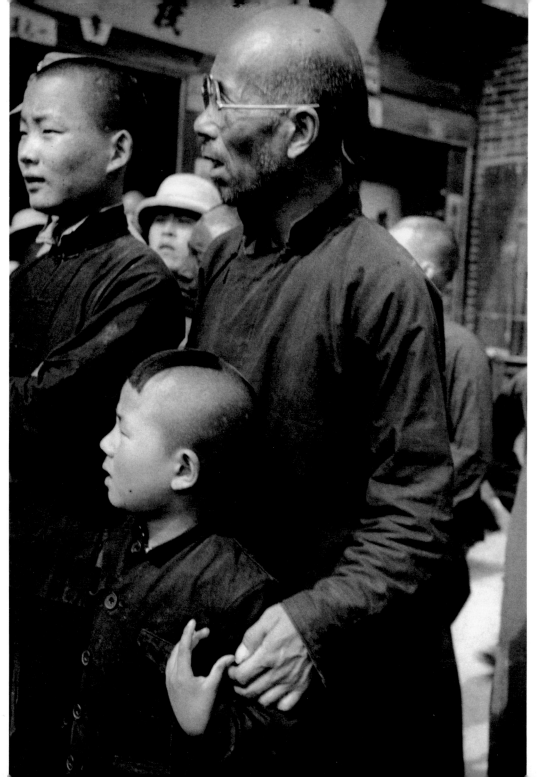

Left:
Watching a parade,
Hankou, 1938

Opposite:
China, 1938

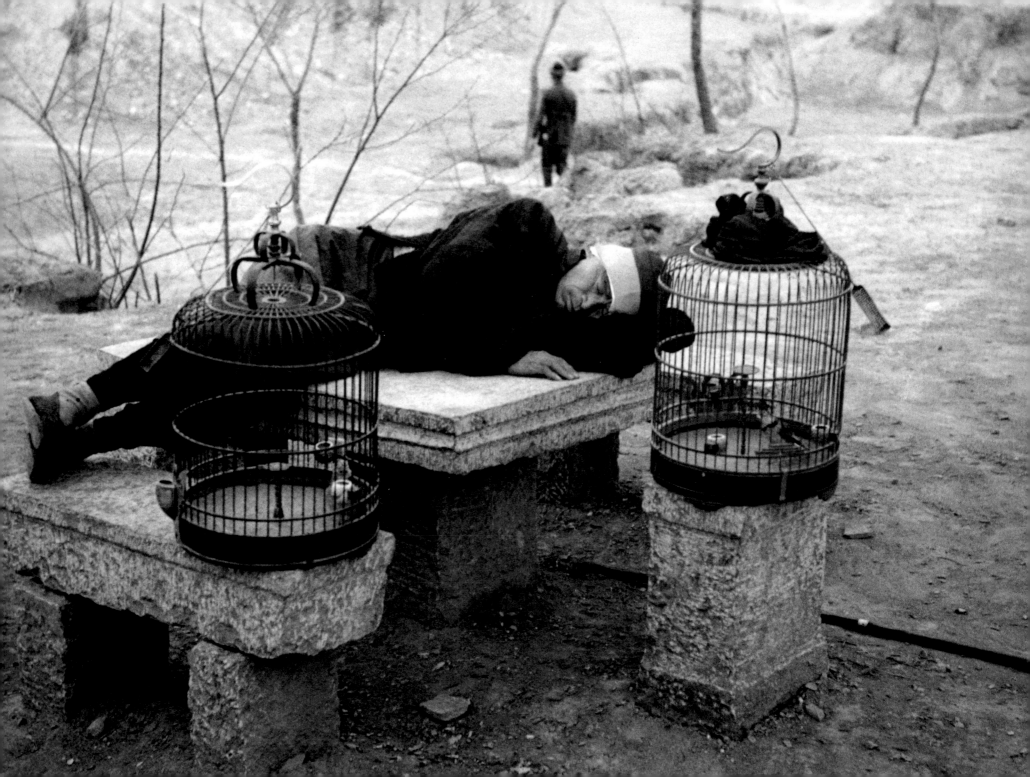

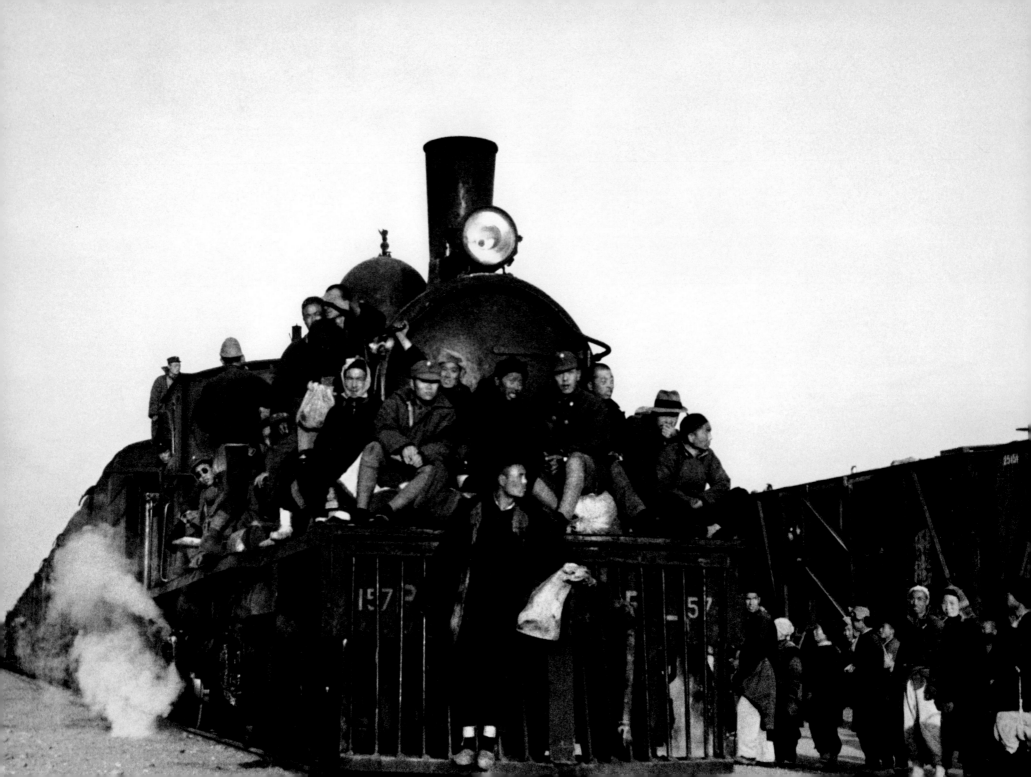

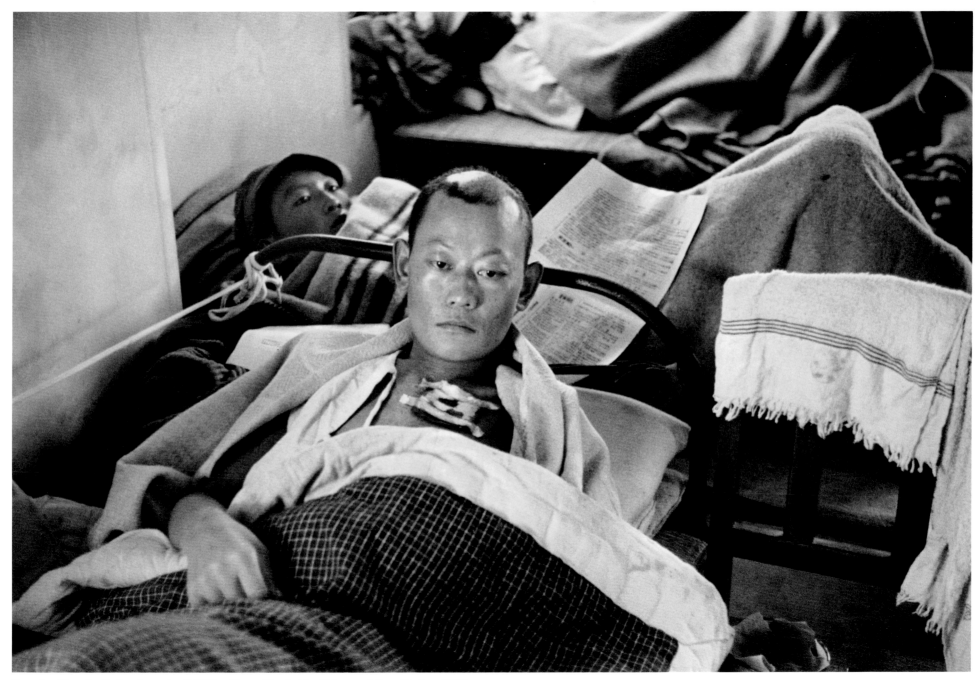

Opposite: Near the Xuzhou front, April 1938 Above: Hospital for Chinese soldiers, Hankou, 1938

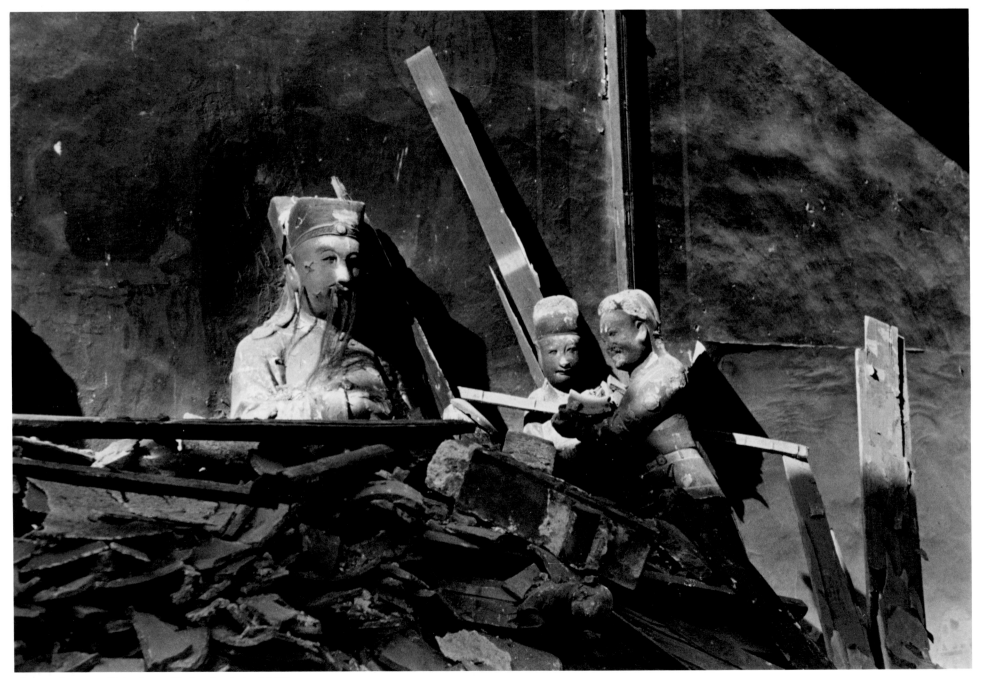

Above and opposite: Tai'erzhuang (Xuzhou front), April 1938

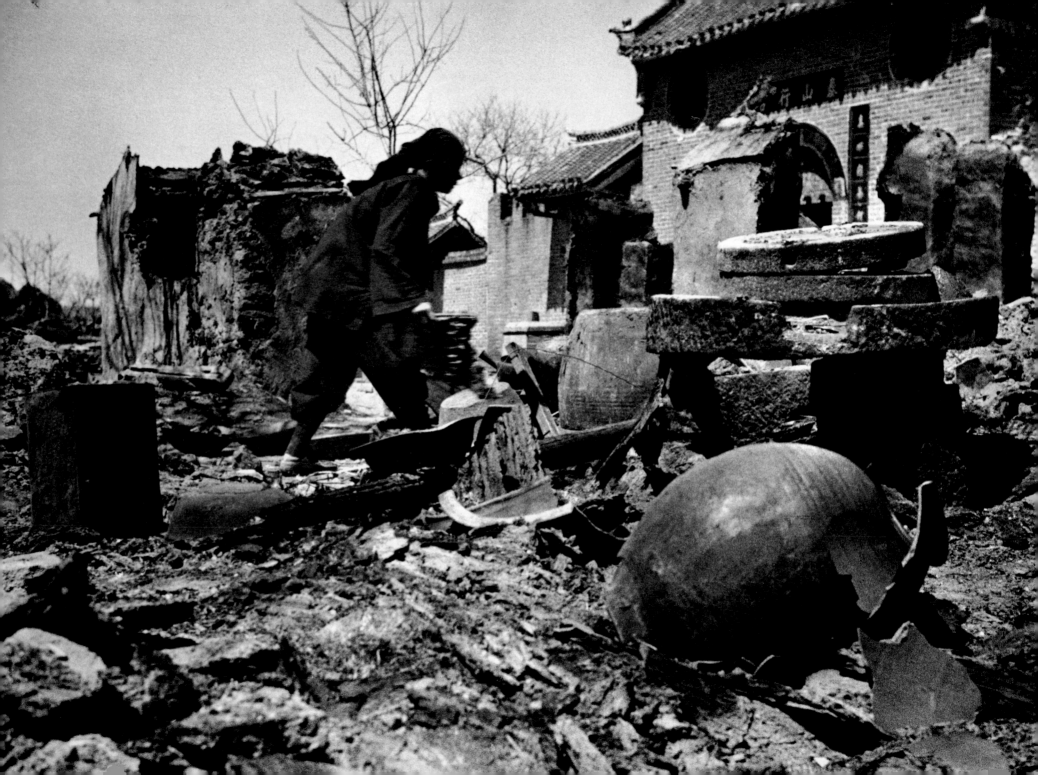

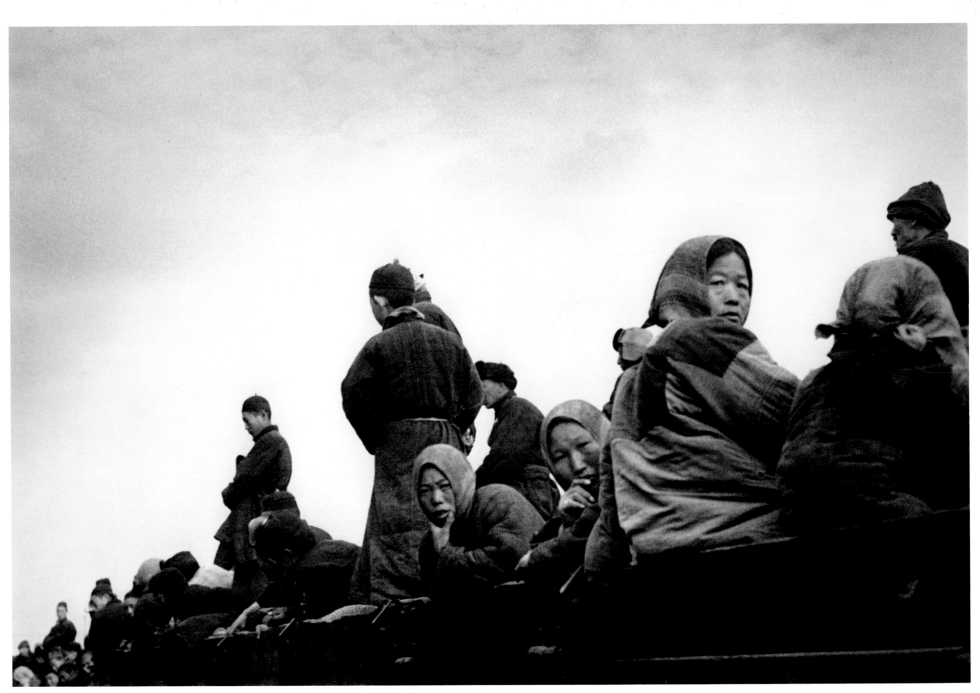

Above: Near the Xuzhou front, April 1938 Opposite: After a Japanese air raid, Hankou, July–September 1938

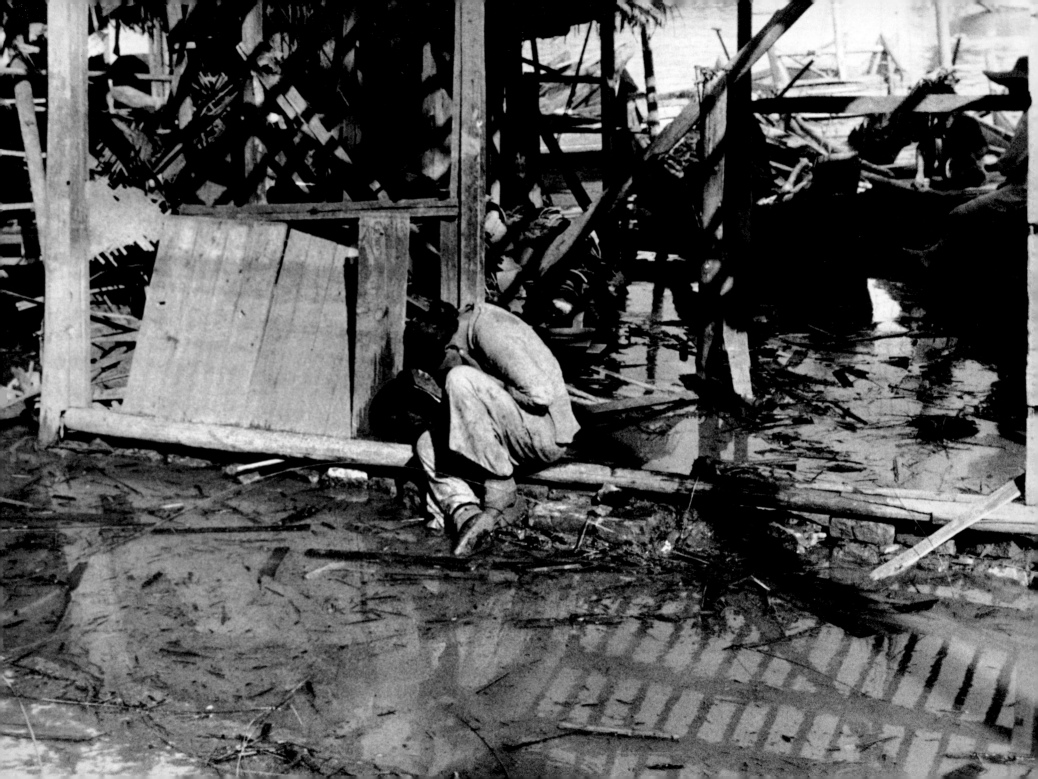

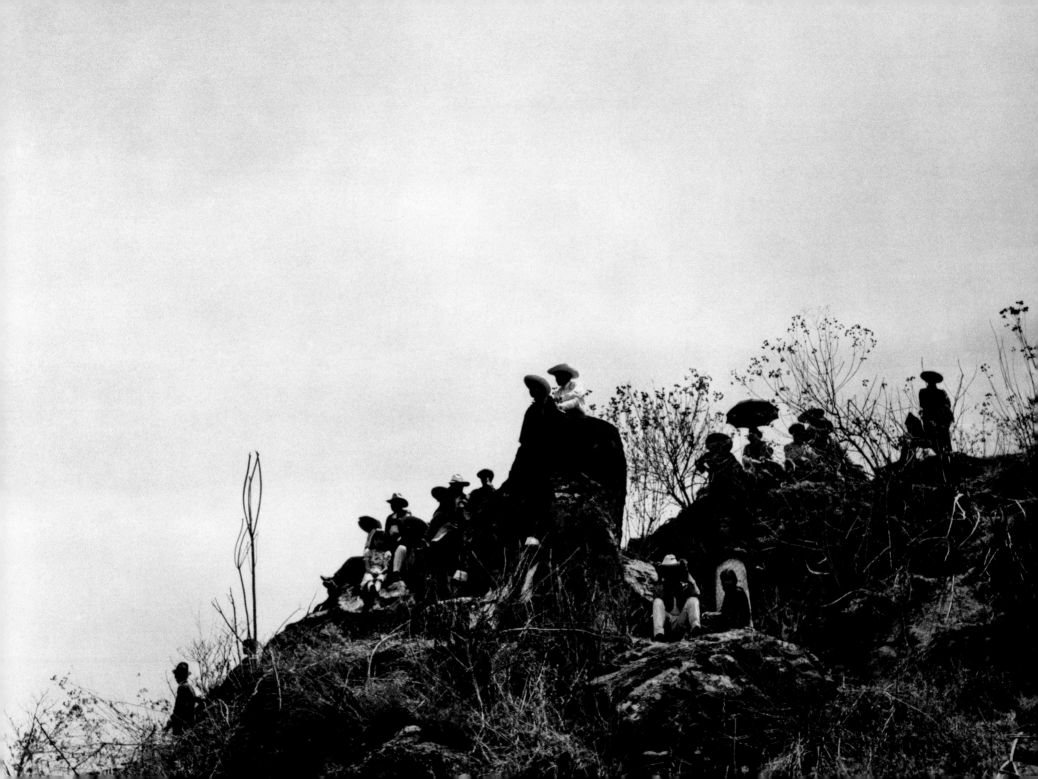

MEXICO 1940

After Capa arrived in New York in October 1939, *Life* began to assign him dozens of rather light human-interest and news-related stories, ranging from Senator Robert A. Taft's presidential campaign swing through Florida to a hangover-theme party in Owosso, Michigan. Capa photographed an elk hunt in northern New Mexico, documented the junket to Hot Springs that a Memphis political boss organized for a thousand of his "good friends," and exposed the tough bars patronized by Indiana steelworkers on Saturday nights. By the spring of 1942 he had seen the United States from coast to coast, but for a man who had brilliantly covered the Spanish Civil War and the Japanese invasion of China, these assignments were discouraging if not downright insulting.

Capa was therefore relieved when *Life* sent him to Mexico for six months in 1940 to chronicle that nation's presidential campaigns and election. Early on the morning of election day, July 7, Capa arrived at a polling place to photograph the inevitable battle to gain control of the ballot box. That afternoon Capa was covering a huge opposition-party demonstration when fanatical supporters of the government party (which won the election) opened fire. There were further clashes throughout the afternoon and evening; by the end of the day at least thirty people had died and several hundred had been wounded. It was one of the calmest election days Mexico City had ever seen.

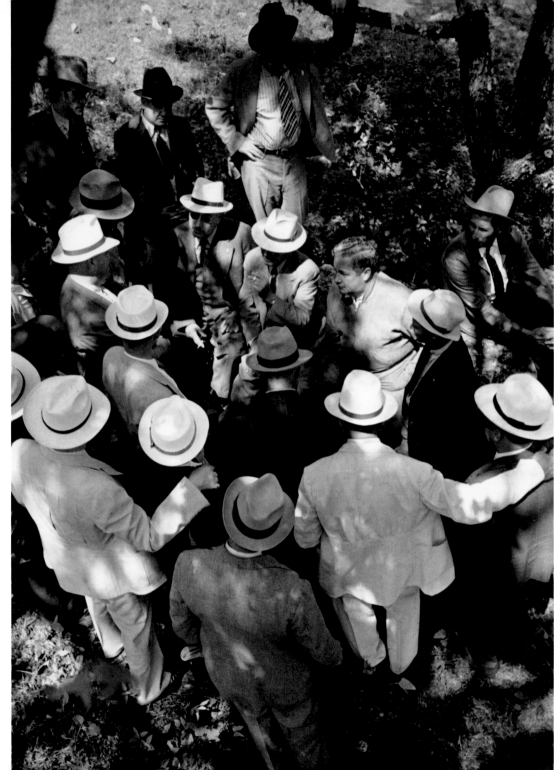

Page 72:
Mexico, 1940

Right:
President-elect Avila
Camacho on his estate with
Mexican politicians,
Teziutlán, Mexico,
August 1940

Opposite:
Supporters of General
Avila Camacho during the
Mexican presidential
campaign, Mexico City,
June–July 1940

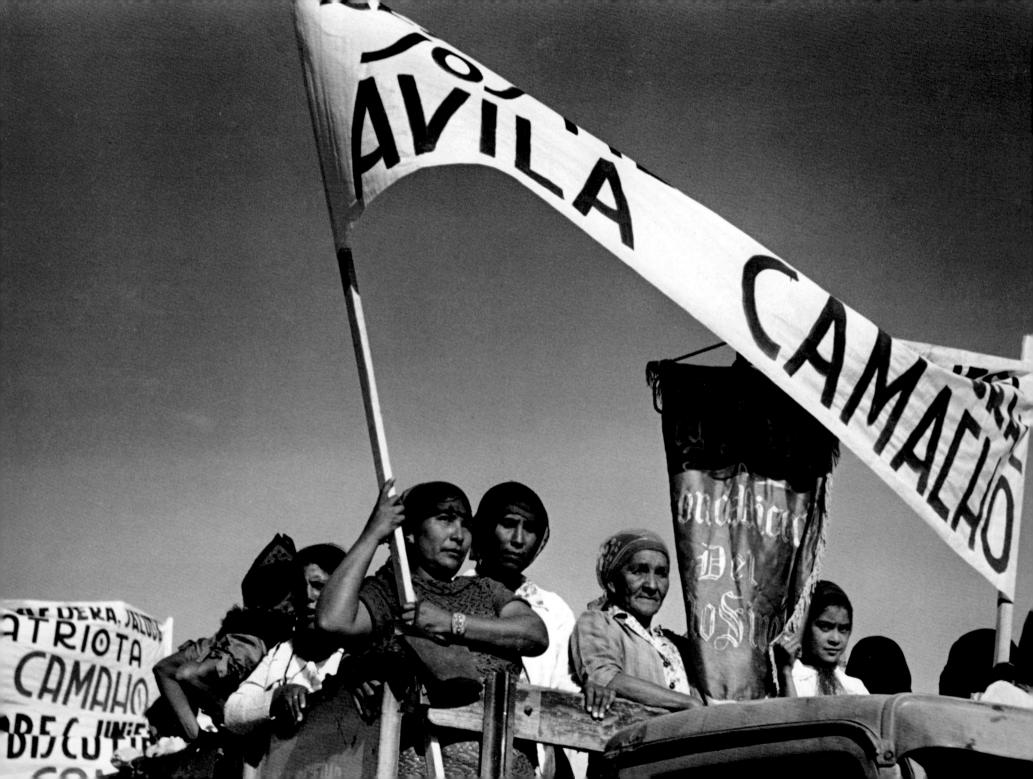

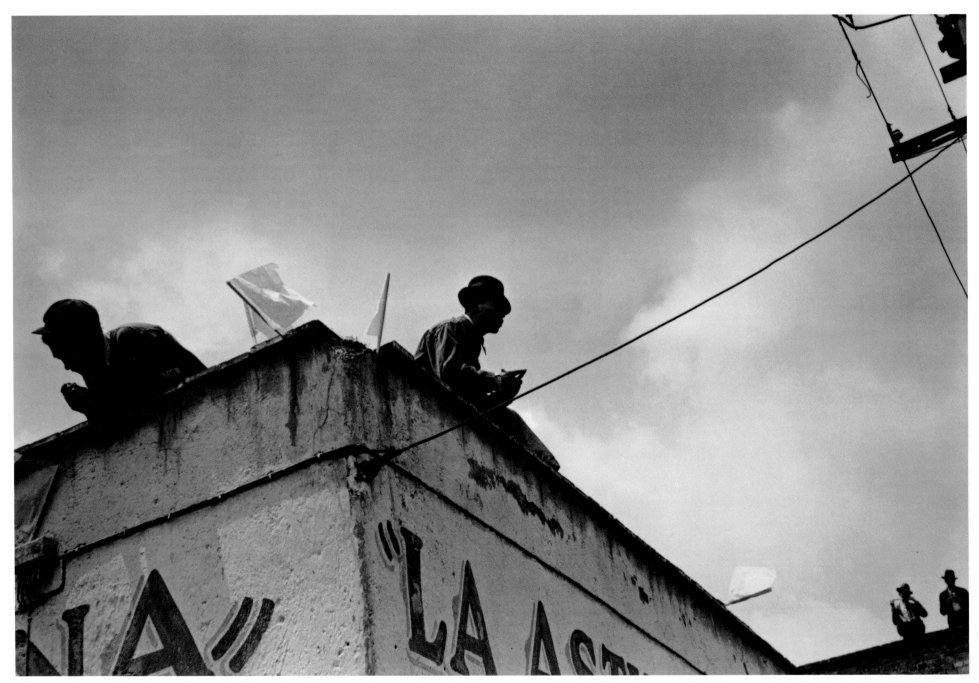

Above: Guards at a polling place on election day, Mexico City, July 7, 1940 Opposite: Mounted policemen attempt to limit the violence between voting factions on election day, Mexico City, July 7, 1940

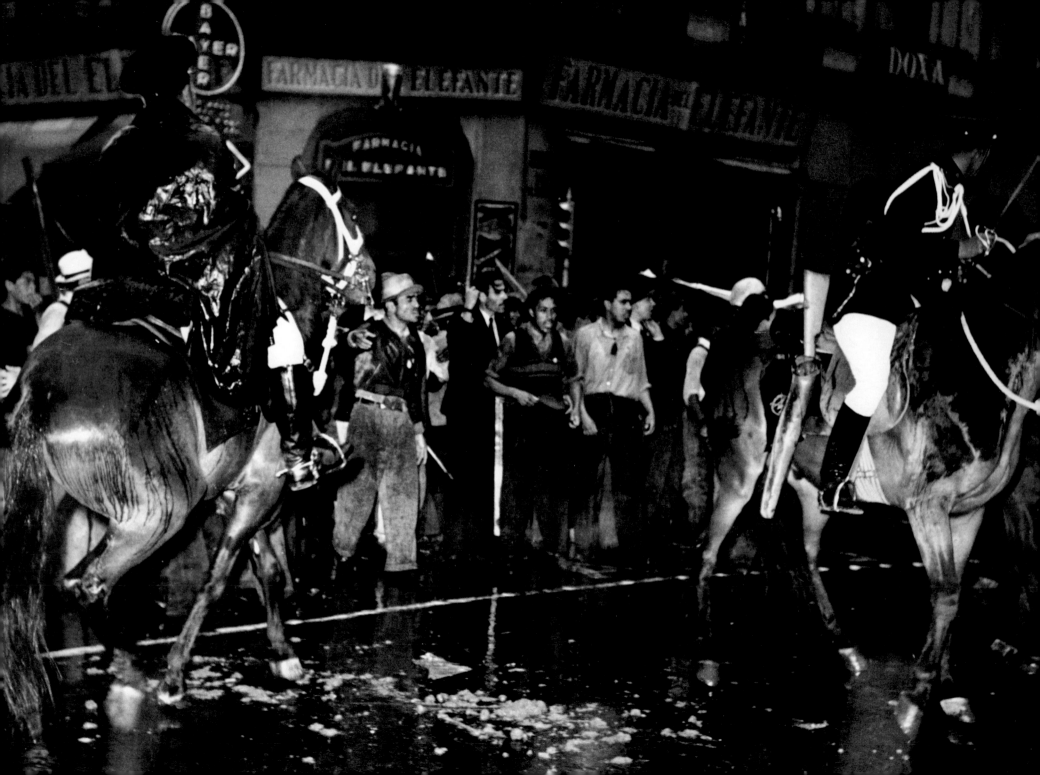

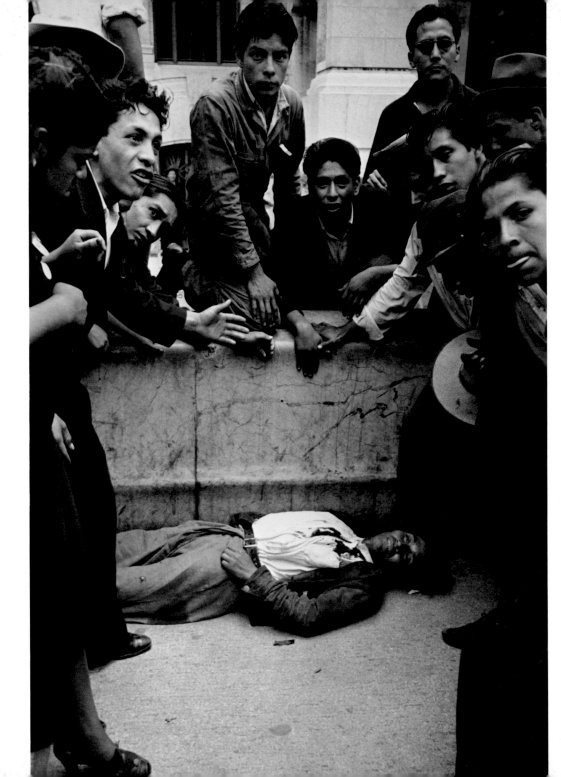

Left:
The first fatality
on election day,
Mexico City, July 7, 1940

Opposite:
Funeral for those killed
on election day, Mexico City,
July 9, 1940

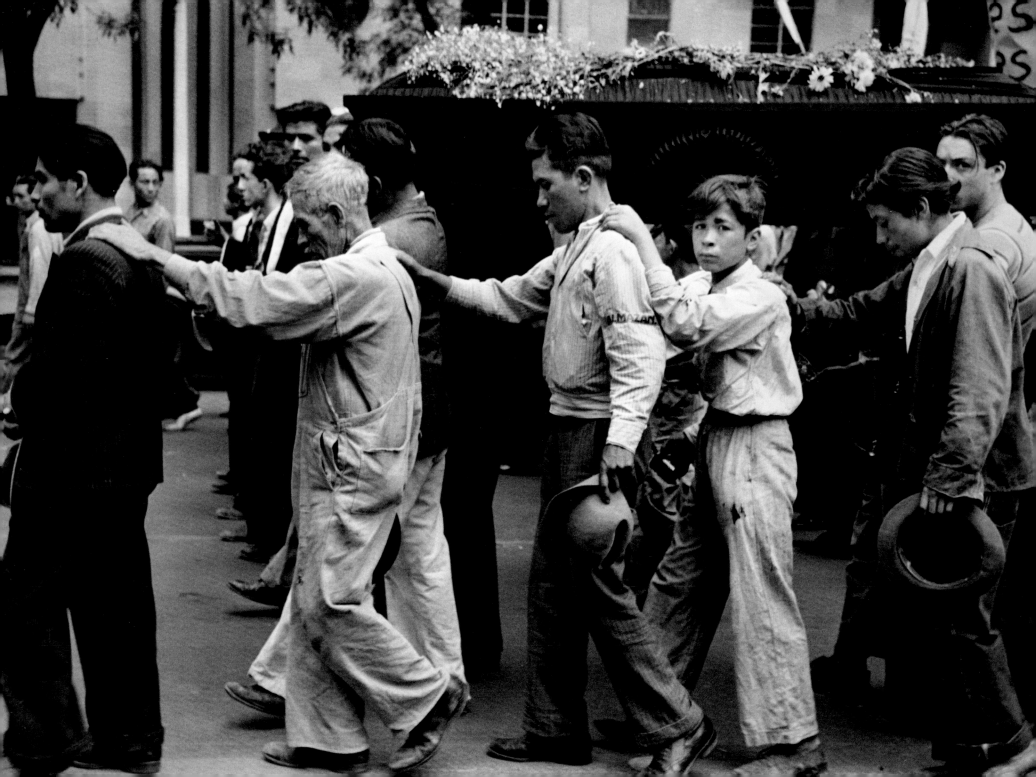

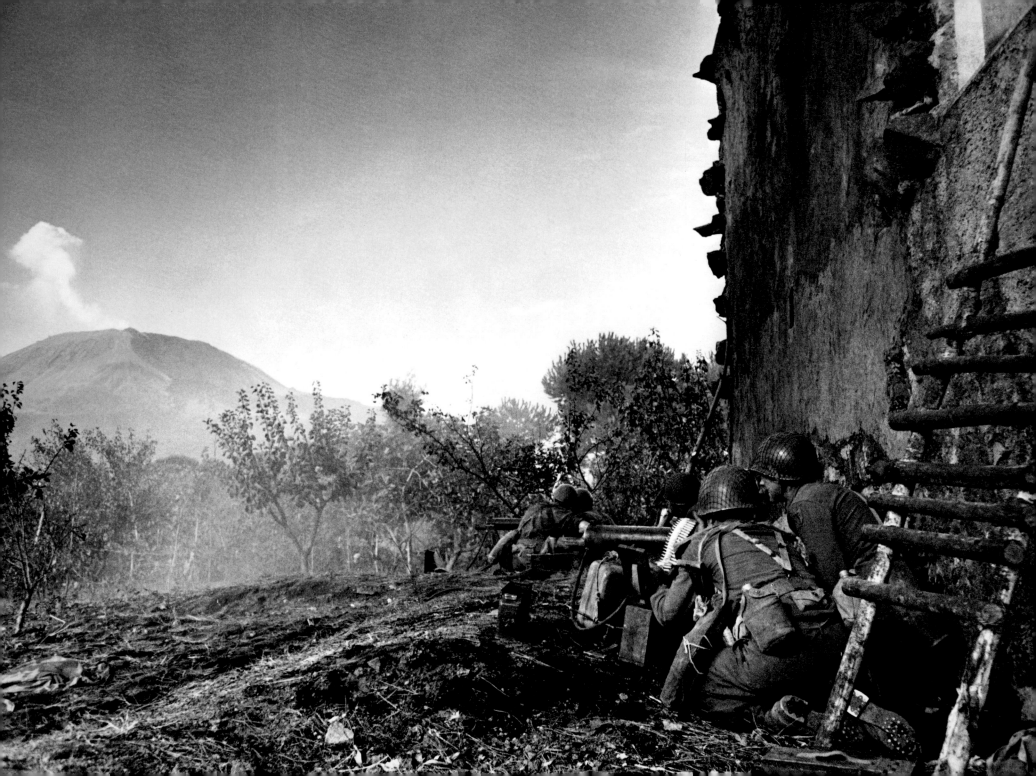

ITALY 1943–1944

It is ironic that a man who had been hailed as "The Greatest War Photographer in the World" in 1939 couldn't find anyone to send him to a battle front until 1943. In 1941 he spent several months in Blitz-ravaged London, and returned there in 1942. But only in March 1943 was he finally sent to North Africa as a photographer/correspondent—the only "enemy alien" accredited to the U.S. Army in such a capacity.

During the summer of 1943, Capa photographed the Allied conquest of Sicily. At first he shared a jeep with John Hersey (whose Pulitzer-prize-winning novel *A Bell for Adano* was based on his experiences in Sicily). Outside the hilltop town of Troina, which the Germans had surrounded with elaborate defenses, Capa joined up with an old friend from Spain, Herbert Matthews. Together they covered the week-long siege, which had many parallels to another experience they had shared—the siege of the Spanish hilltop town of Teruel. In both cases the two men entered the town with the first patrol, and when Capa photographed a man of Troina carrying his injured and traumatized daughter (page 94), he may very well have been remembering the extremely similar image he had made in Teruel (page 47).

From Sicily, Capa went on to cover the fighting in mainland Italy, as Allied troops pushed their way north from the Sorrento peninsula to Naples. In that city he photographed the funeral of twenty high-school boys who had stolen guns and ammunition with which to fight the Germans. About his images of the grieving mothers, Capa wrote, "Those were my truest pictures of victory."

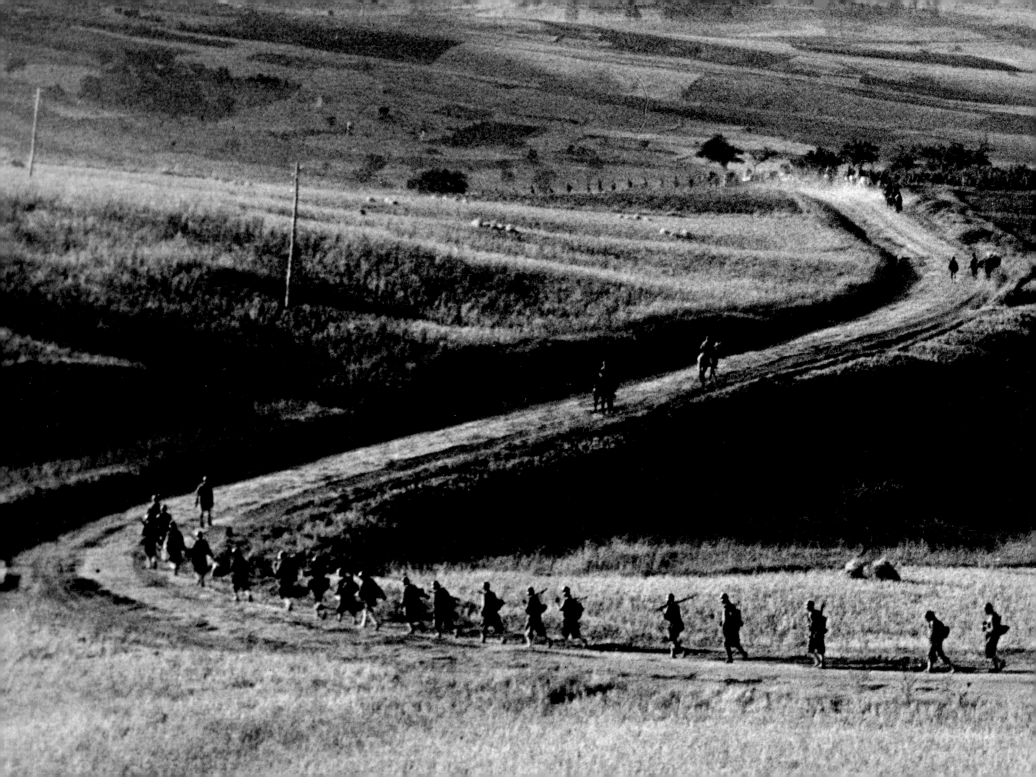

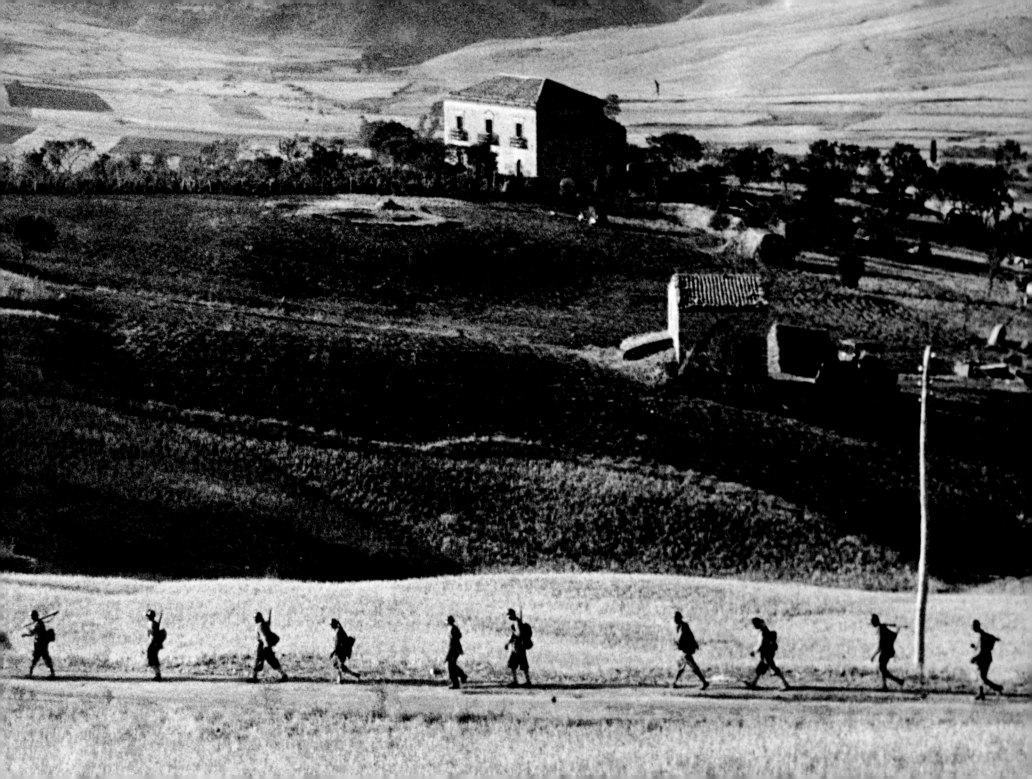

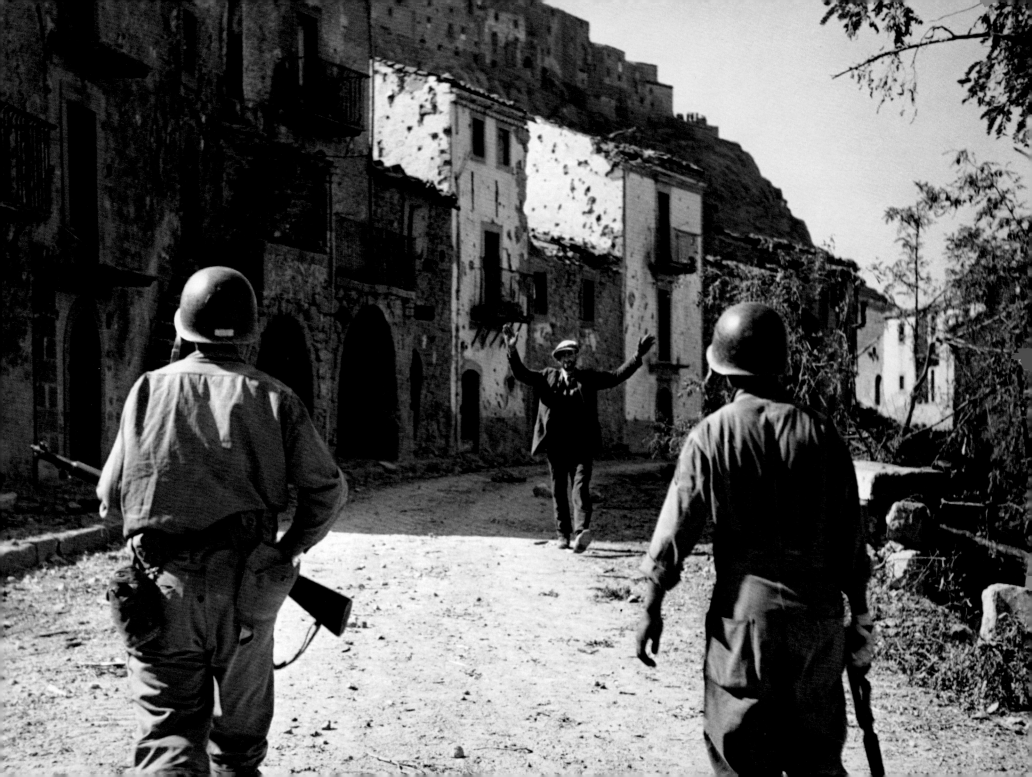

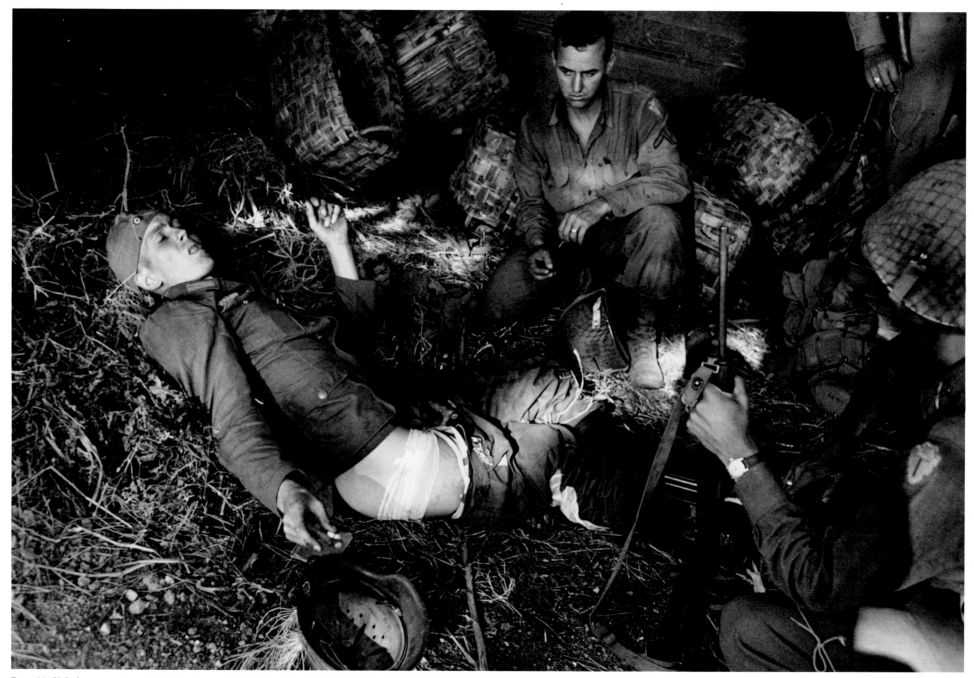

Page 80: U.S. forces en route to Naples, September, 1943 Pages 82–83: U.S. troops nearing Troina, Sicily, August 4–5, 1943 Opposite: Troina, August 6, 1943 Above: Near Naples, September 1943

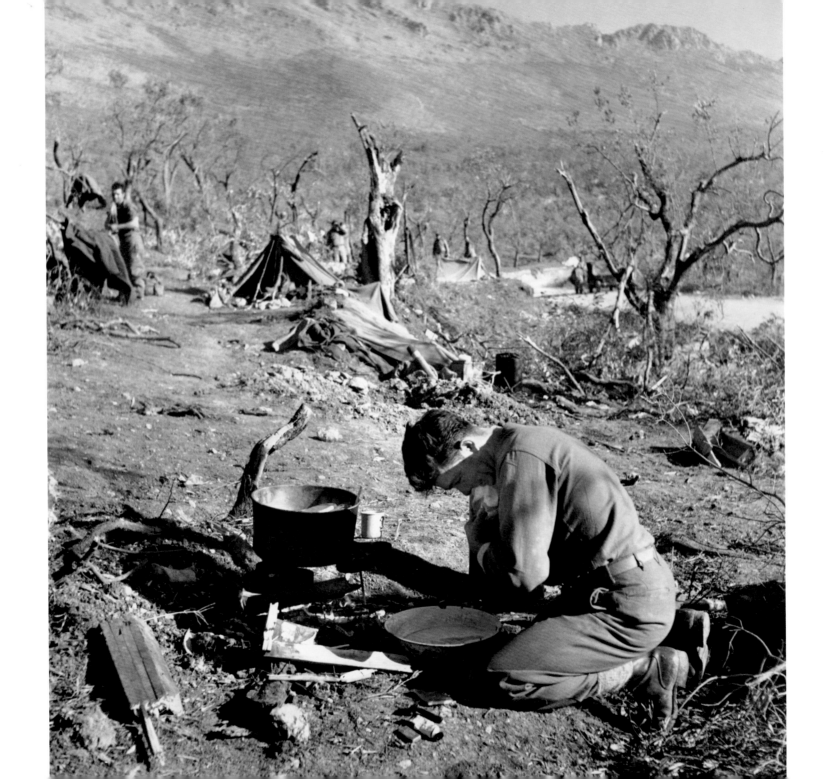

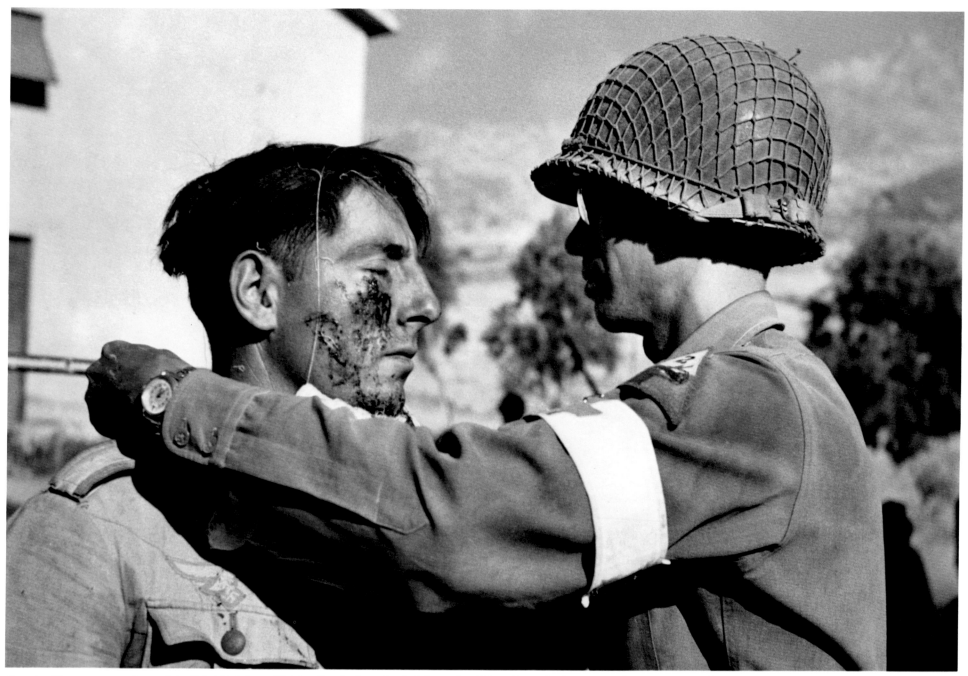

Opposite: The rear command post of the U.S. 45th Infantry Division, Venafro (near Cassino), December 1943 Above: An American medic treats a captured German soldier, Sicily, July 1943

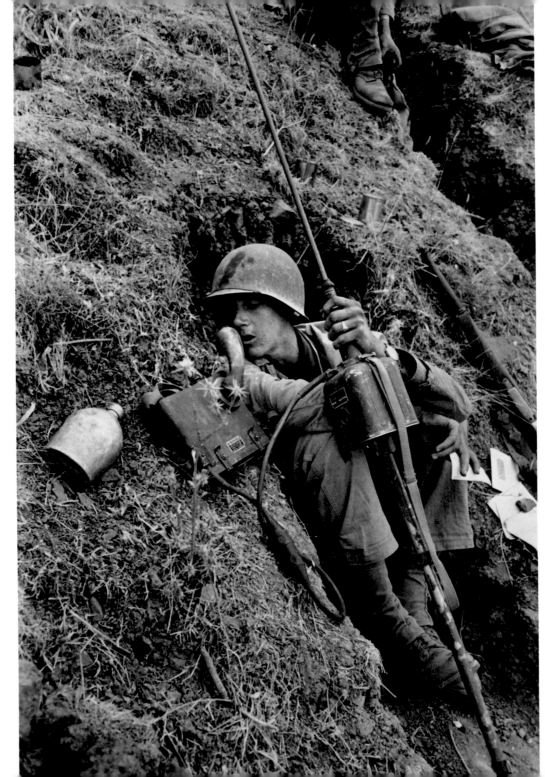

Left:
Near Troina, Sicily,
August 1943

Opposite:
German prisoners
carrying their dead
and wounded down
the mountainside,
Radicosa (near Cassino),
January 4, 1944

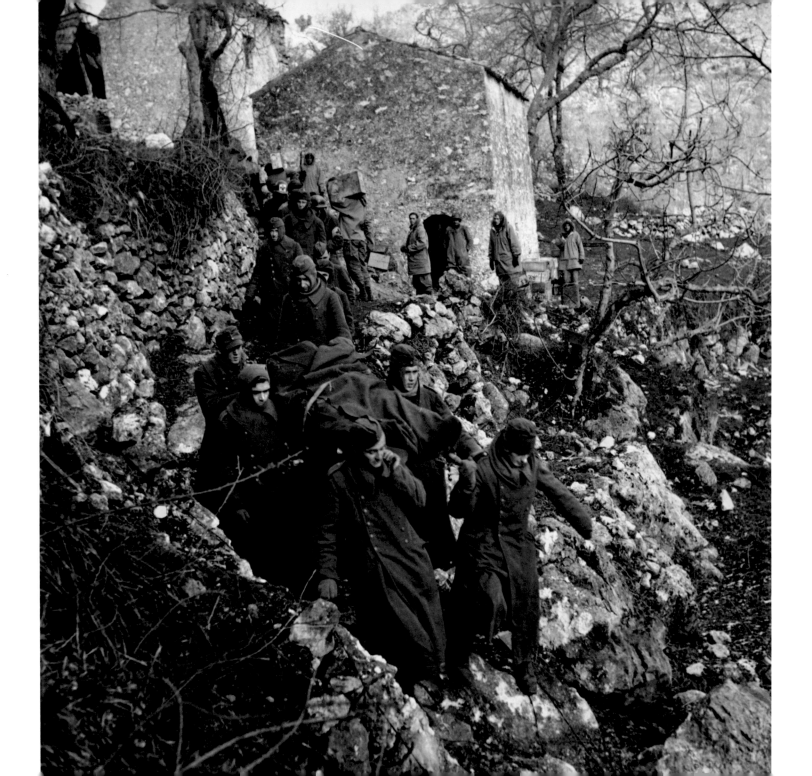

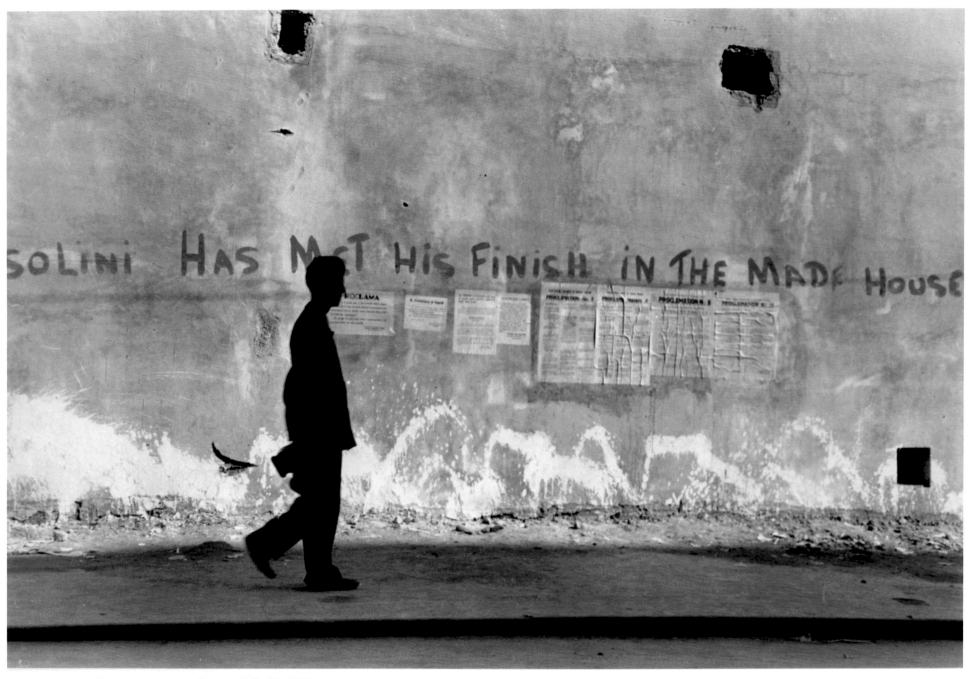

Above: Naples, October 1943 Opposite: Nicosia, Sicily, July 1943

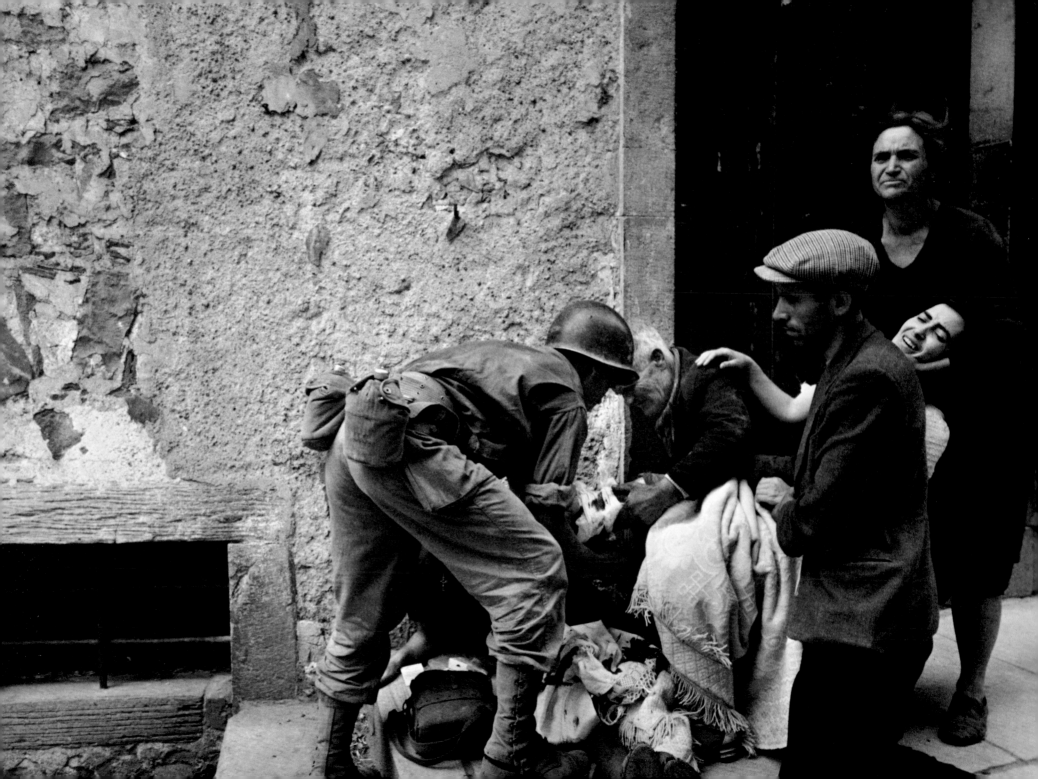

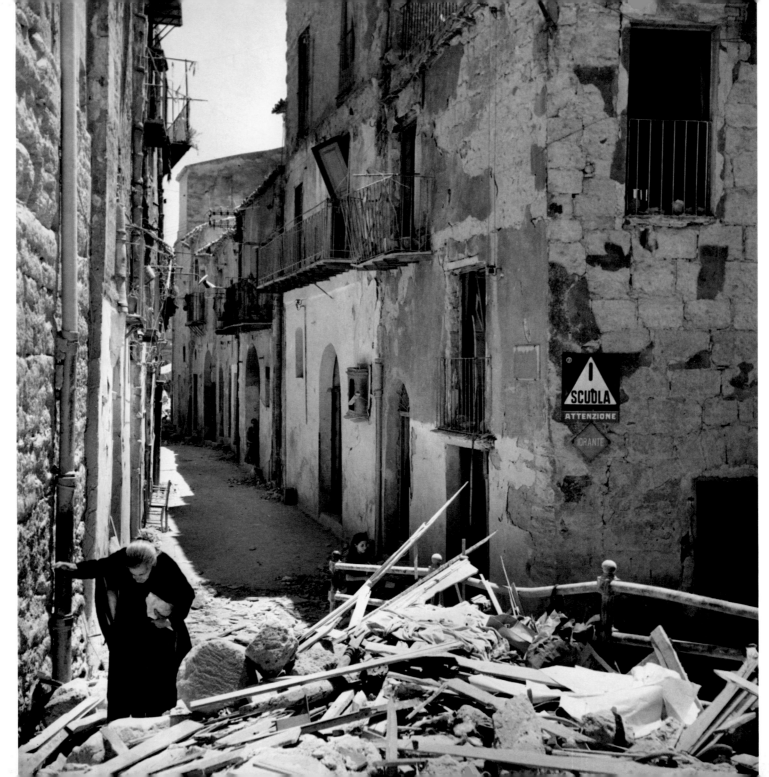

Left:
Agrigento, Sicily,
July 1943

Opposite:
Funeral of
twenty teenage
partisans in
the Vomero
district, Naples,
October 2, 1943

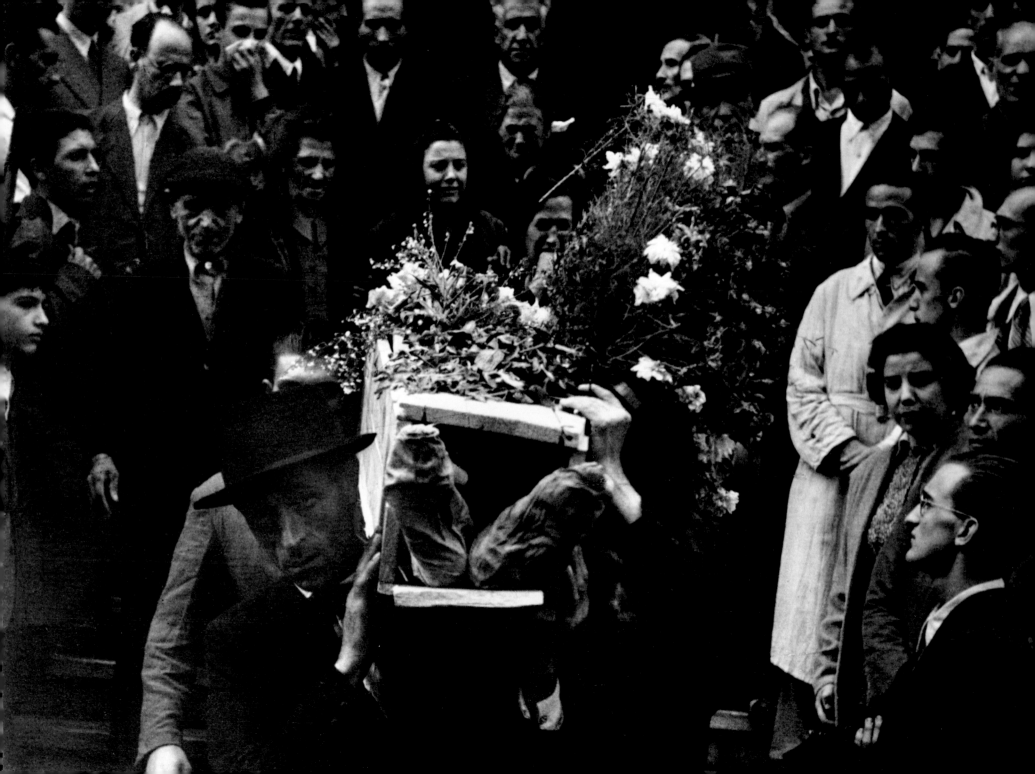

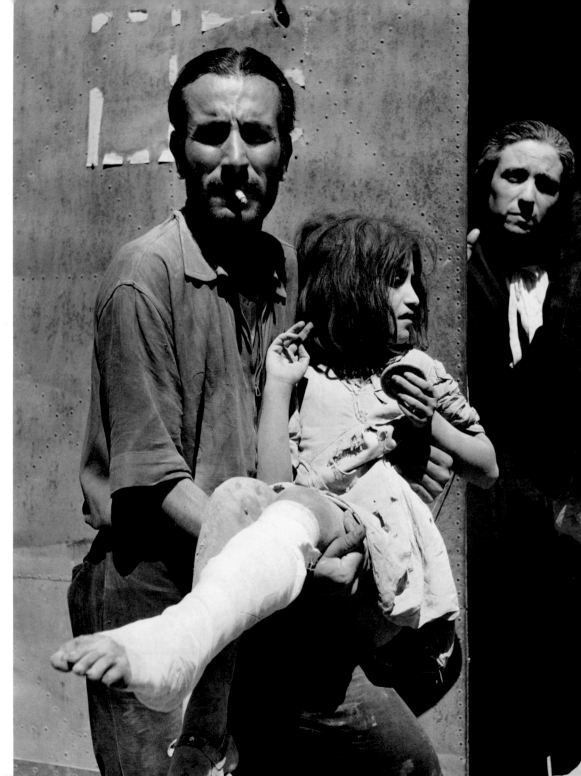

Right:
Troina, Sicily,
August 6, 1943

Opposite:
Funeral of twenty
teenage partisans in the
Vomero district,
Naples, October 2, 1943

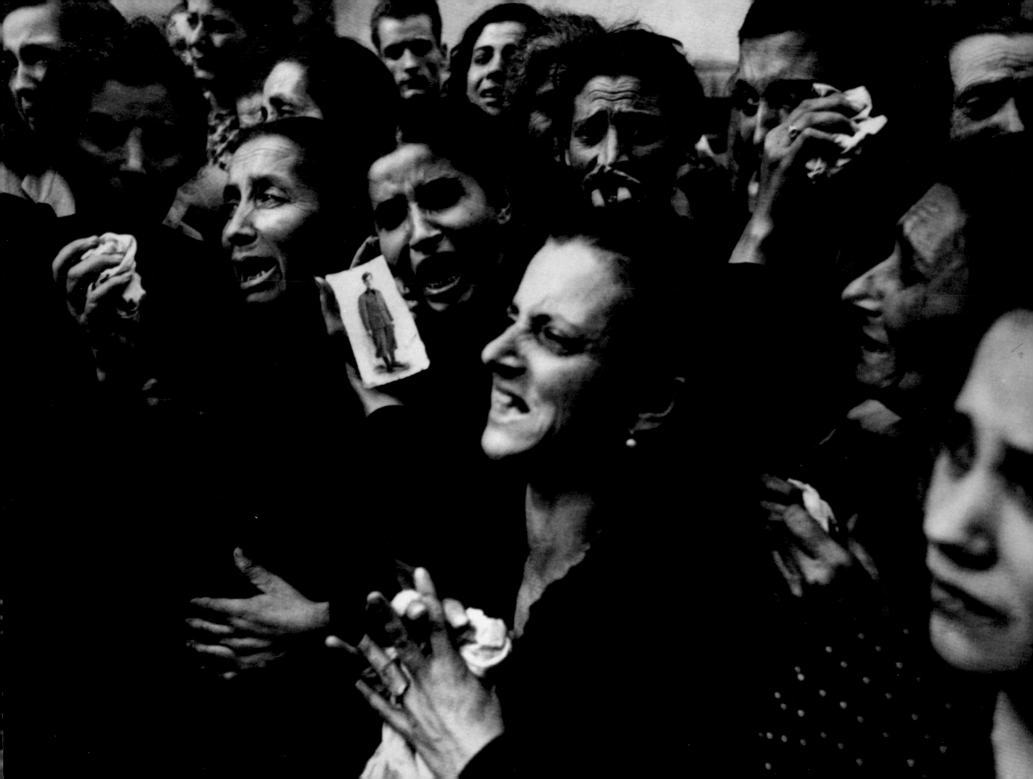

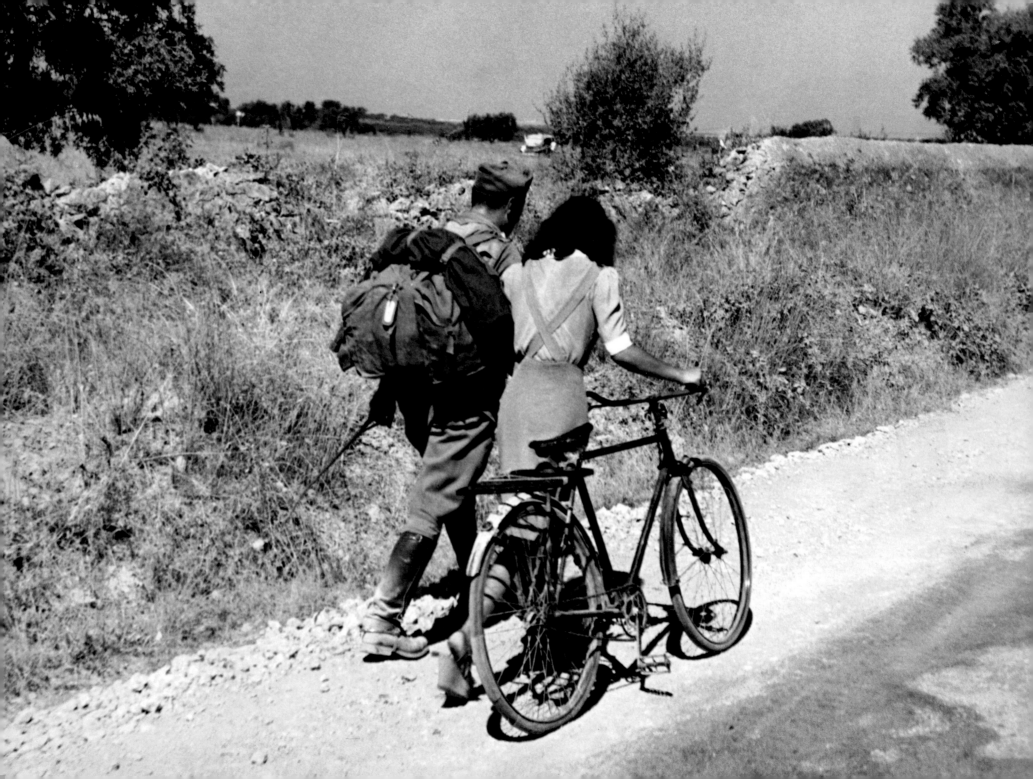

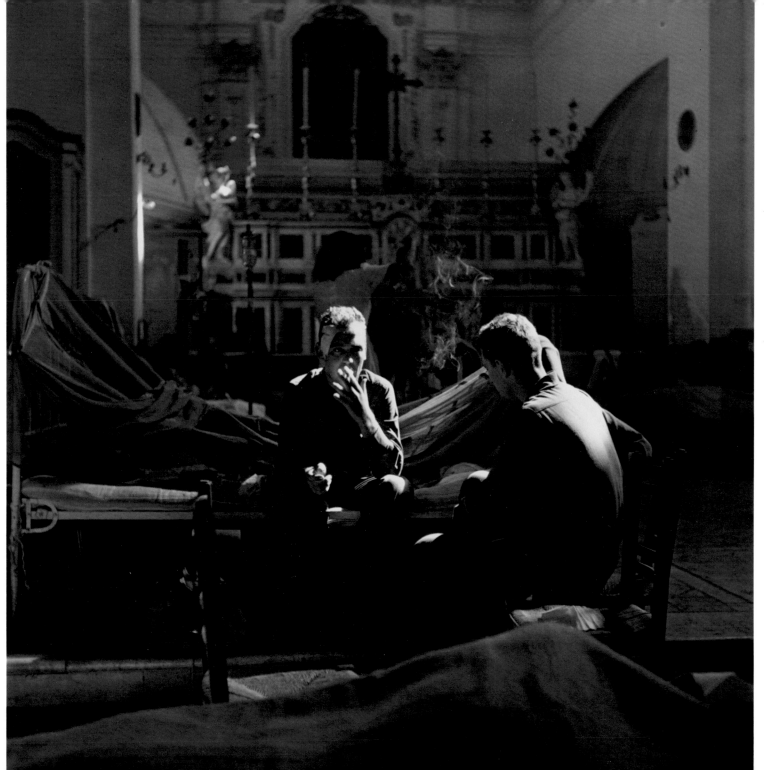

Opposite:
An Italian
soldier straggles
behind a column of
his captured
comrades as they
march off to a
P.O.W. camp, near
Nicosia, Sicily,
July 1943

Left:
Hospital set up in a
church, Maiori
(Sorrento peninsula),
September 19, 1943

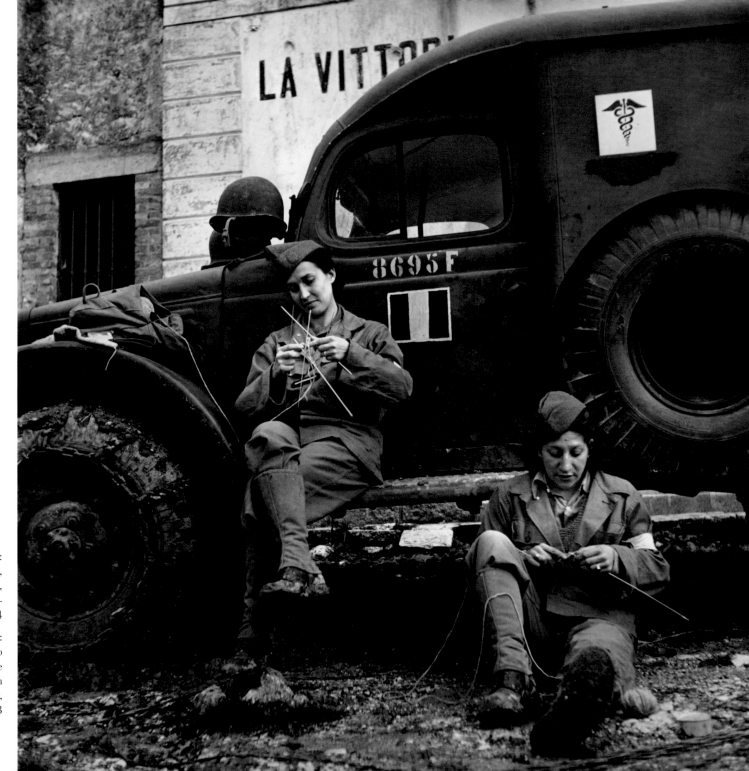

Right:
Ambulance drivers,
near Cassino,
December 1943–
January 1944

Opposite:
Street scene two
days after the
liberation
of Cefalú, Sicily,
July 26, 1943

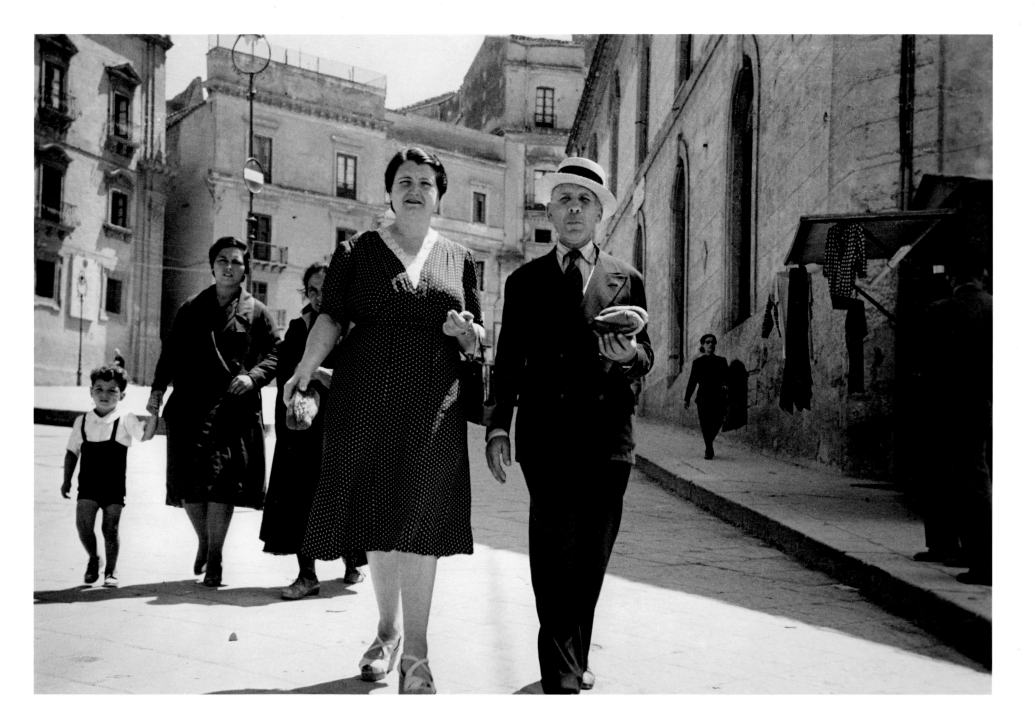

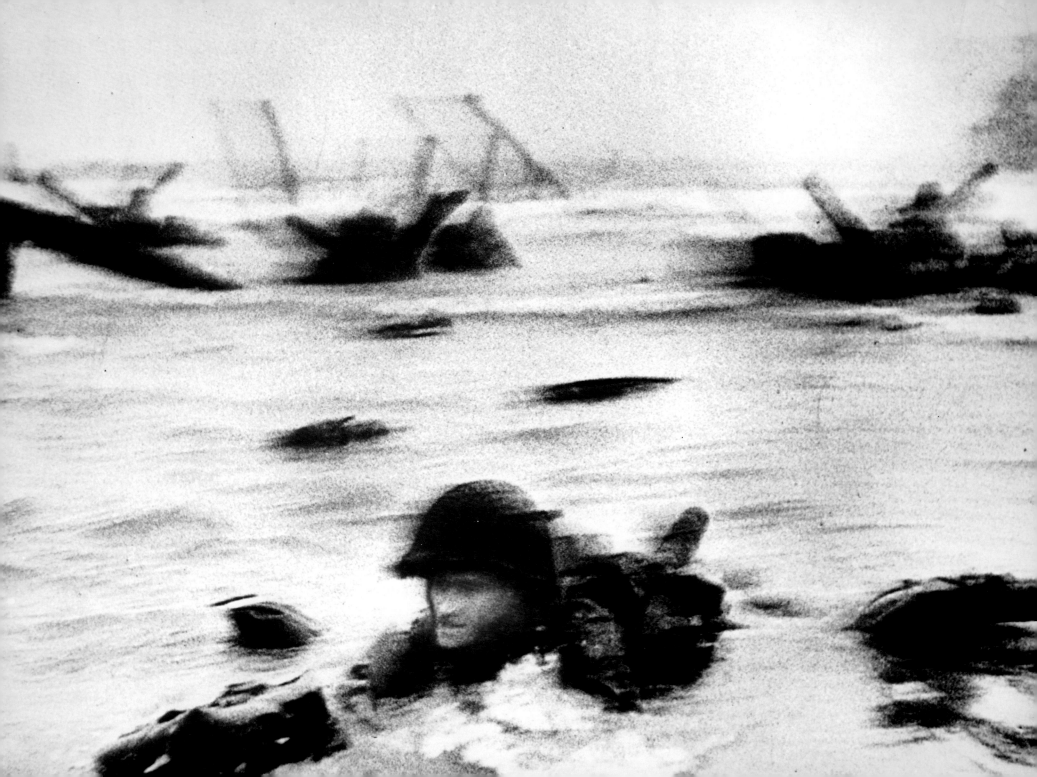

FRANCE 1944

On D-Day, June 6, 1944, Capa photographed the amphibious landing of American troops on the section of the French Normandy coast that had been code-named Omaha Beach. He went ashore with the first wave of troops shortly before dawn and photographed the G.I.'s as they fought their way onto the heavily defended beach. "The bullets tore holes in the water around me, and I made for the nearest steel obstacle," he wrote. "It was still very early and very gray for good pictures, but the gray water and the gray sky made the little men, dodging under the surrealistic designs of Hitler's anti-invasion braintrust, very effective." All but eleven of Capa's negatives were spoiled by an overly eager darkroom worker in the London office of Time Inc. who turned up the heat in the drying cabinet too high. When *Life* published the photographs, a caption disingenuously explained that the "immense excitement of [the] moment made photographer Capa move his camera and blur [his] picture."

Together with Ernest Hemingway, Capa accompanied American armored troops from Normandy to the outskirts of Paris. There on August 25, 1944, the photographer joined up with the French armored division that spearheaded the liberation of the city. Welcomed at his old haunts with embraces and champagne, he soon settled down in a modest room of the luxurious Hotel Lancaster, which would remain his base of operations for the rest of his life.

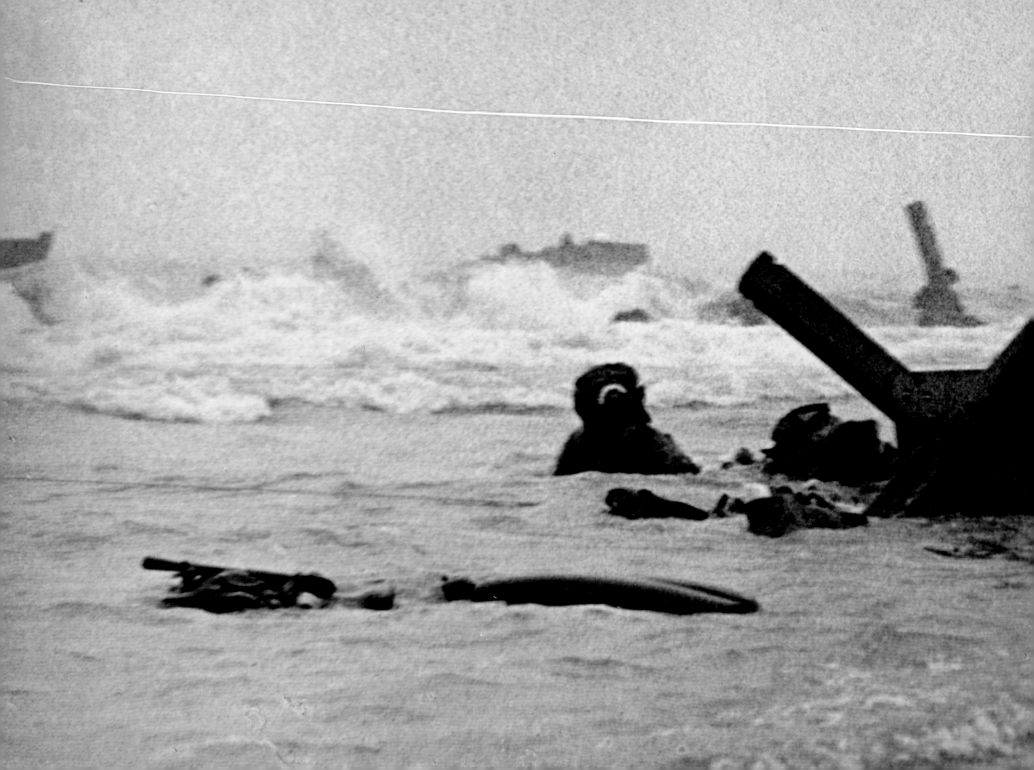

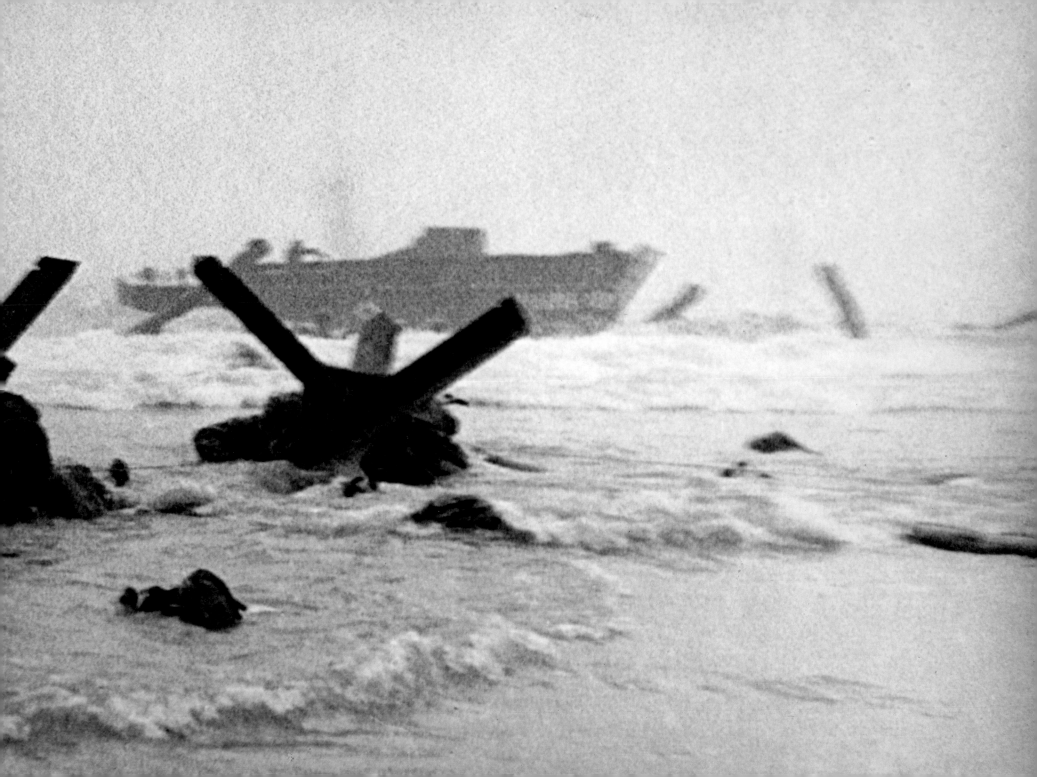

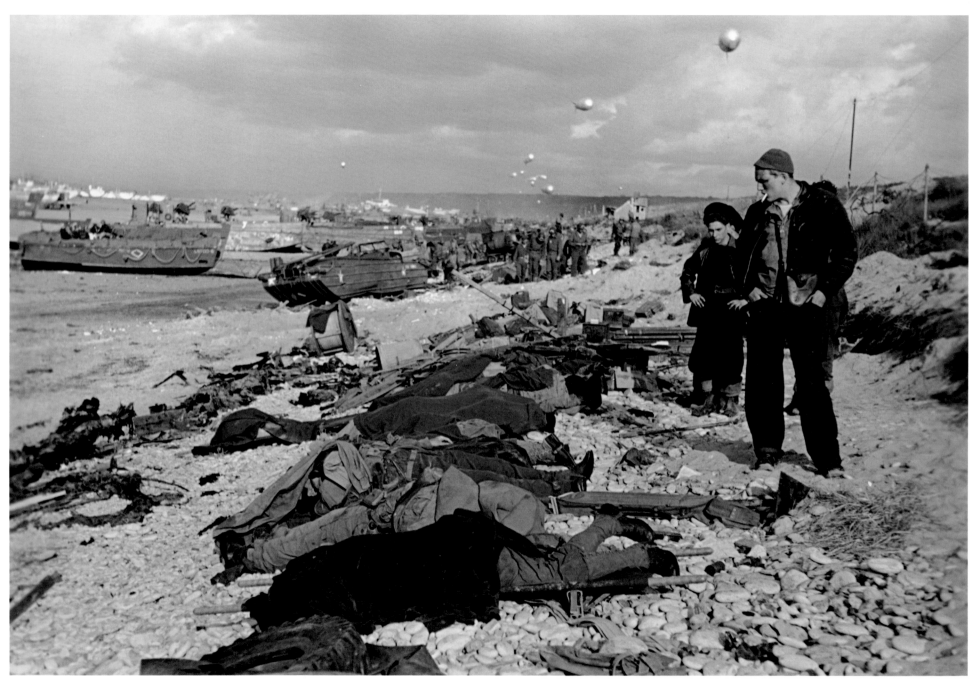

Pages 100–103: U.S. troops landing on D-Day, Omaha Beach, Normandy coast, June 6, 1944 Above: French fishermen with the bodies of men killed during the D-Day landings, Omaha Beach, June 1944

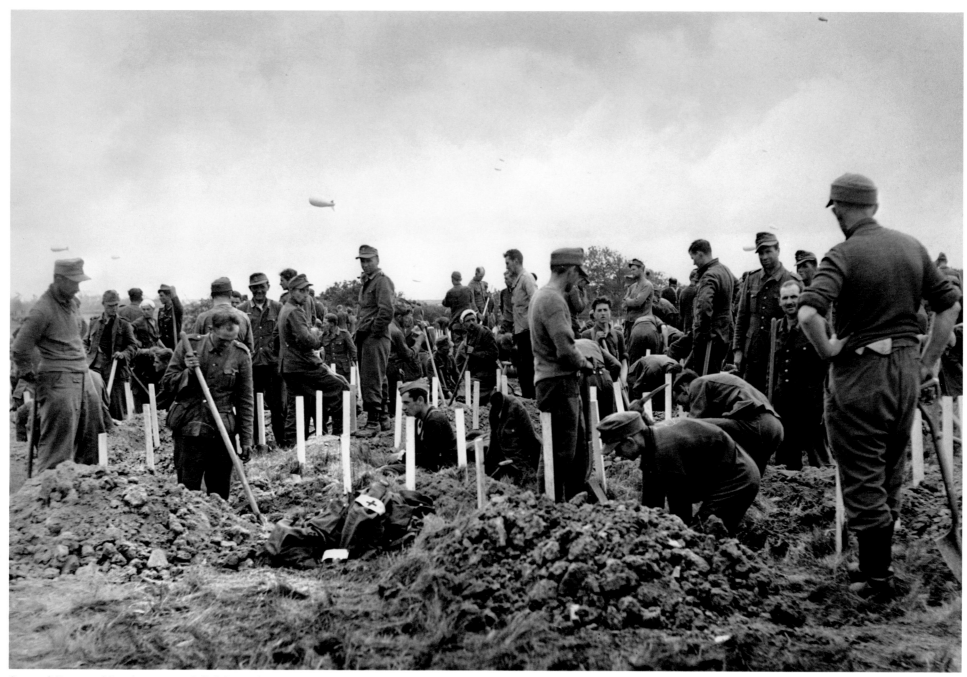

Captured German soldiers burying men killed during the D-Day landings, Omaha Beach, June 1944

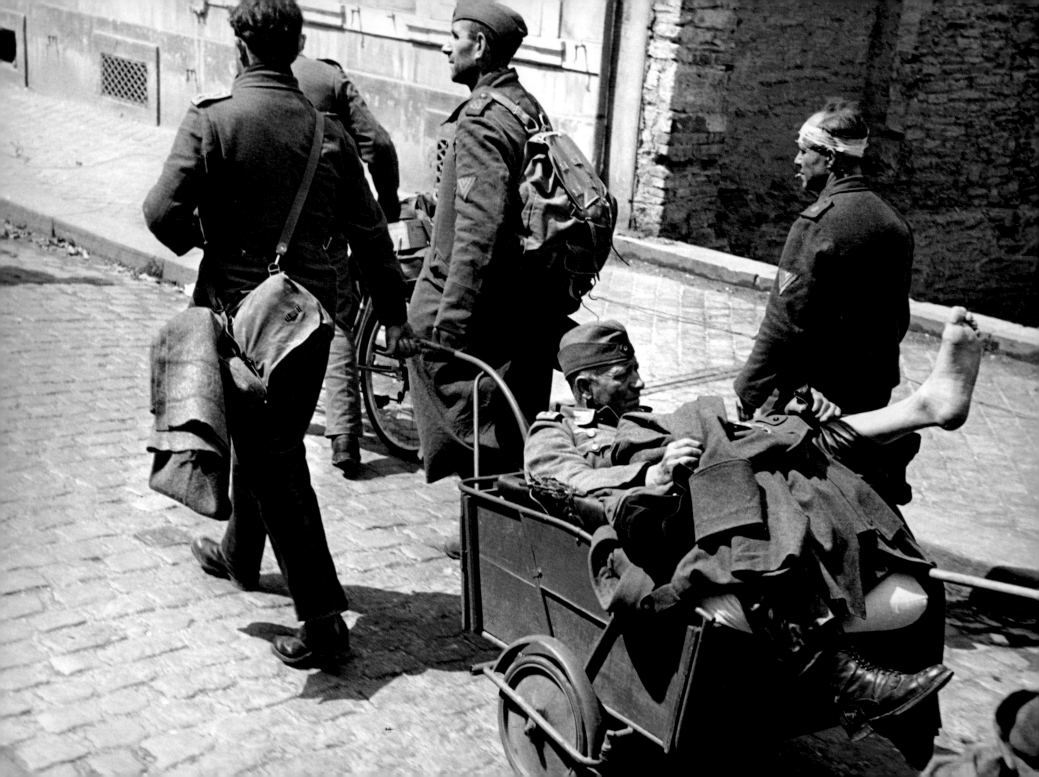

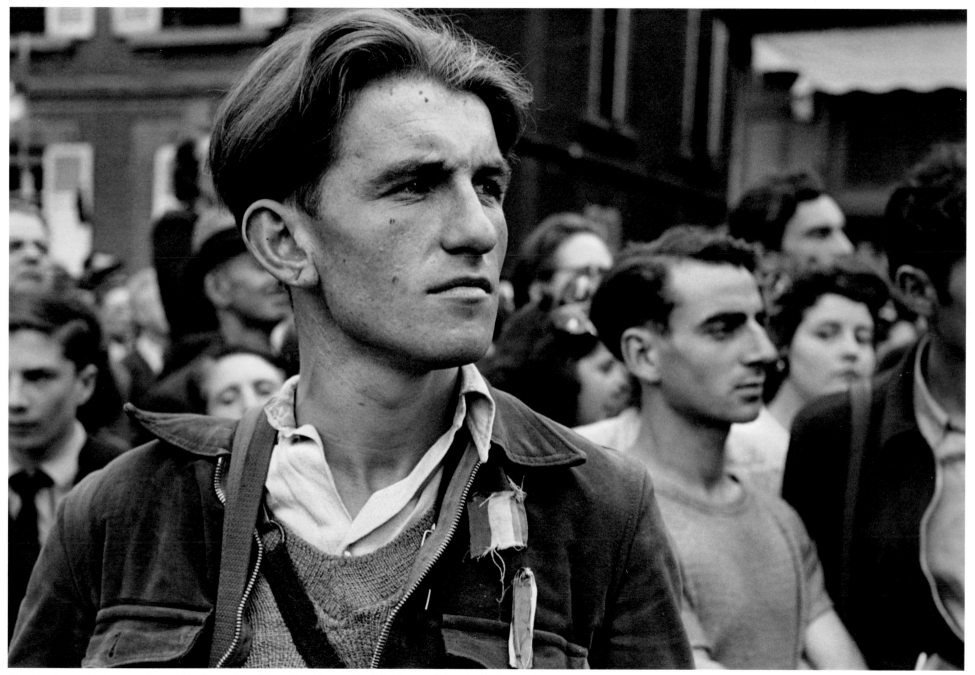

Opposite: Captured German soldiers, Cherbourg, June 27, 1944 Above: French Resistance fighter, Paris, August 25–26, 1944

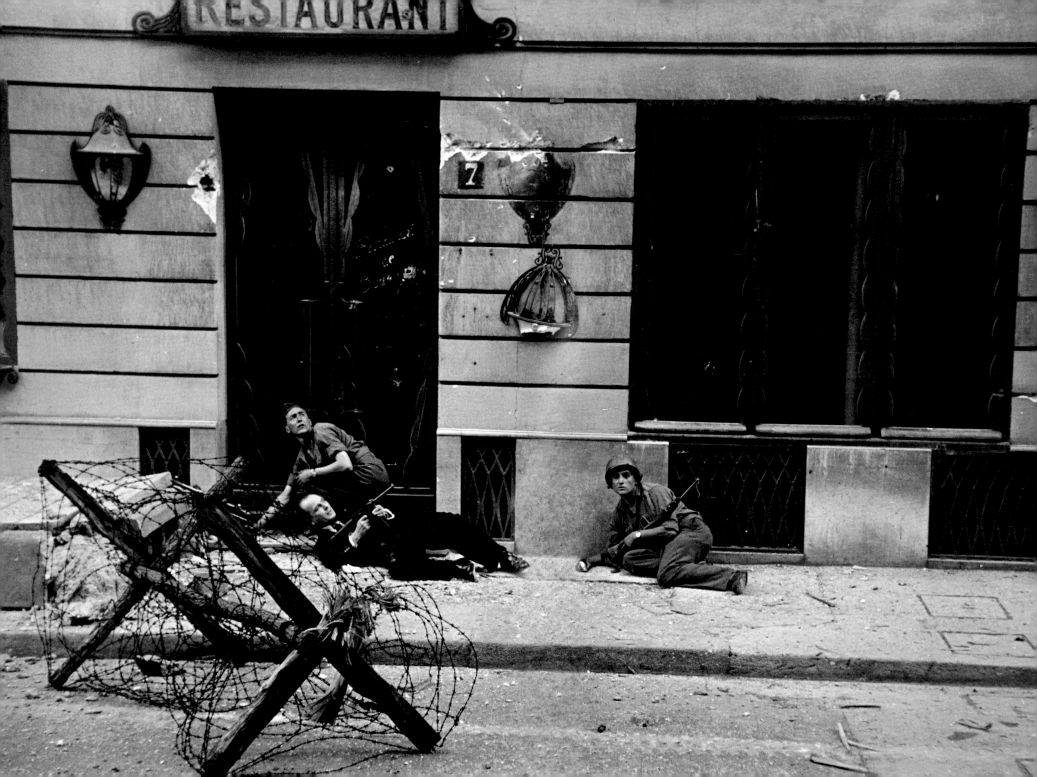

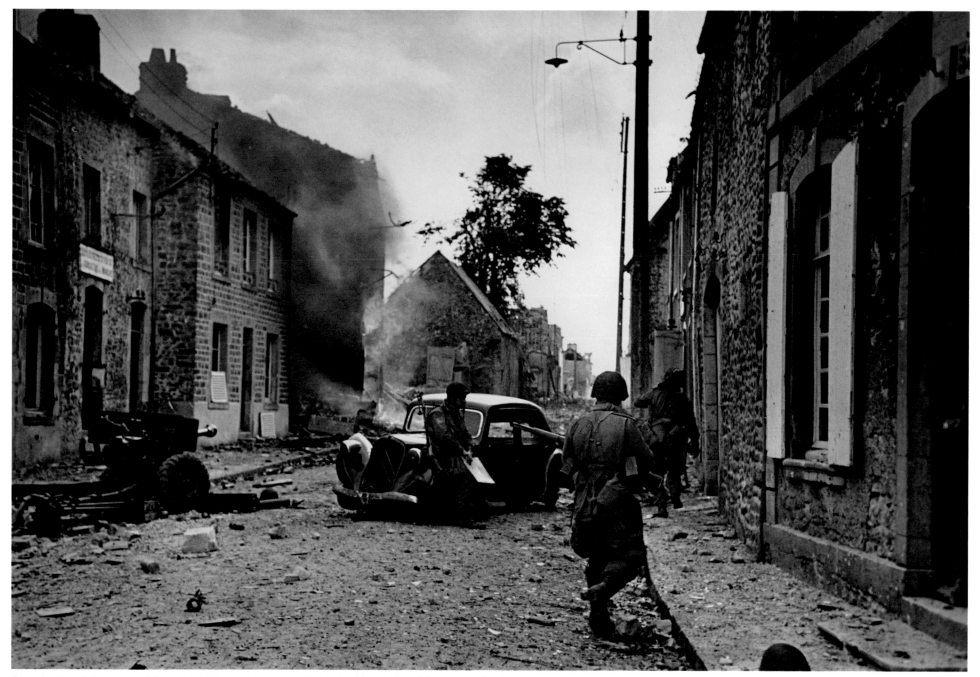

Opposite: French Resistance fighter and soldiers, Paris, August 25, 1944 Above: Men of the U.S. 82nd Airborne Division, St. Sauveur-le-Vicomte, Normandy, June 16, 1944

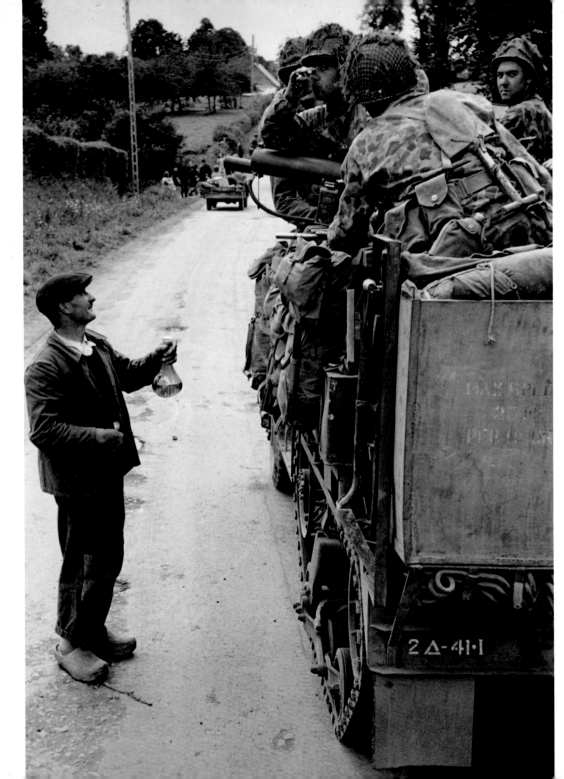

Left:
Notre-Dame-de-Cenilly,
Normandy,
July 28, 1944

Opposite:
Granville, Normandy,
July 31, 1944

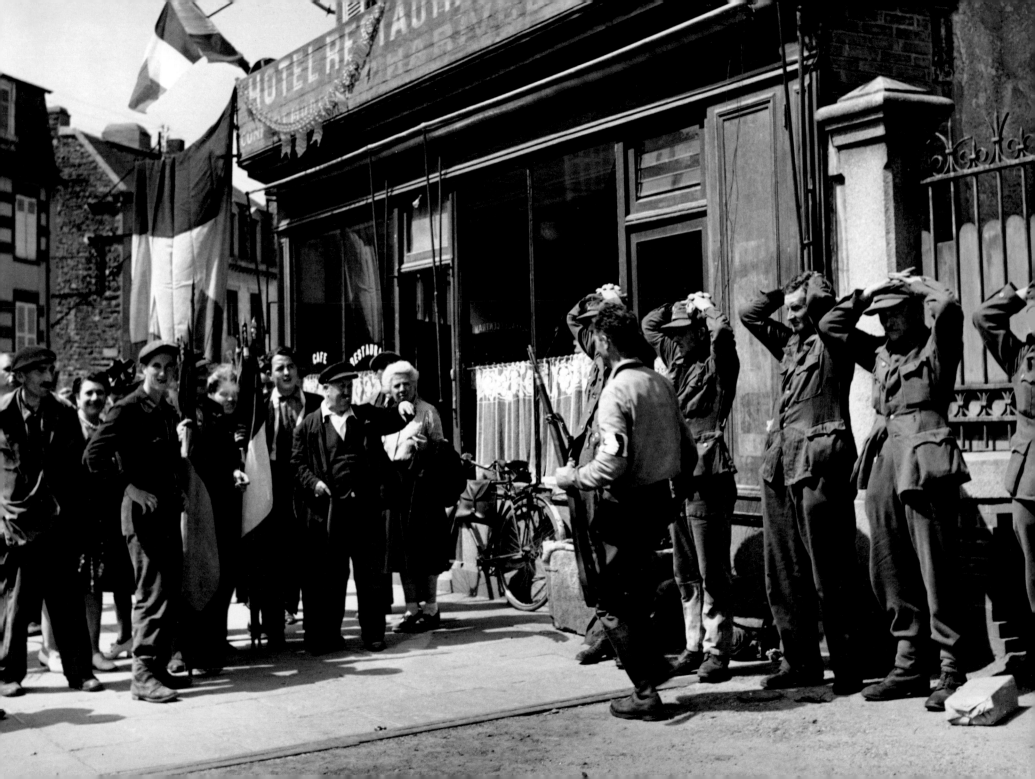

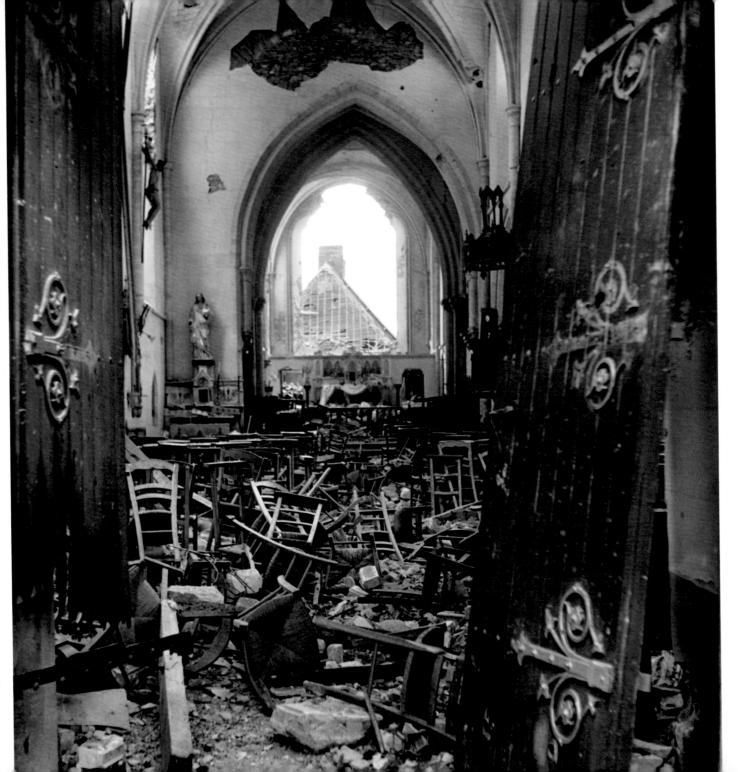

Right:
Granville, Normandy,
July 31, 1944

Opposite:
A Frenchwoman,
with her baby fathered
by a German soldier,
punished by having her
head shaved after
the liberation of the
town, Chartres,
August 18, 1944

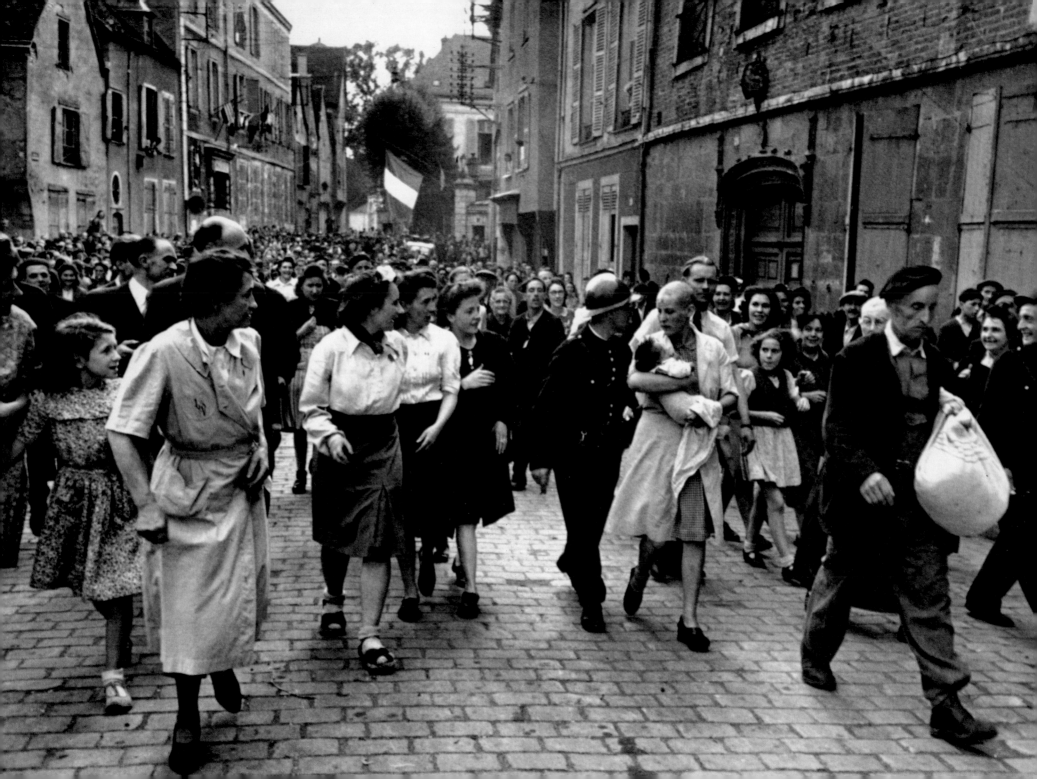

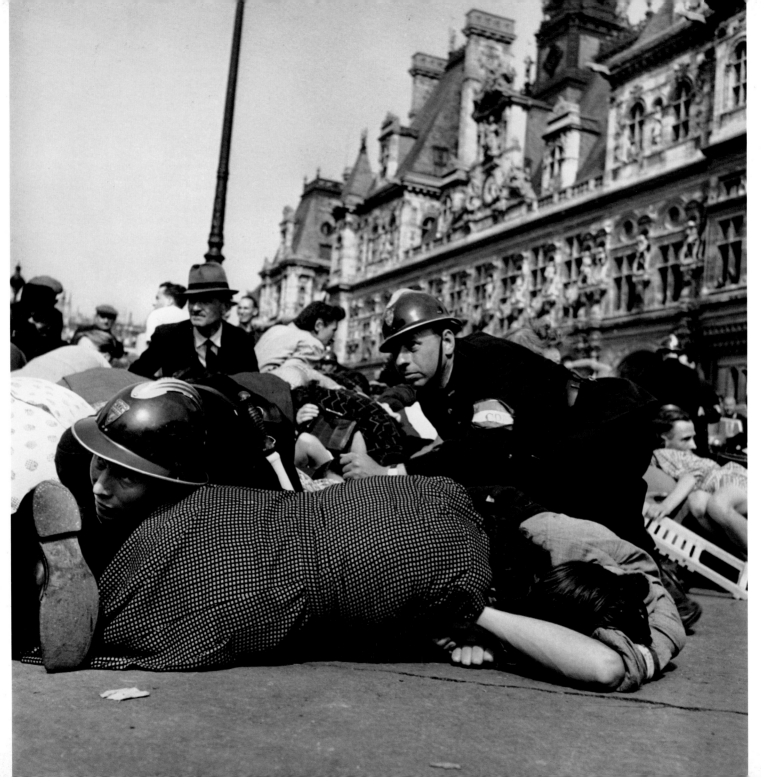

Right:
Sniper fire in the
Place de l'Hôtel de
Ville, Paris,
August 26, 1944

Opposite:
General Charles
de Gaulle
leading parade
along the Avenue
des Champs-
Elysées after the
liberation of Paris,
August 26, 1944

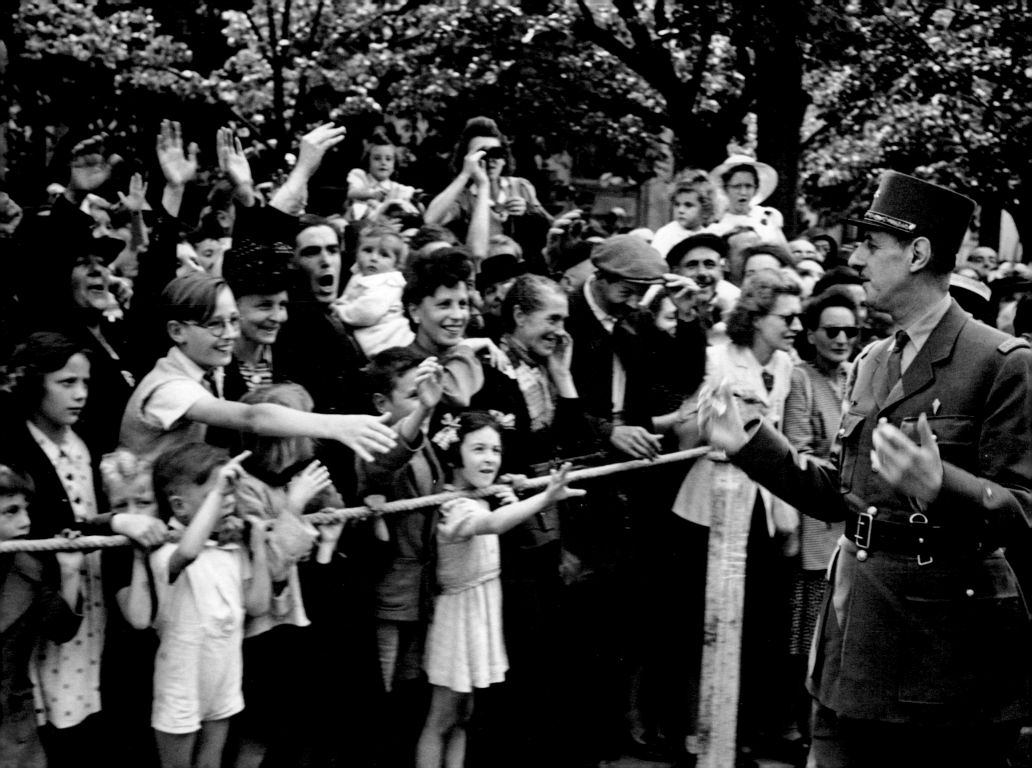

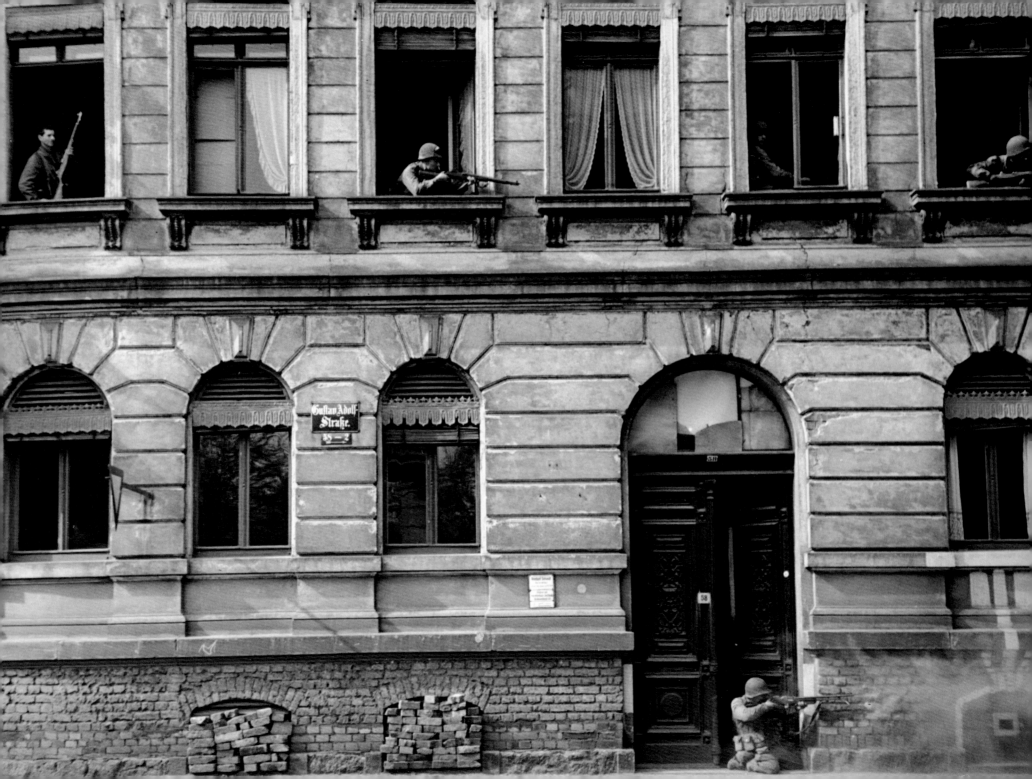

GERMANY 1945

Late in March 1945 Capa parachuted into Germany with American troops. He was lucky to land in a field, for many whose chutes became caught in the high branches of trees were shot as they dangled helplessly. Other Americans were killed as their uncontrollable gliders crash-landed. The paratroopers soon flushed a unit of Germans, as well as several families of civilians, out of a burning group of farm buildings. The German soldiers fought hard until they knew they were beaten. "Afterwards," wrote Capa, "they all have cousins in Philadelphia. That is what I like about the French. They do not have cousins in Philadelphia."

A few weeks later Capa joined the U.S. First Army as it entered Leipzig, which had been his lover Gerda Taro's home. As he photographed a corporal manning a machine gun on the balcony of an apartment building, a bullet from a sniper in the street below hit the young soldier, killing him almost instantly (see page 125). Capa would always refer to him as "the last man to die" in World War II.

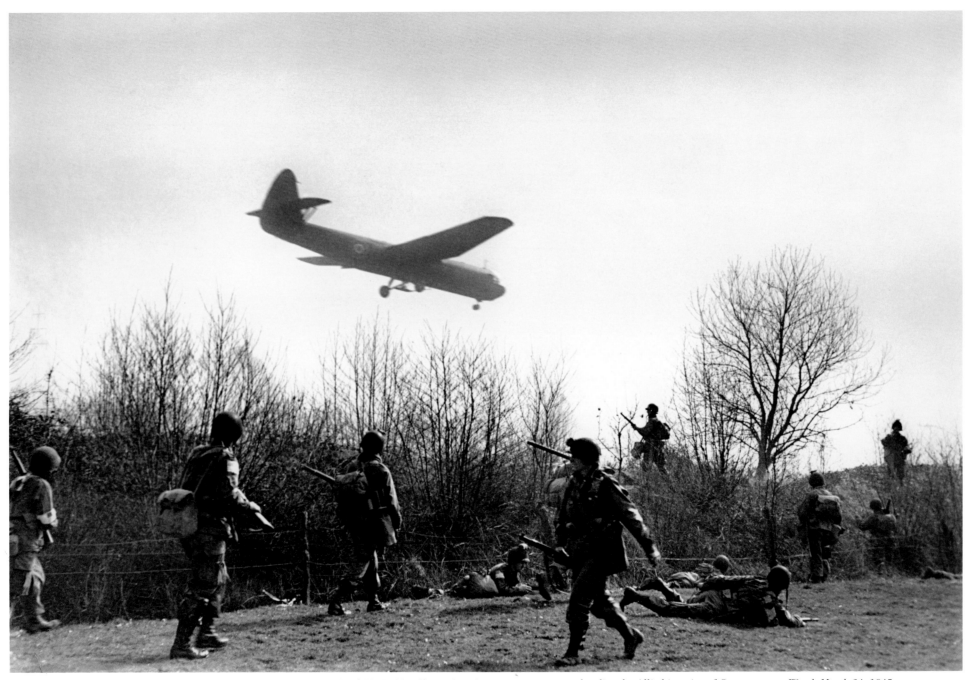

Page 116: U.S. soldiers rooting out pockets of German snipers, Leipzig, April 18, 1945 Above: American paratroopers spearheading the Allied invasion of Germany, near Wesel, March 24, 1945

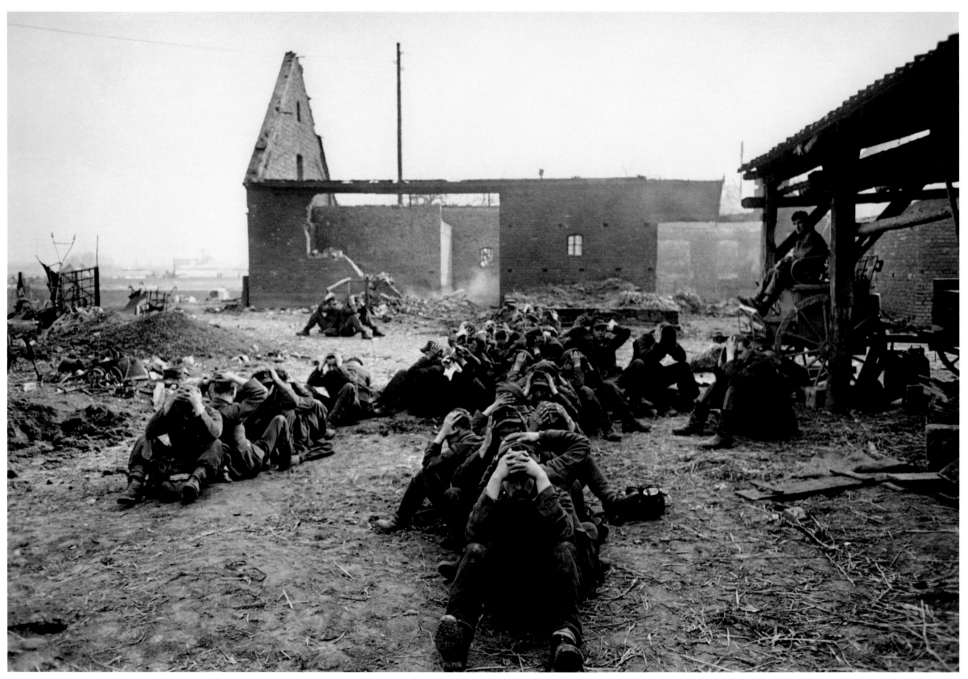

German soldiers captured by American forces, near Wesel, March 24, 1945

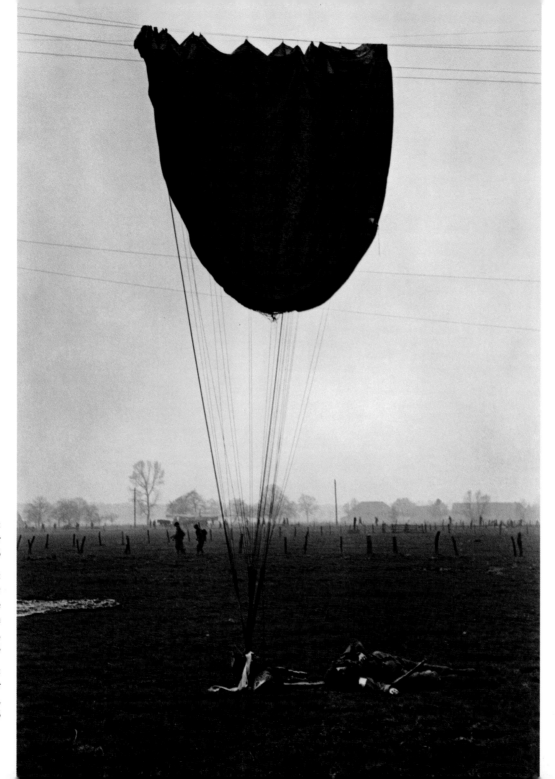

Right:
American paratroopers, near
Wesel, March 24, 1945

Opposite:
German soldier captured by
U.S. forces during the
Battle of the Bulge, south
of Bastogne, Belgium,
December 23–26, 1944

Following pages:
German farmers fleeing their
burning home, near Wesel,
Germany, March 24, 1945

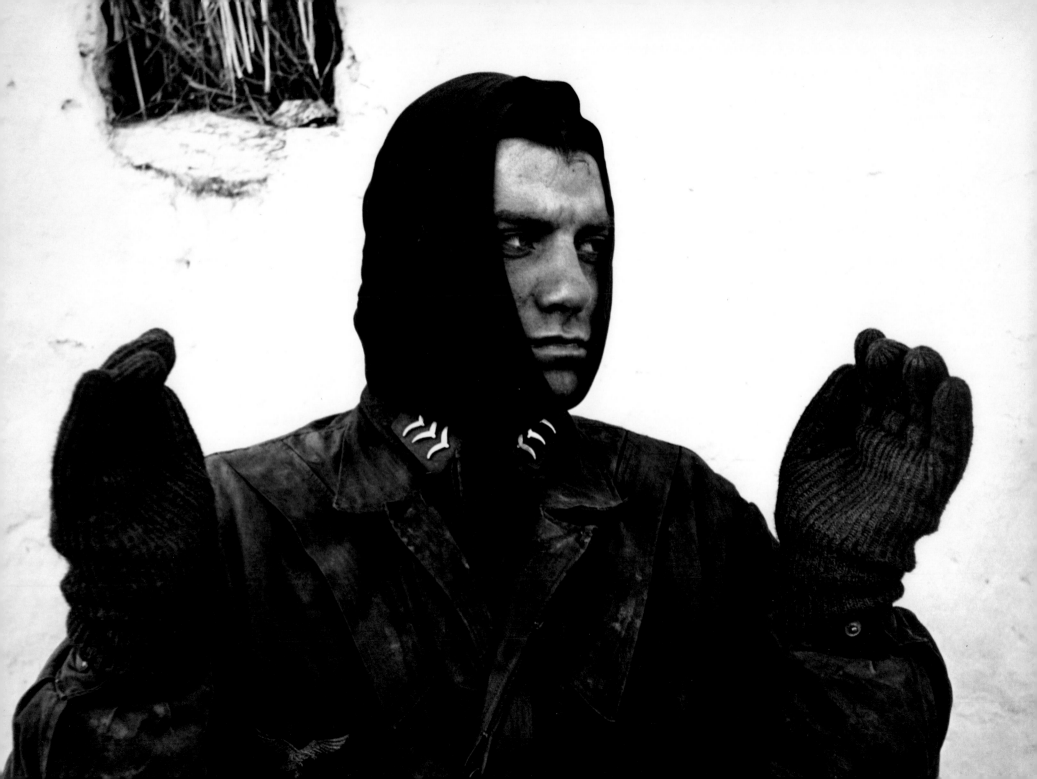

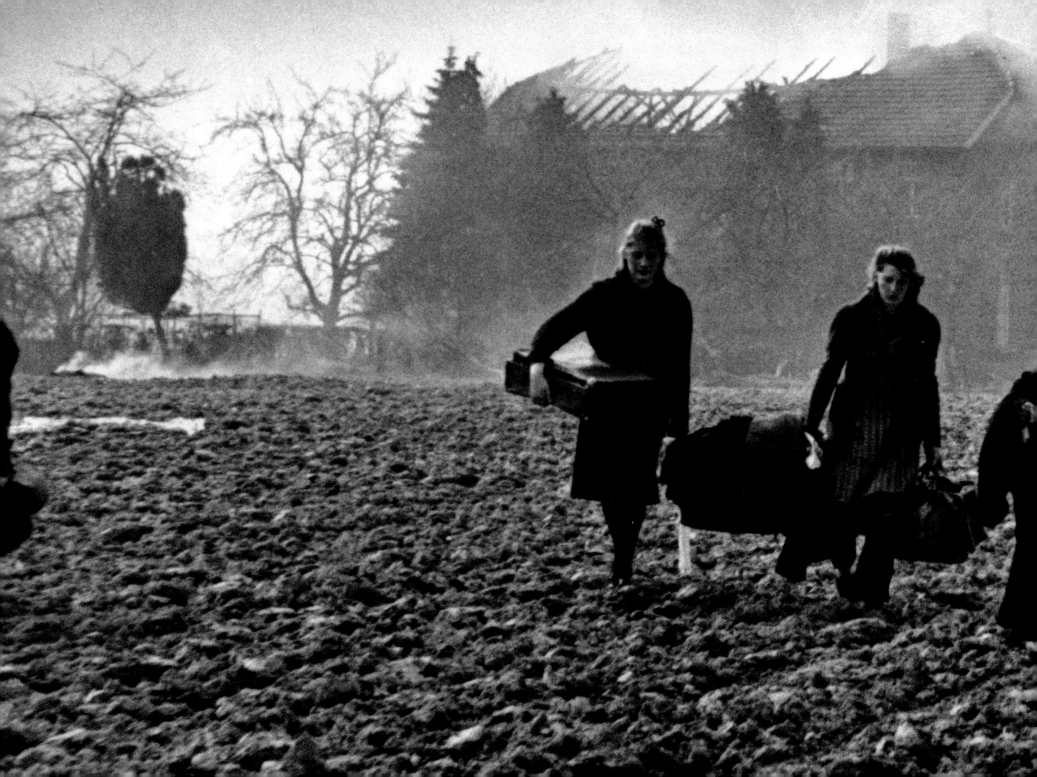

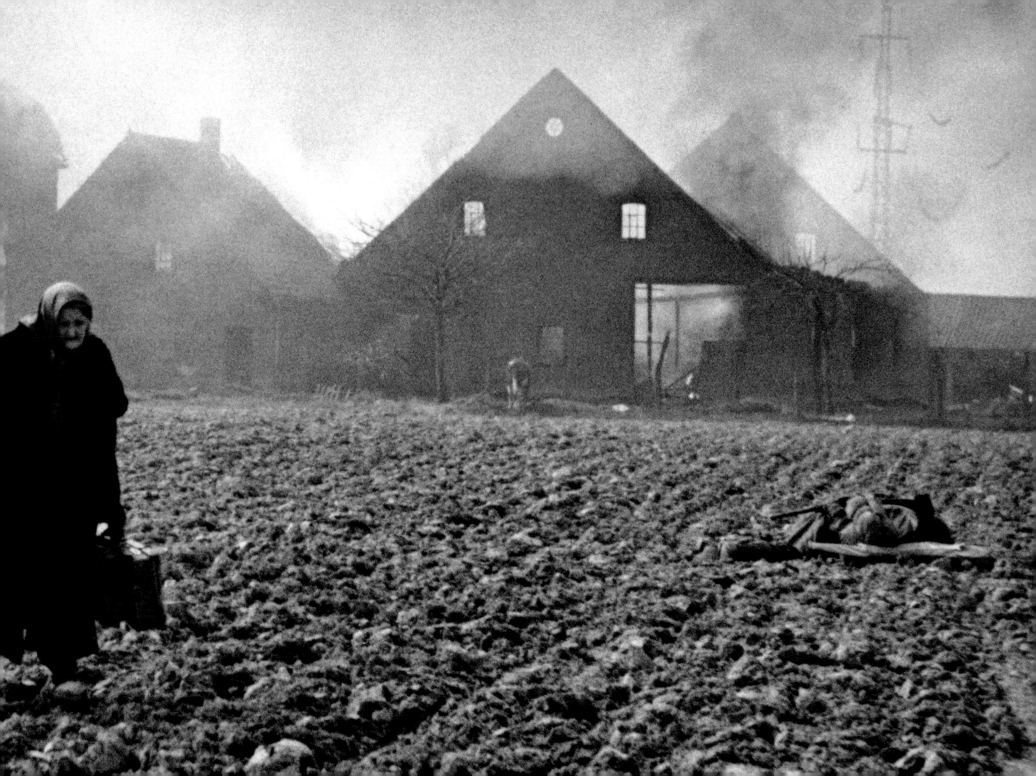

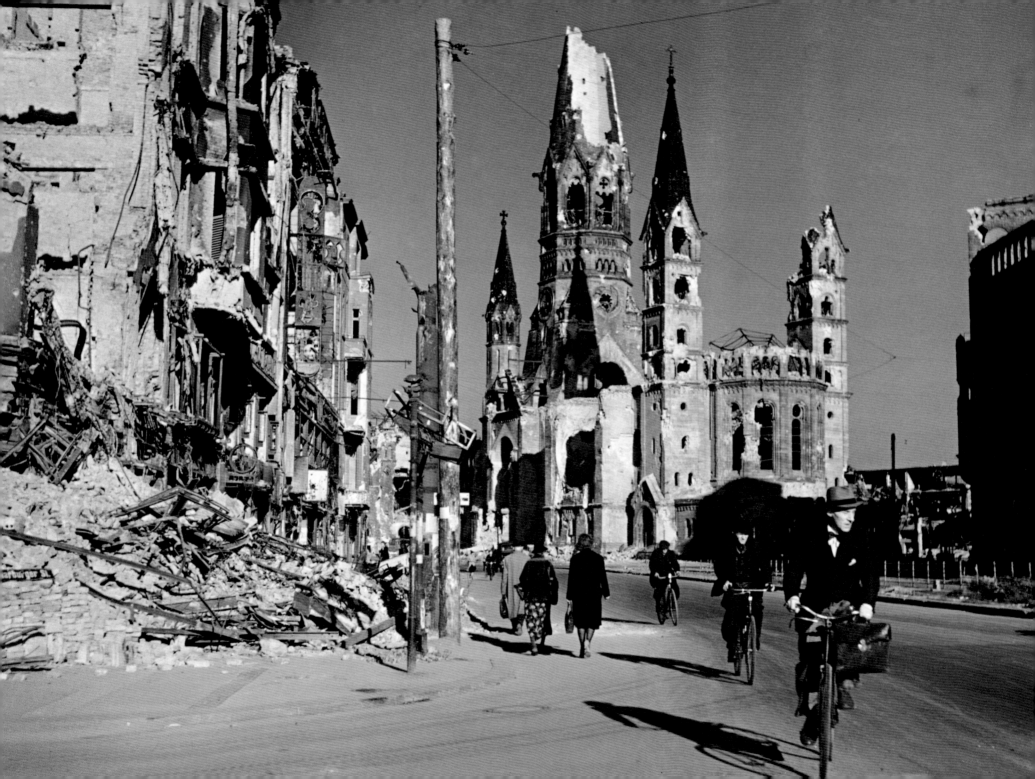

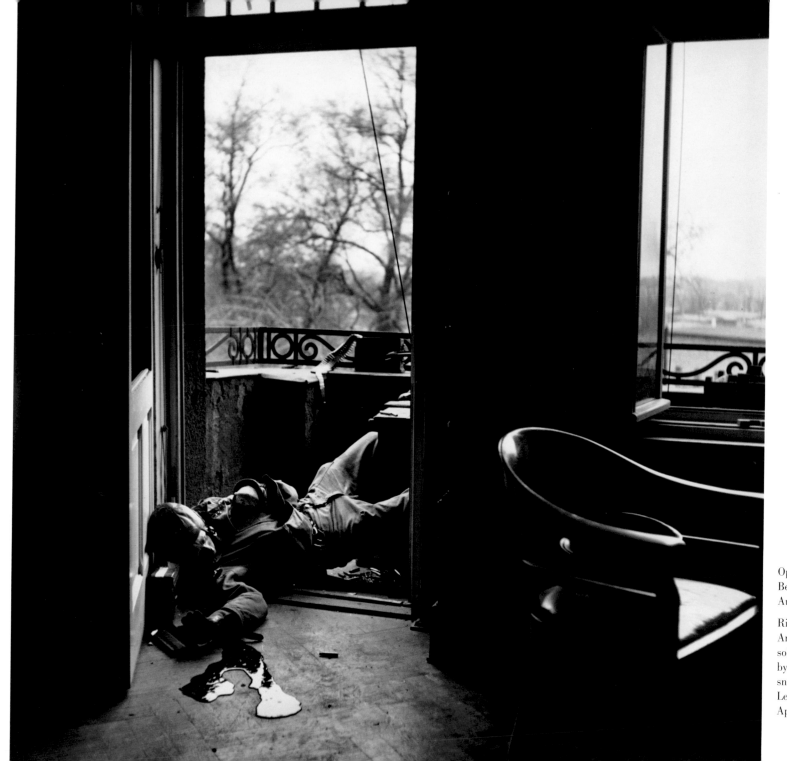

Opposite:
Berlin,
August 1945

Right:
An American
soldier, killed
by German
snipers,
Leipzig,
April 18, 1945

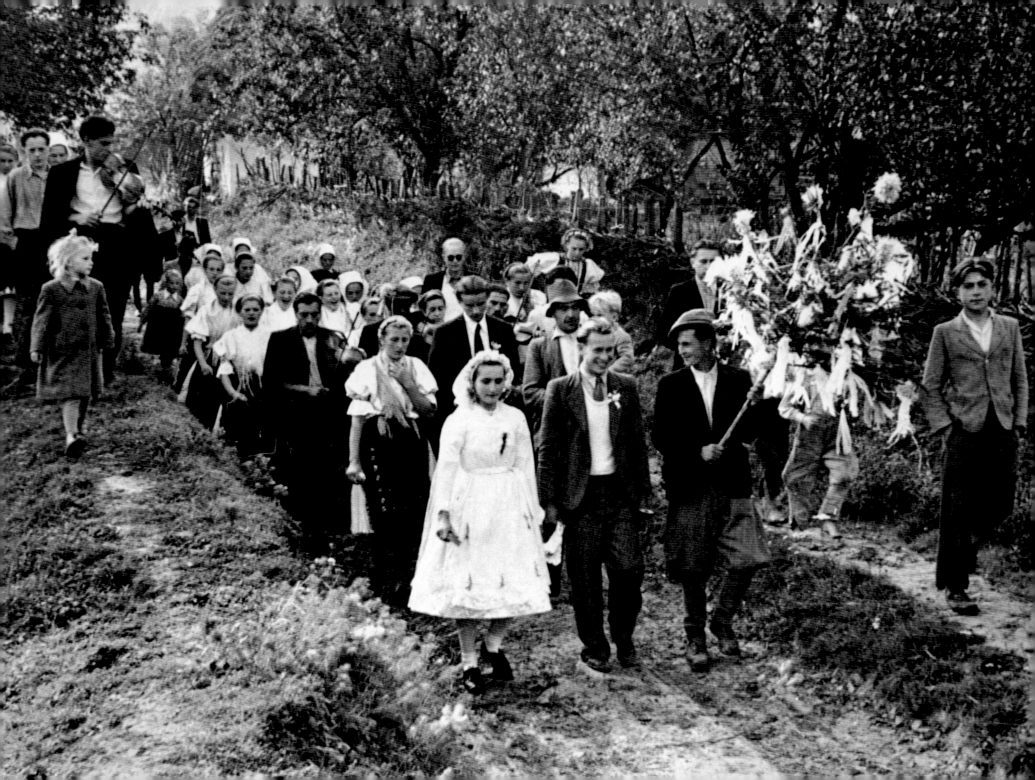

EASTERN EUROPE 1947–1949

Because the postwar Soviet Union was closed to most Western photographers, Capa jumped at the opportunity to travel there with his friend John Steinbeck, whose novels were officially praised as Socialist Realism by the Russian government. They spent a month in the USSR during the summer of 1947, visiting Moscow, Stalingrad, Georgia, and the Ukraine. In *A Russian Journal*, the book on which he collaborated with Steinbeck, Capa complained, with his tongue in his cheek, "I am not happy at all. The hundred and ninety million Russians are against me. They are not holding wild meetings on street corners, do not practice spectacular free love, do not have any kind of new look, they are very righteous, moral, hard-working people, for a photographer as dull as apple pie. Also they seem to like the Russian way of living, and dislike being photographed. My four cameras, used to wars and revolutions, are disgusted, and every time I click them something goes wrong."

In 1948, Capa accompanied writer Theodore H. White to Hungary, Poland, and Czechoslovakia. At the end of the war the photographer had been unable to bear the thought of documenting the atrocities committed in Nazi concentration camps, where many members of his extended family had died. But on this trip he finally visited Auschwitz, and photographed its barbed-wire fences from the outside.

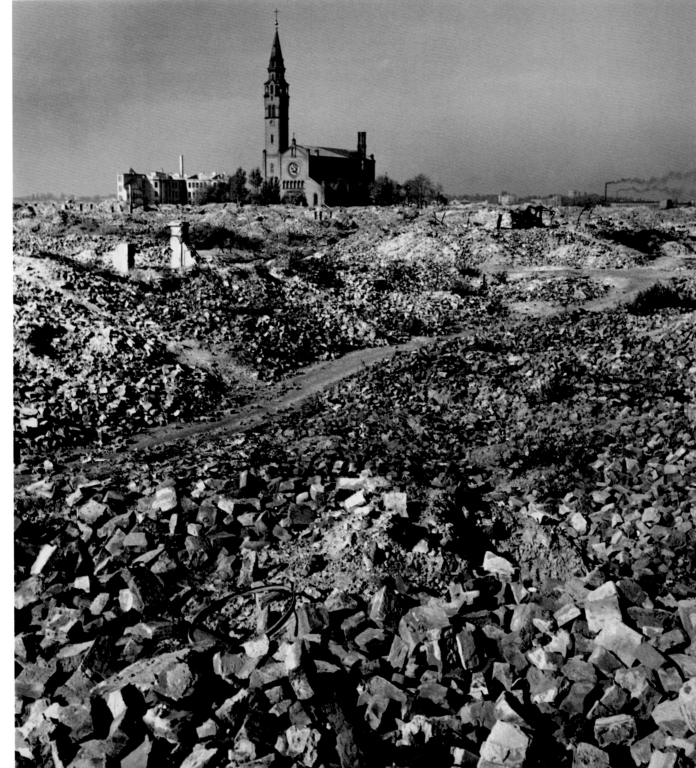

Page 126:
Wedding in a
Slovakian town in
the Carpathian
Mountains, Furolac,
Czechoslovakia,
September 1947

Right:
The bulldozed
ruins of the ghetto,
Warsaw, 1948

Opposite:
Stalingrad,
August 1947

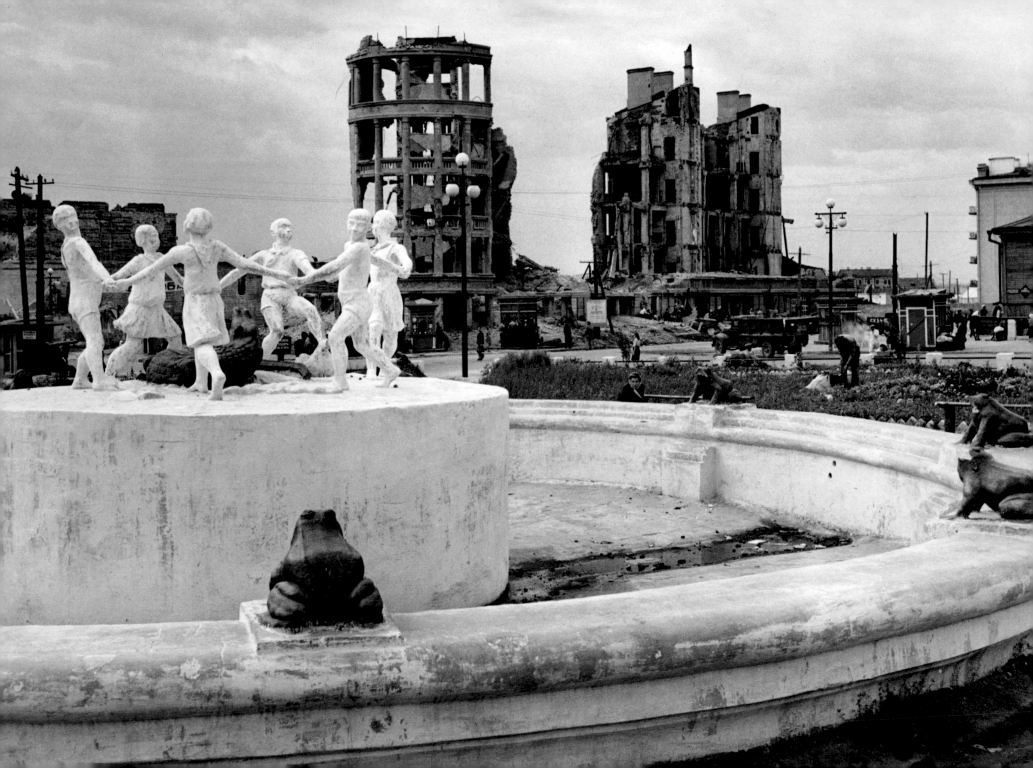

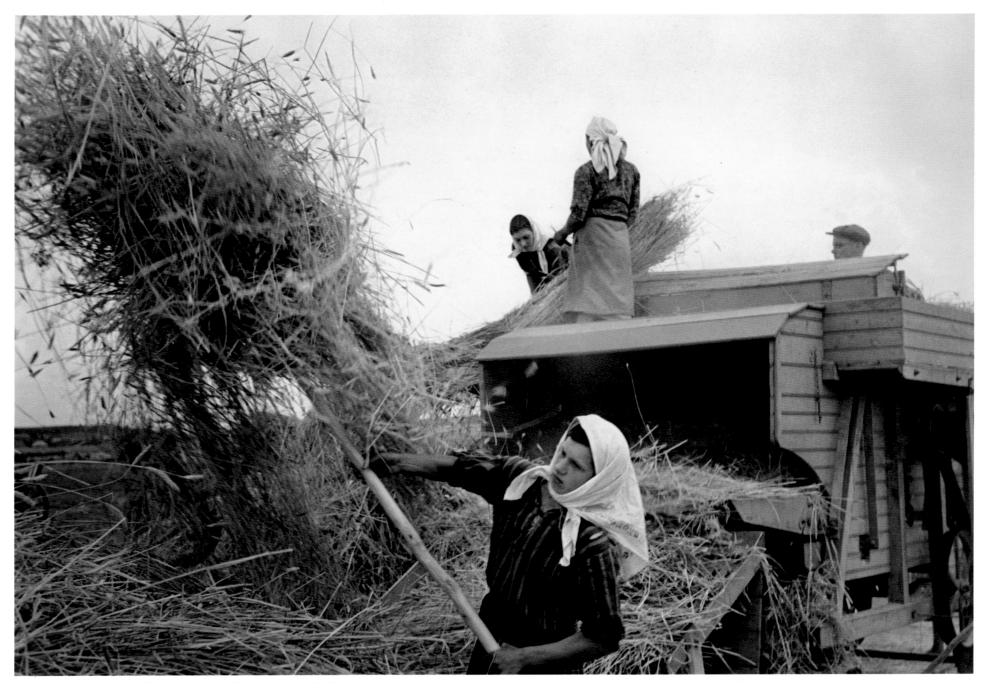

Above and opposite: On a collective farm in the Ukraine, August 1947

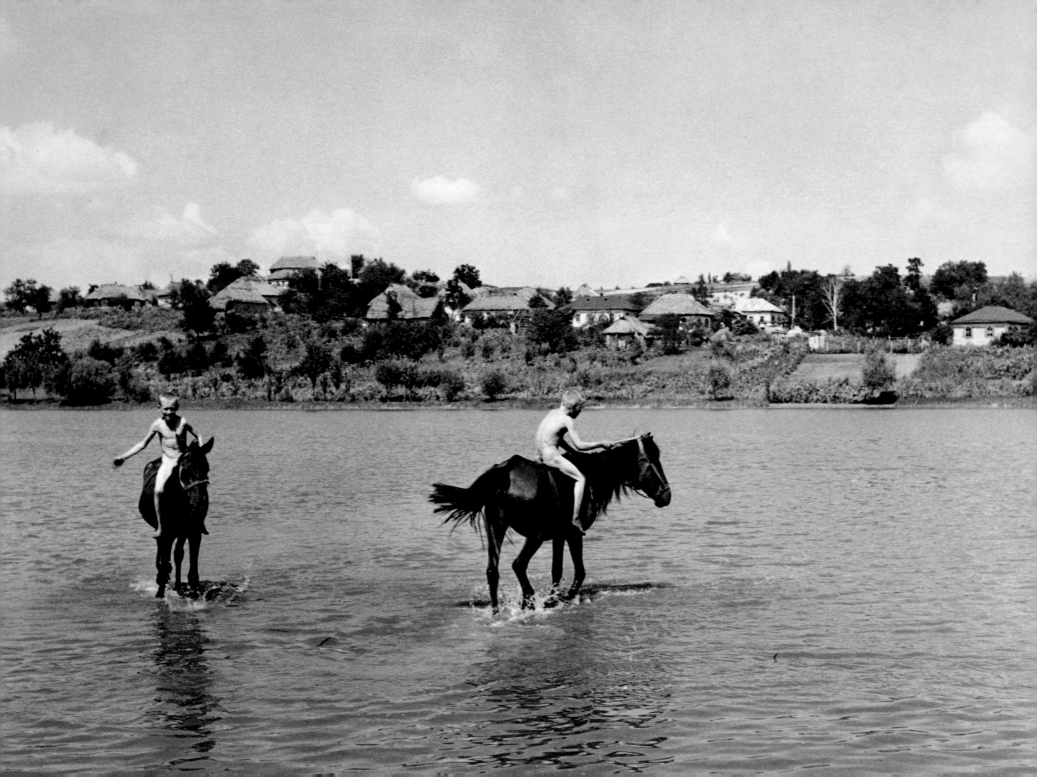

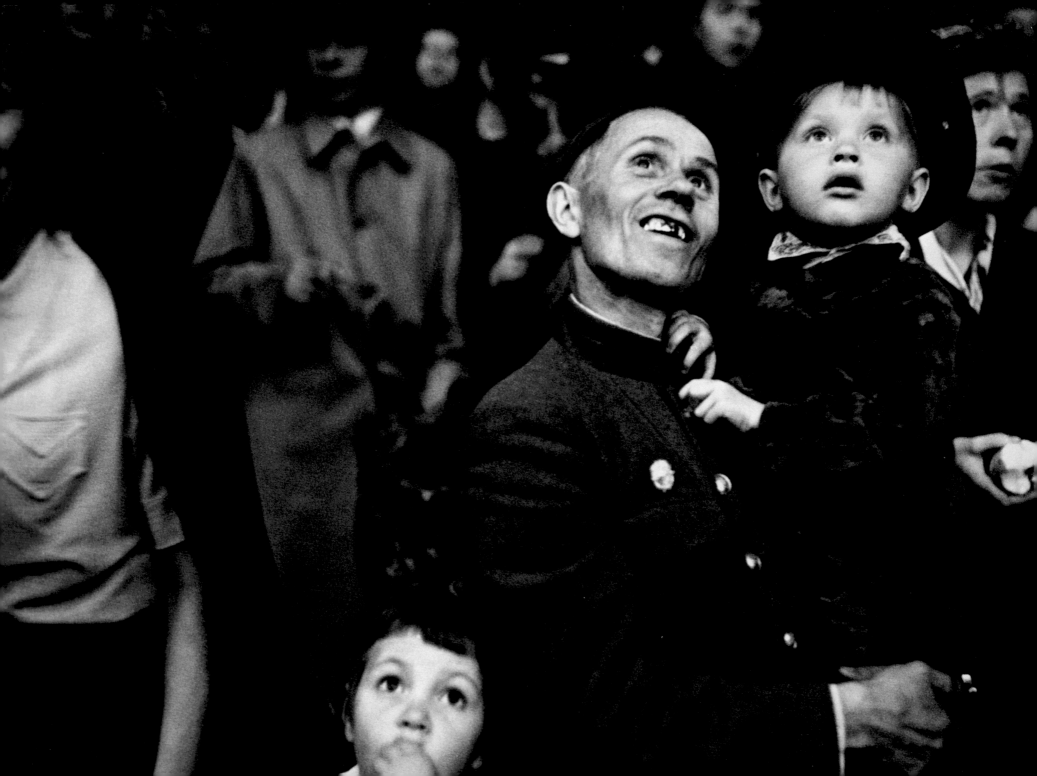

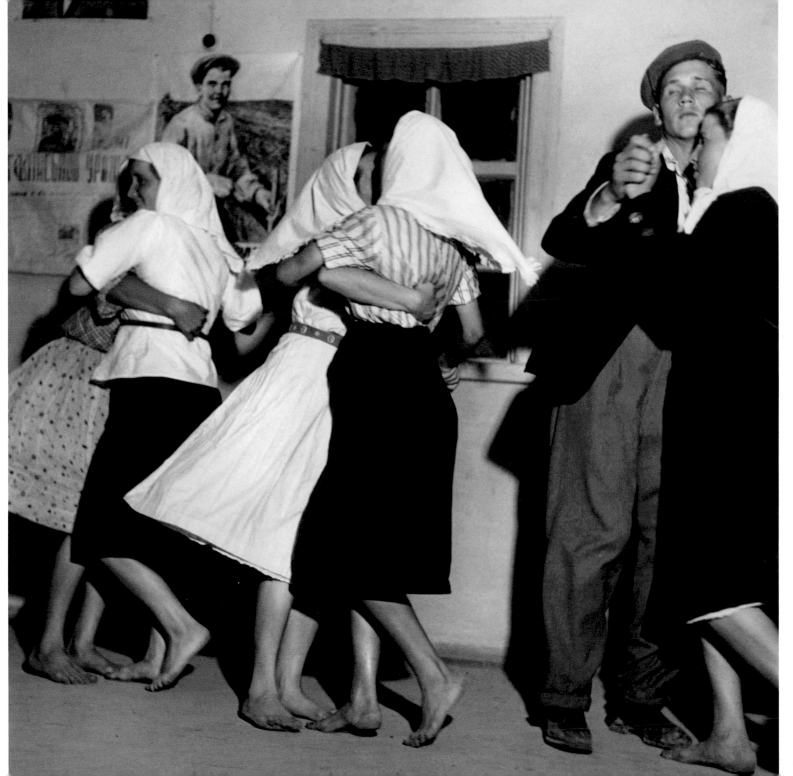

Opposite:
Watching
fireworks during
the celebration
of the 800th
anniversary of
the founding
of Moscow,
September 1947

Left: On a
collective farm
in the Ukraine,
August 1947

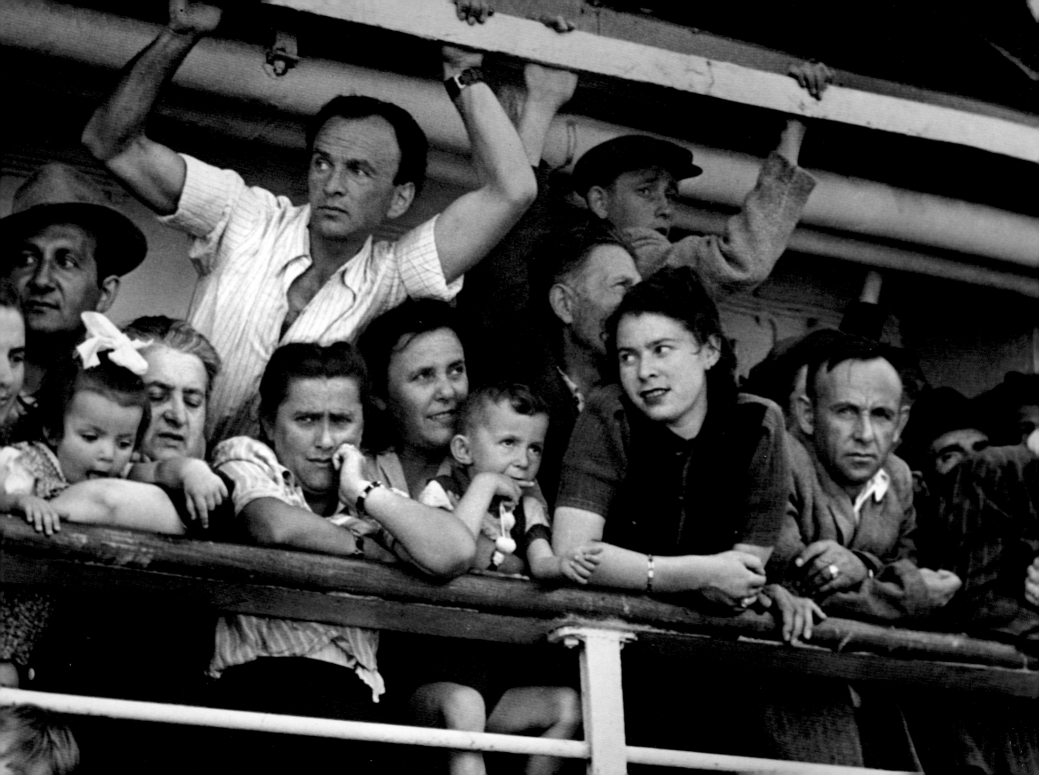

ISRAEL 1948–1950

Capa was in Tel Aviv for the official declaration of the founding of the state of Israel, on May 14, 1948, and he remained in the new nation for about six weeks to cover its war of independence against its Arab neighbors. He wrote that the Israeli army reminds one strongly of the Republican Army of Spain at the beginning of the Civil War. "The same enthusiasm, the same differences in politics, professions, and age."

Capa covered the construction of an emergency supply road to Jerusalem, which was completed just before a four-week truce began on June 11. When extreme right-wing Israelis jeopardized that truce by trying to unload a shipment of arms at Tel Aviv on June 22, Israeli government troops fired on their ship, the *Altalena*, and on the partisans trying to land the crates of weapons on the city's main beach. Capa was grazed by a bullet while photographing the incident.

On his two subsequent trips to Israel, in 1949 and 1950, Capa concentrated mainly on the plight of refugees arriving in the country, only to find themselves interned in vast camps until homes and jobs could be found for them.

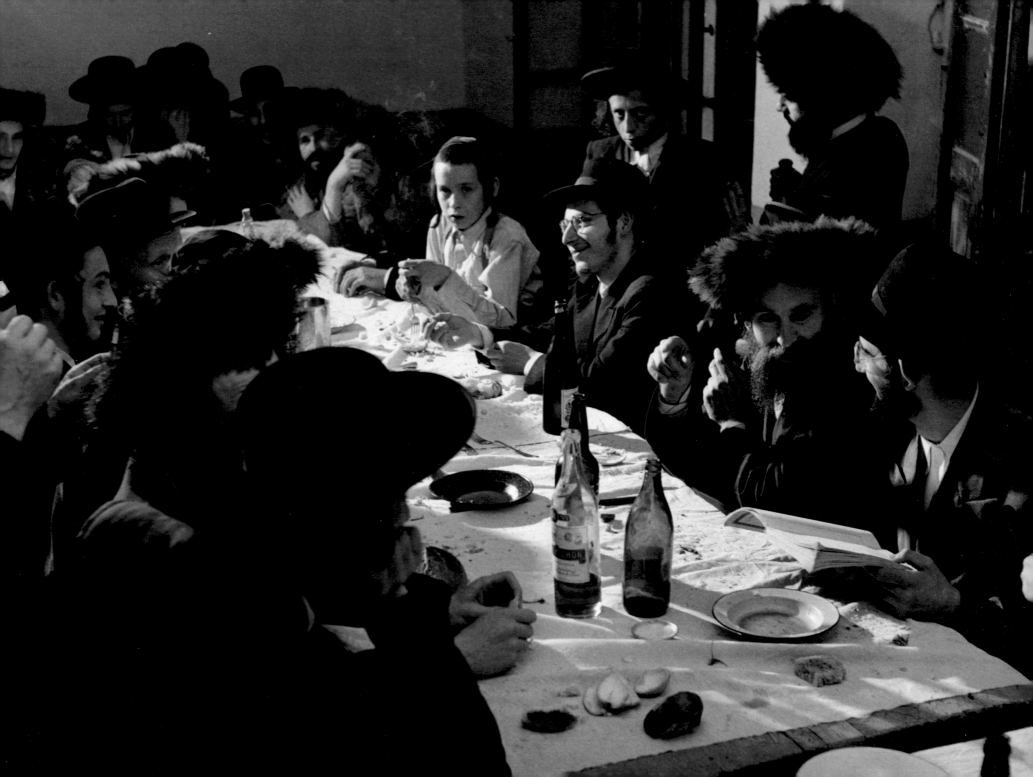

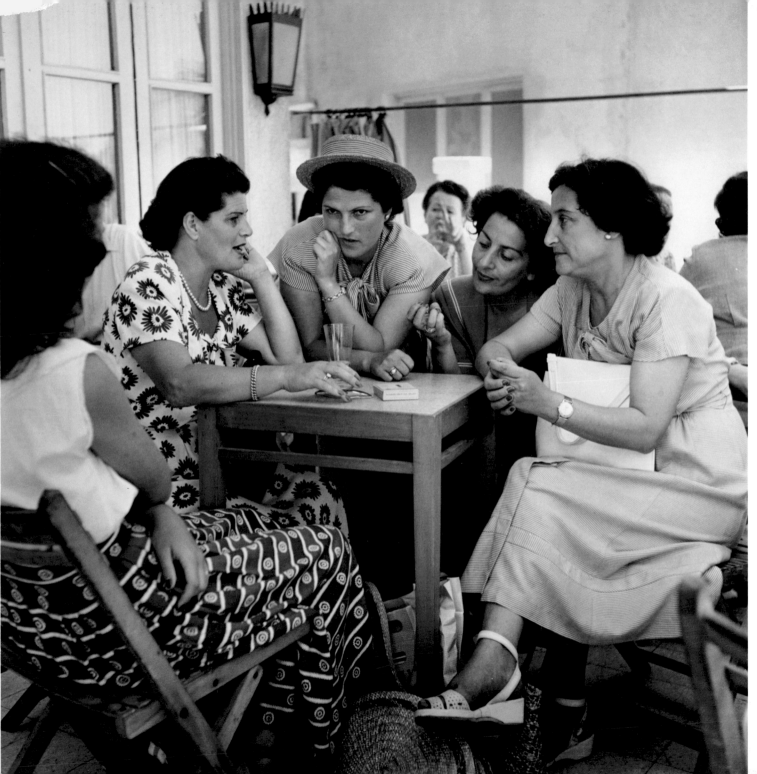

Page 134:
Immigrants
from Europe
arriving in Israel,
Haifa, May–June
1949

Opposite:
A meeting of the
Talmud Society
in the Mea
Shearim district,
Jerusalem,
May–June 1949

Left:
Tel Aviv,
May 1949

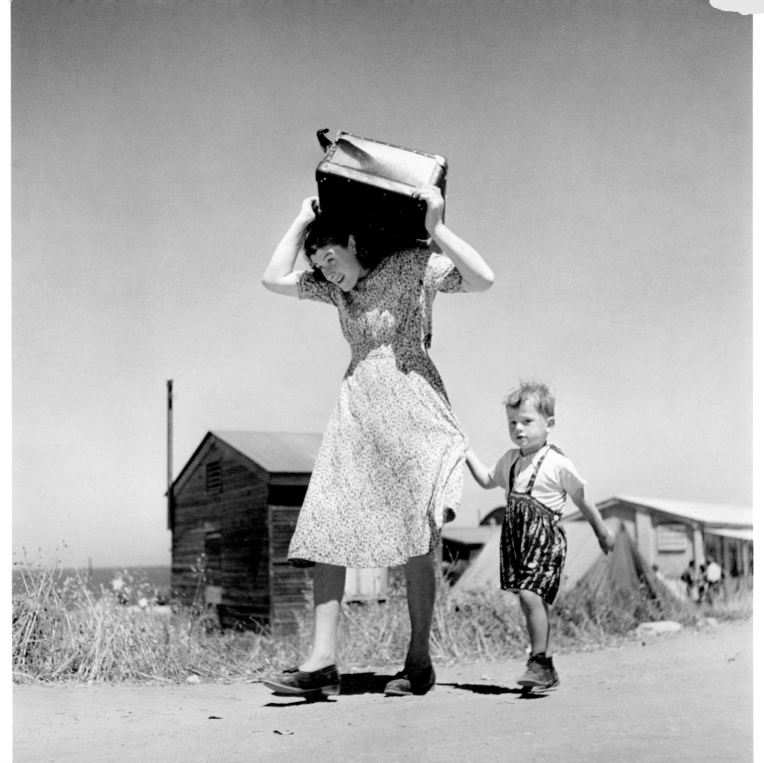

Left:
Arriving
immigrants, Haifa,
1949

Opposite:
Building the
"Burma Road" to
transport supplies
to Jerusalem,
June 1948

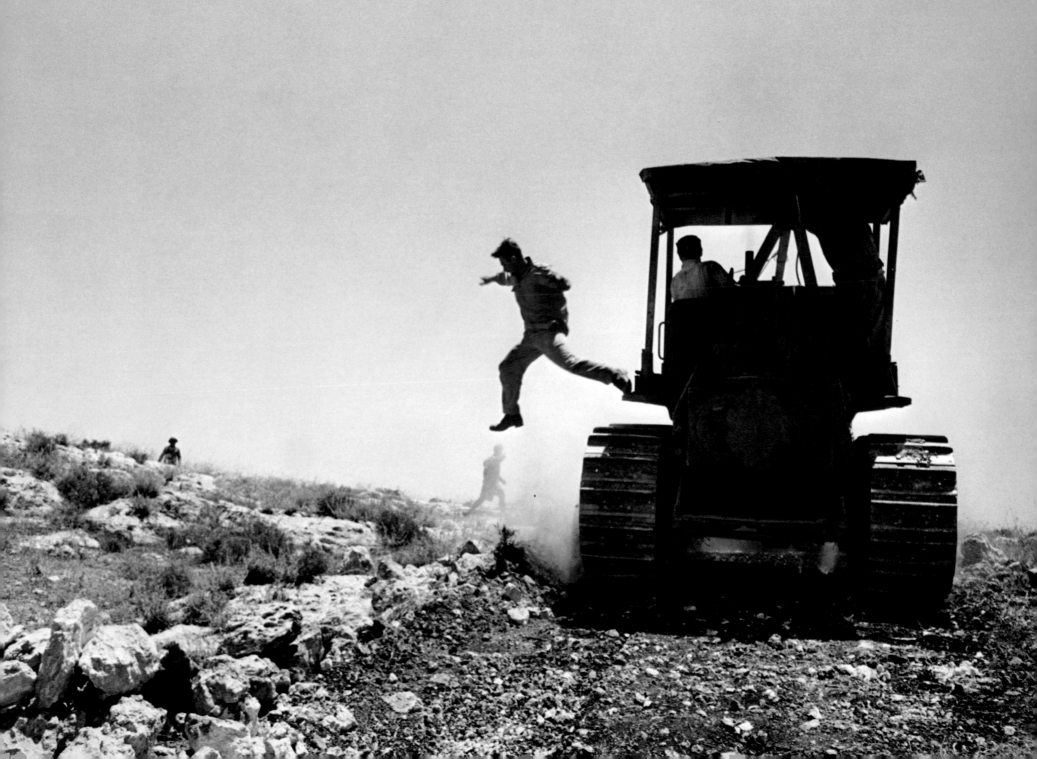

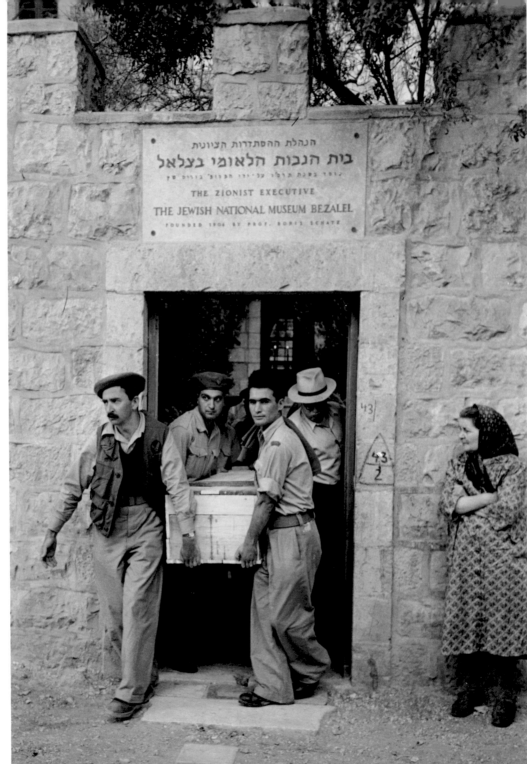

Right:
The funeral of
David Marcus, the
American who had been
in charge of building
the "Burma Road,"
Tel Aviv, June 1948

Opposite:
Clearing land,
Israel, 1950

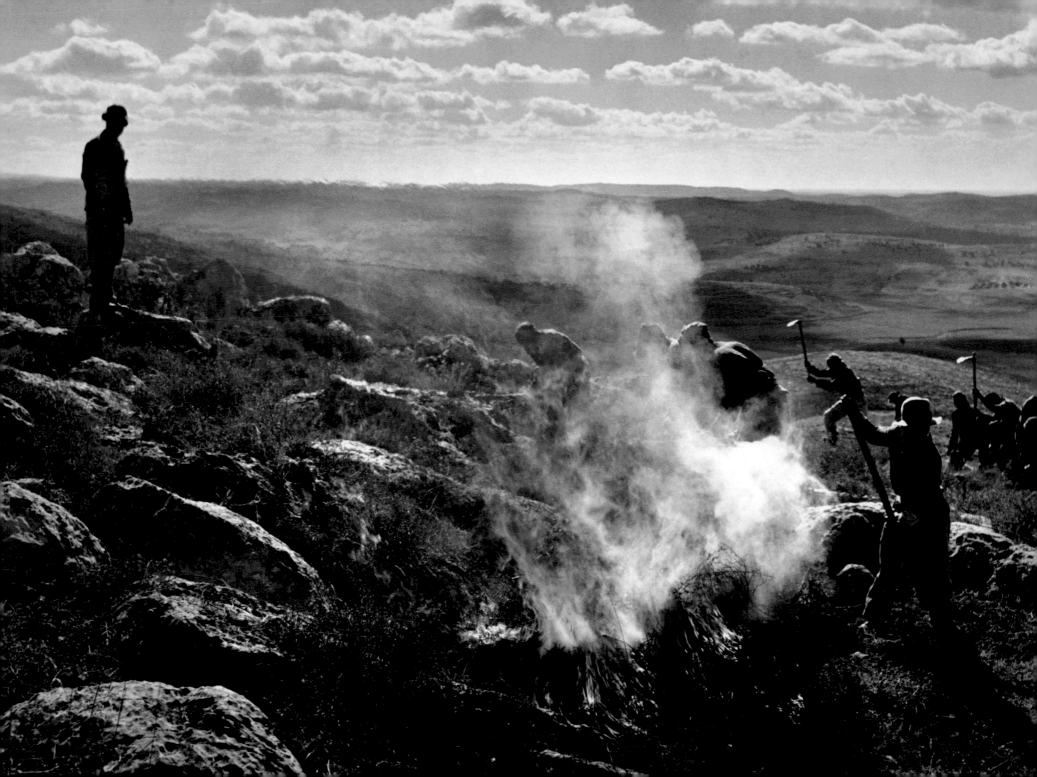

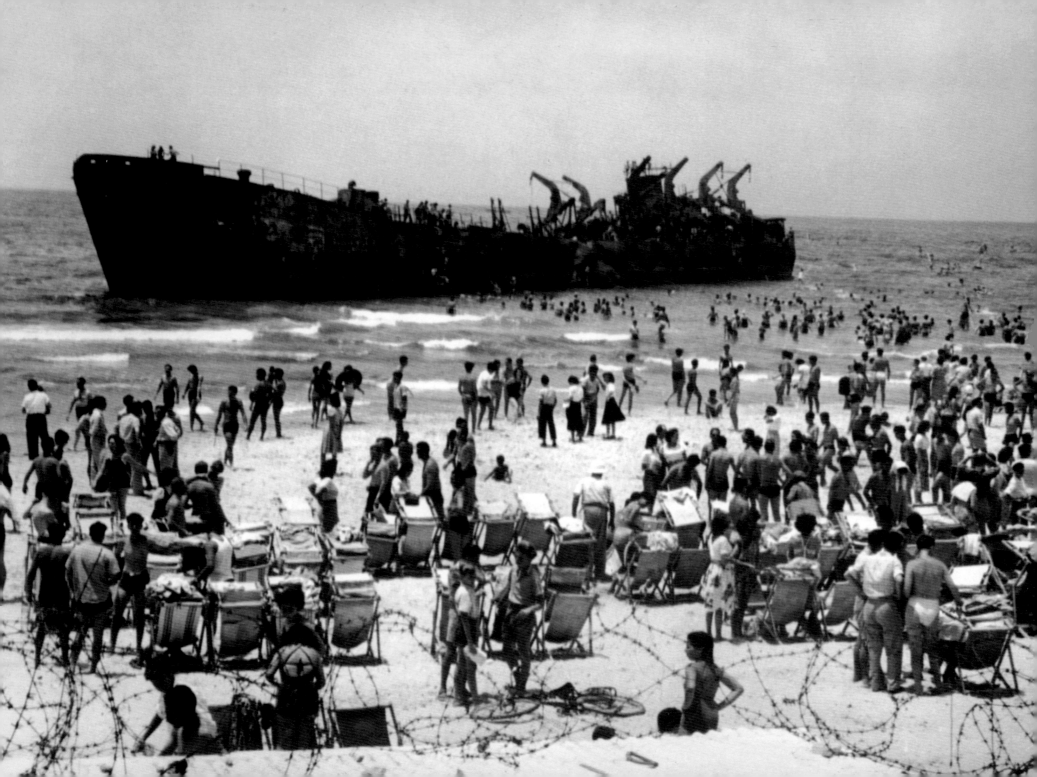

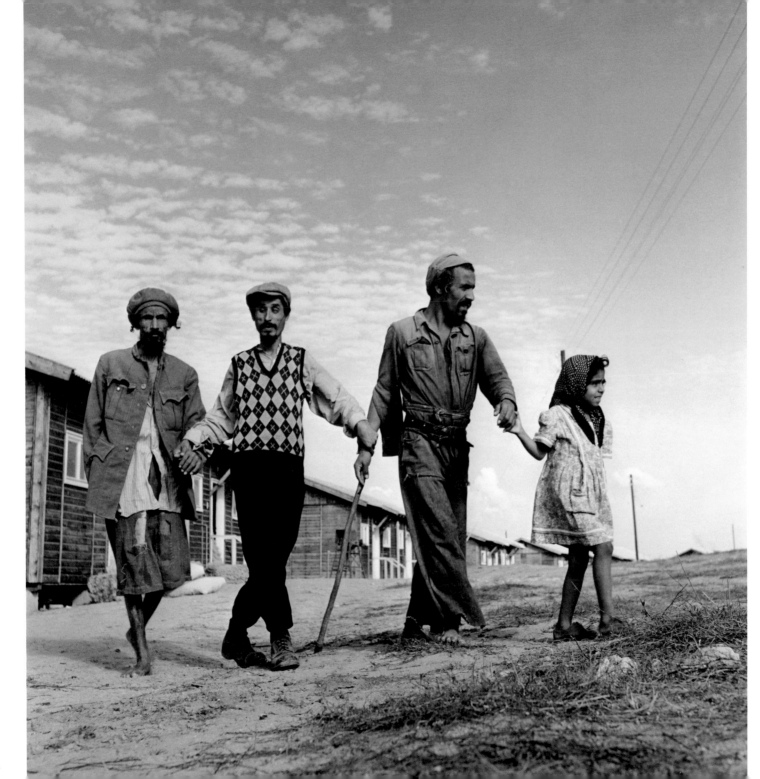

Opposite:
The rusting hulk
of the *Altalena*,
which a year earlier
had been used by
extreme right-wing
Irgunists to deliver a
shipload of arms
during a cease-fire
in the war against
the Arabs, Tel Aviv,
May 1949

Left:
Blind immigrants,
near Gedera
(south of Tel Aviv),
November–December
1950

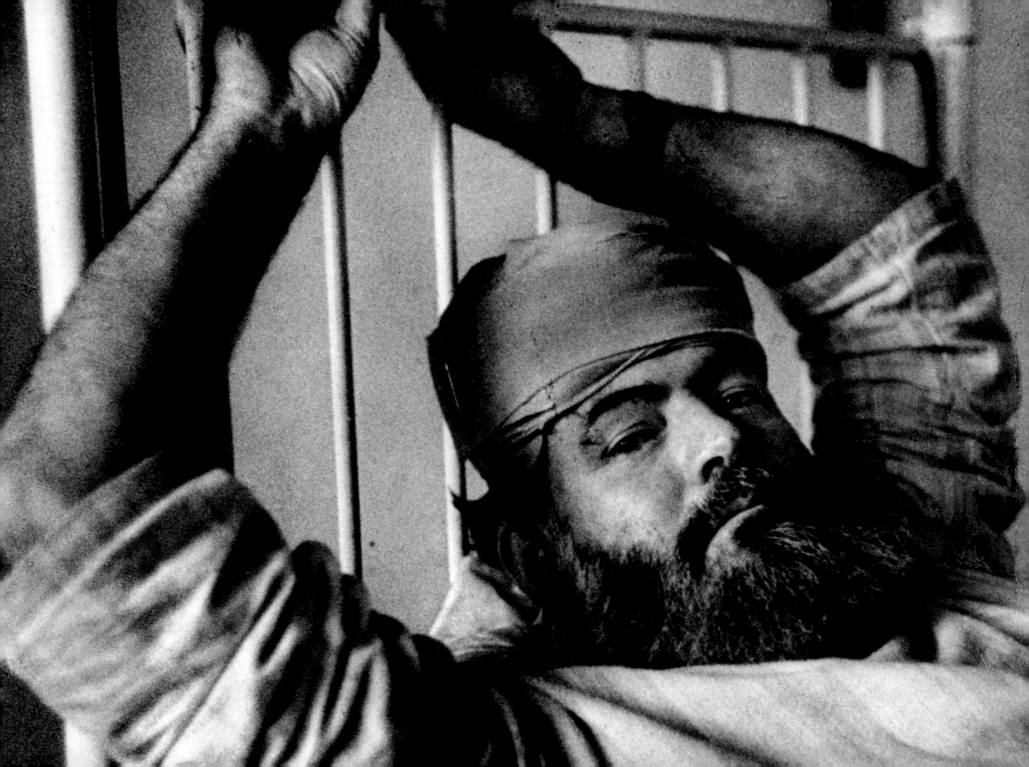

FRIENDS

It seems that practically everyone who ever had a drink with Capa—or played poker with him, or went to the races with him—thought of him, on the basis of those few hours, as a close friend. Geraldine Fitzgerald has recalled that "Capa was extremely friendly. He conveyed a sense of inner euphoria. You got the feeling that he wanted to share this euphoria.... He always seemed to be having great fun, and people wanted to join in and share the fun."

He had an astonishing galaxy of friends, many of them photographers and journalists who were as peripatetic as himself. Whenever he and his friends happened to find themselves in the same place at the same time, their interrupted friendships would be resumed, however briefly. Capa seemed to have friends everywhere; wherever he arrived, he would make a few phone calls, and at once there would be a party or poker game.

At home in Paris, Capa had a circle of close friends composed mainly of expatriate Americans—Ernest Hemingway, John Steinbeck, Irwin Shaw, columnist Art Buchwald, screenwriter Peter Viertel, and movie directors John Huston and Anatole Litvak. Pablo Picasso and Françoise Gilot were good friends. And then there was Capa's extended family of Magnum photographers, all of whom were given entrée into Capa's glittering and glamorous world.

Page 144:
Ernest Hemingway,
London, May 1944

Right and opposite:
Ernest Hemingway, Sun
Valley, Idaho,
November 1940

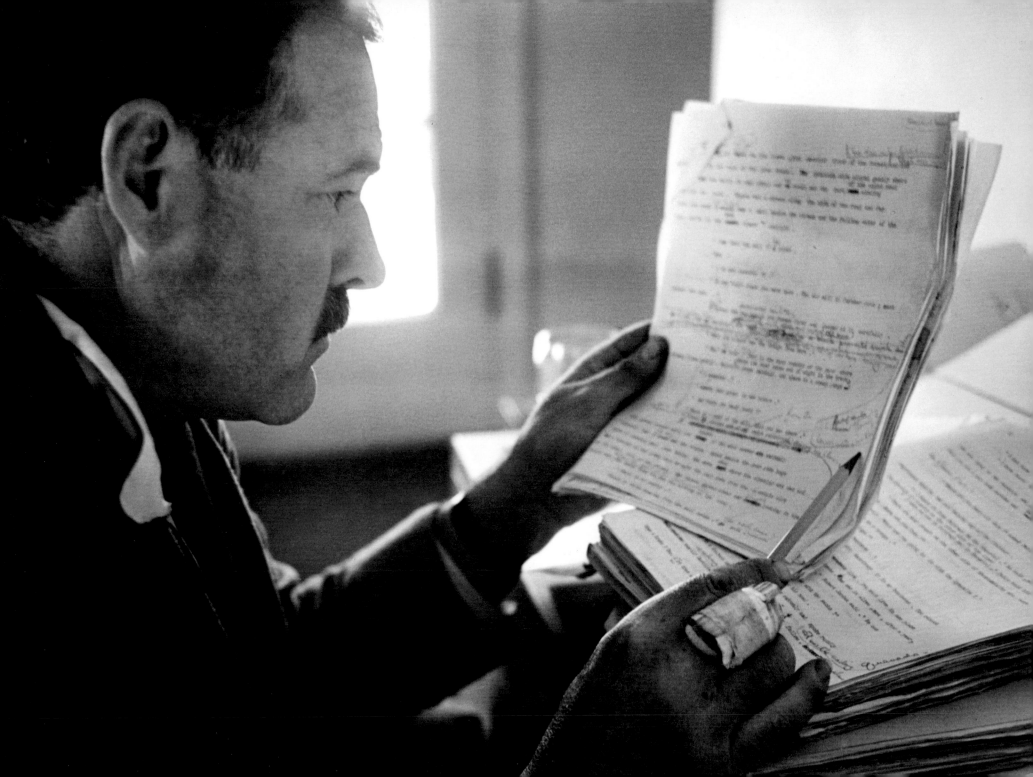

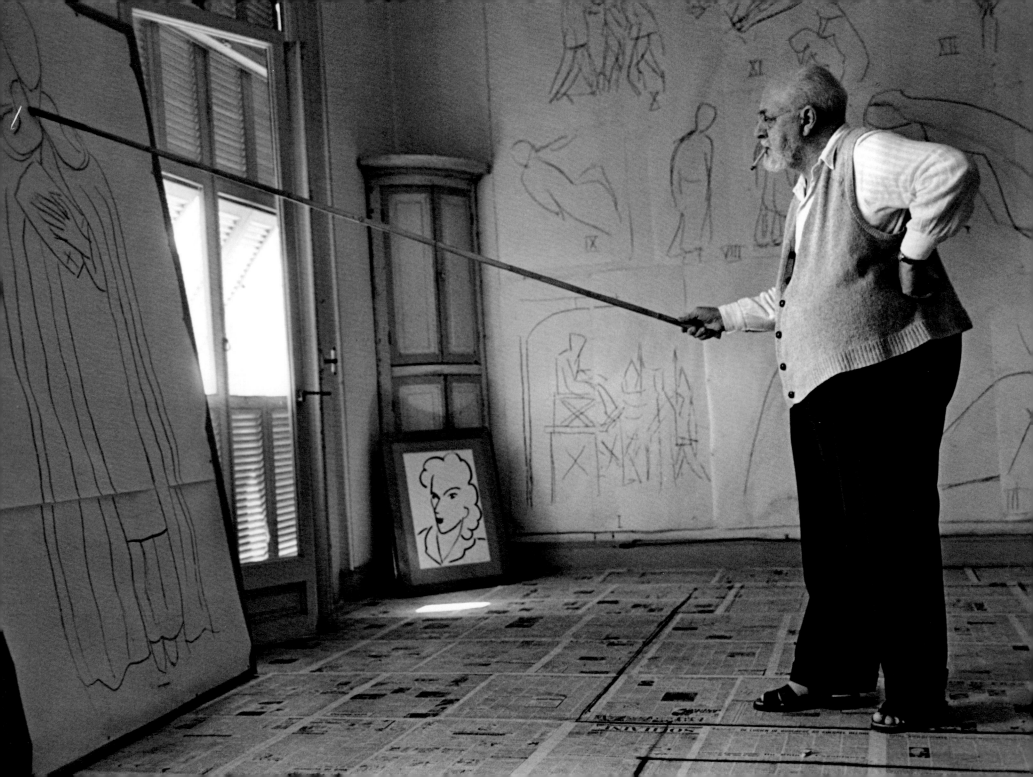

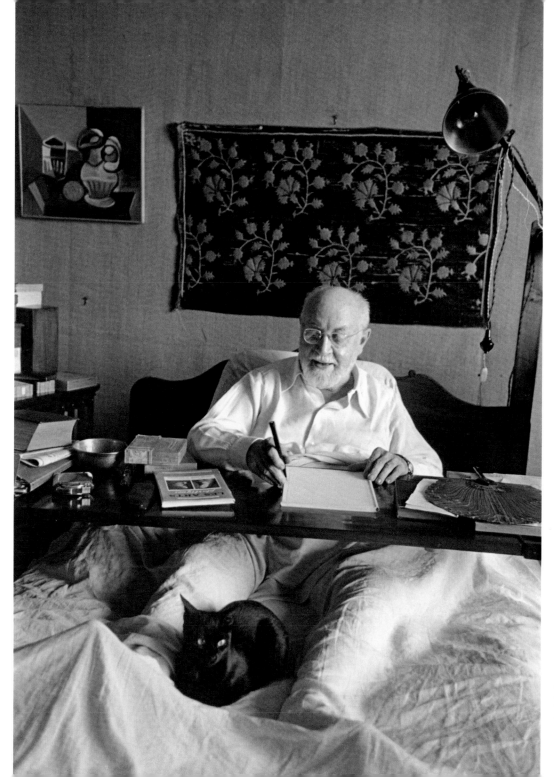

Opposite and left:
Henri Matisse, Cimiez (Nice),
August 1949

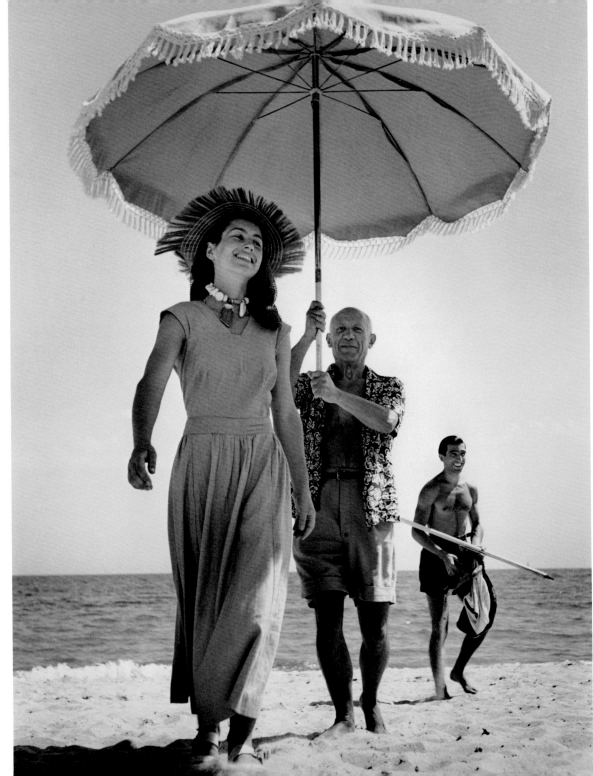

Right:
Pablo Picasso
and Françoise Gilot
(background:
Picasso's nephew
Javier Vilato),
Golfe-Juan, France,
August 1948

Opposite:
Picasso and his
son Claude, Golfe-Juan,
France, August 1948

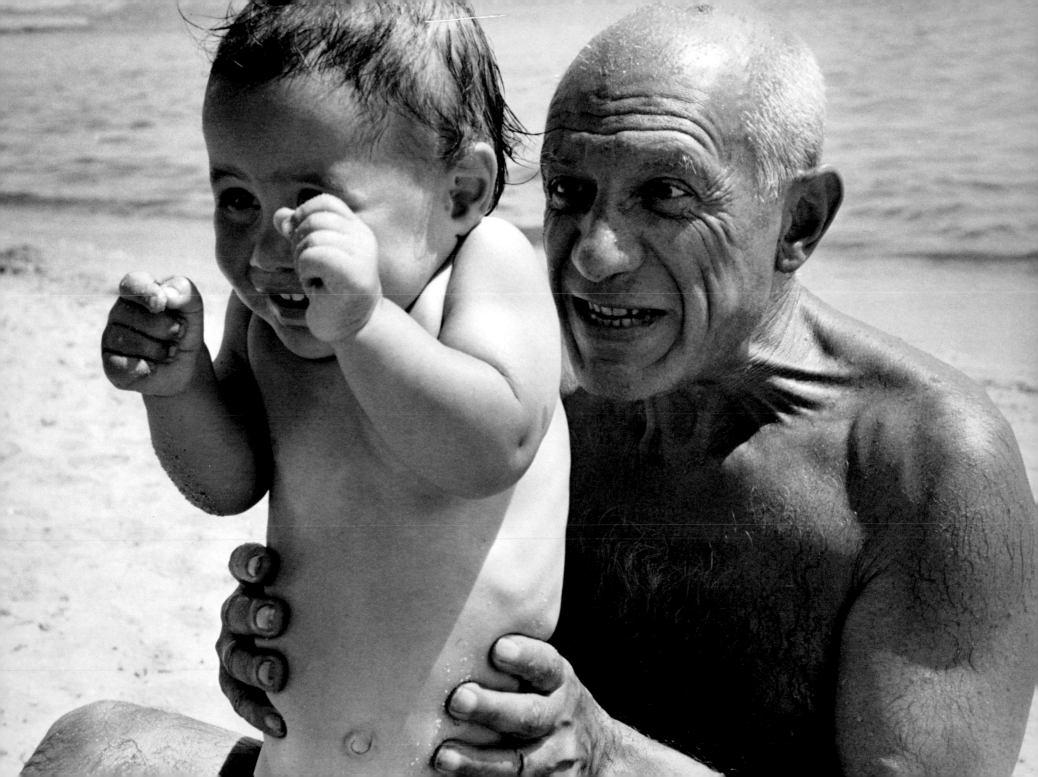

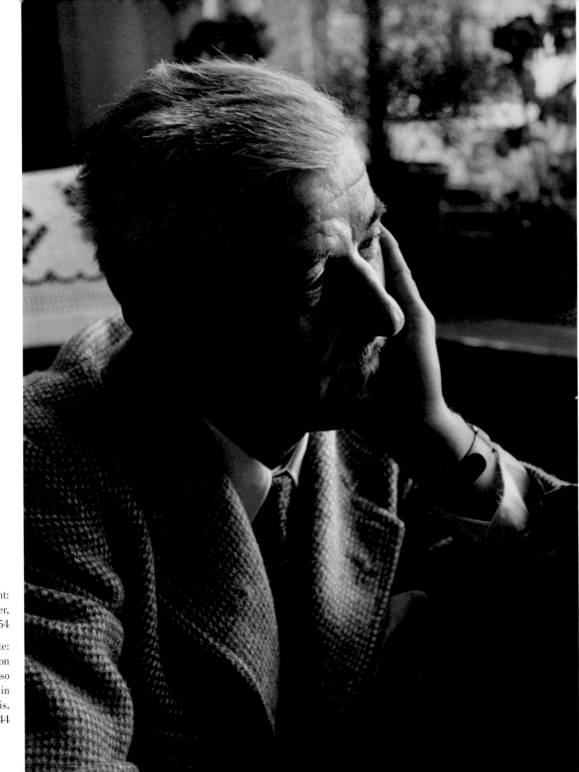

Right:
William Faulkner,
Paris, 1954

Opposite:
After the liberation
of Paris, Picasso
receiving friends in
his studio, Paris,
September 2, 1944

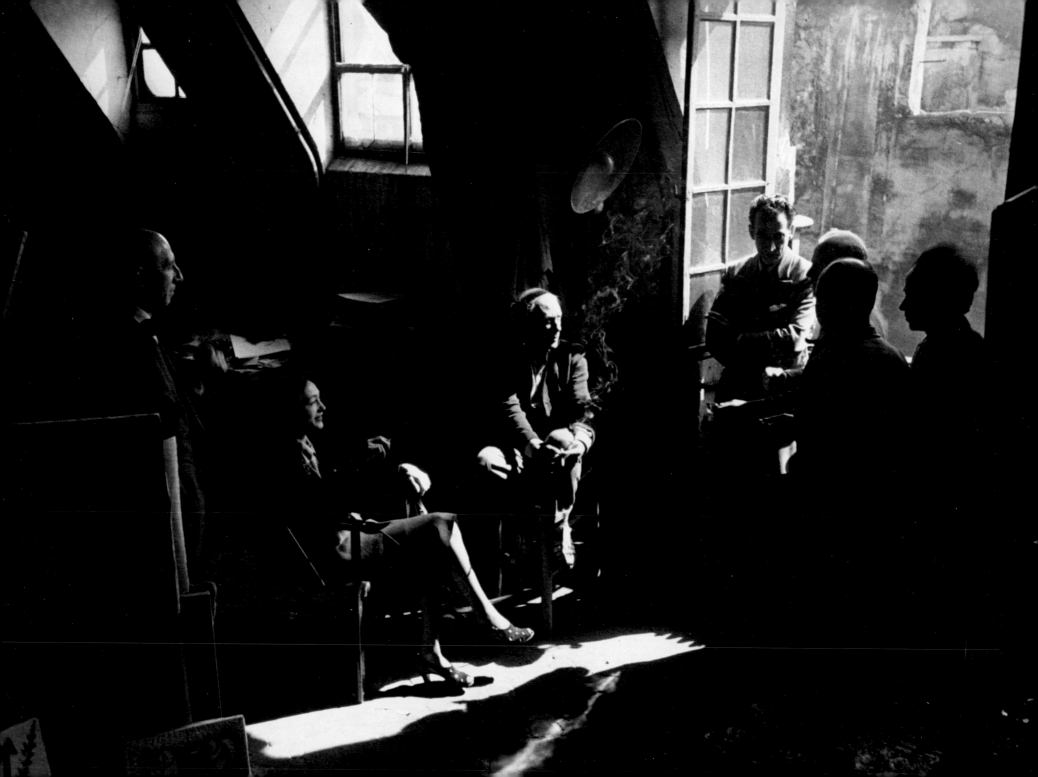

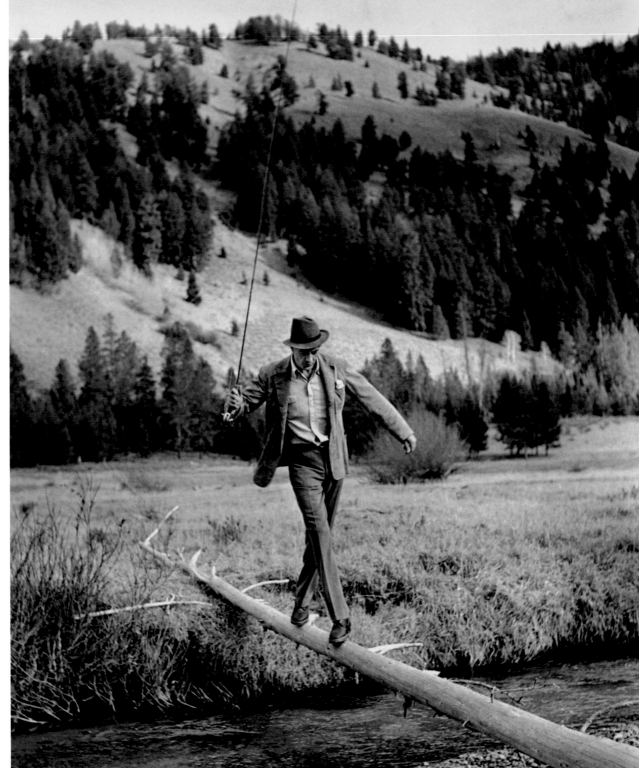

Right:
Gary Cooper,
Sun Valley, Idaho,
October 1941

Opposite:
Truman Capote,
Italy, 1953

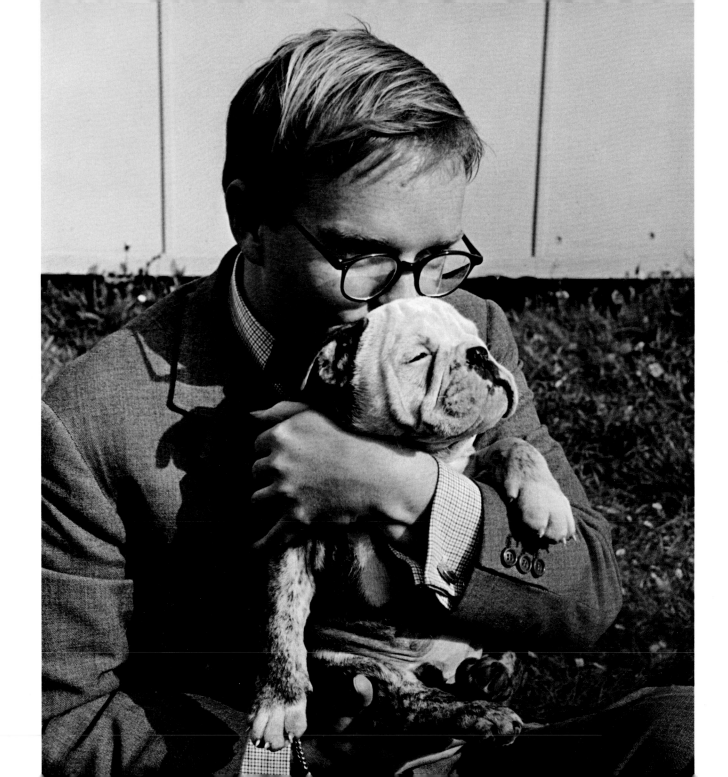

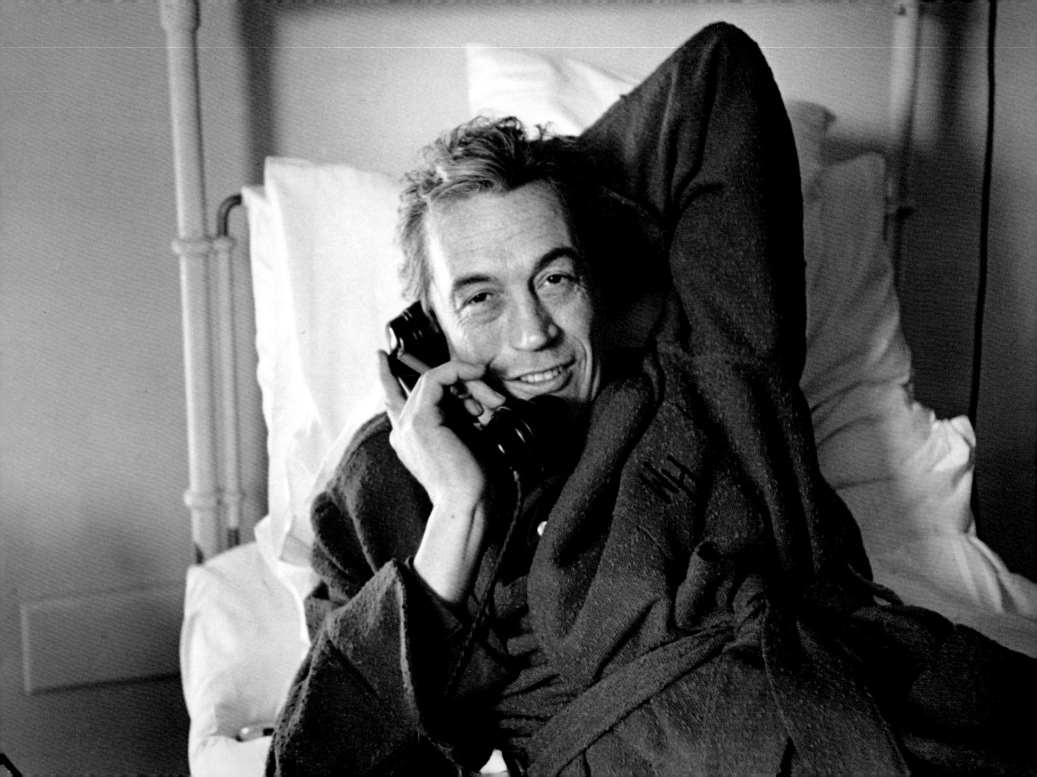

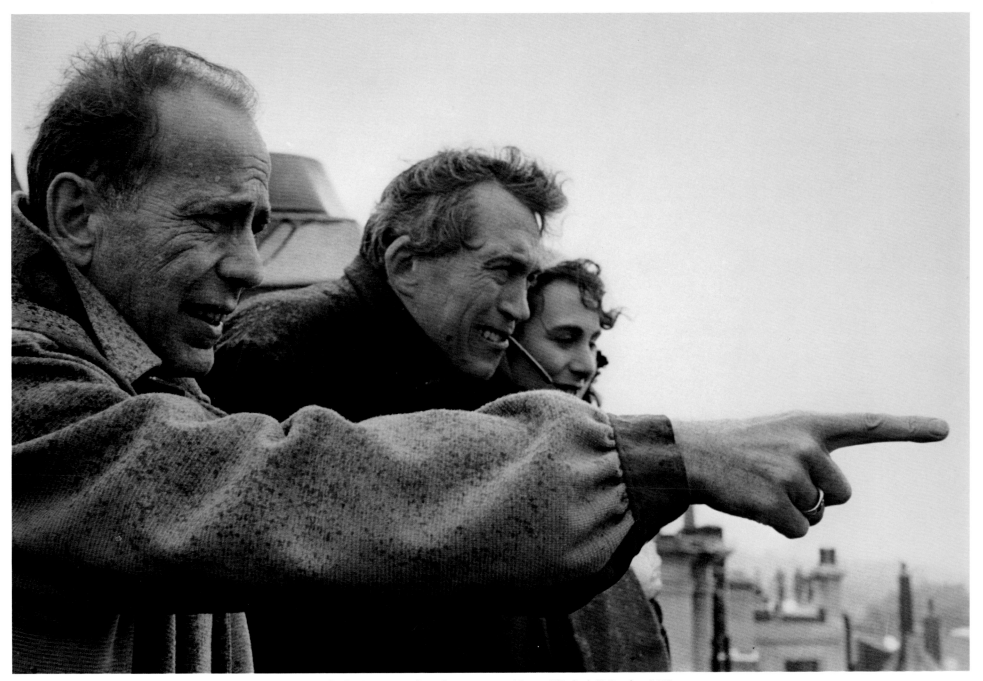

Opposite: John Huston, London, 1953 Above: Humphrey Bogart and John Huston watching the coronation of Queen Elizabeth II, London, 1953

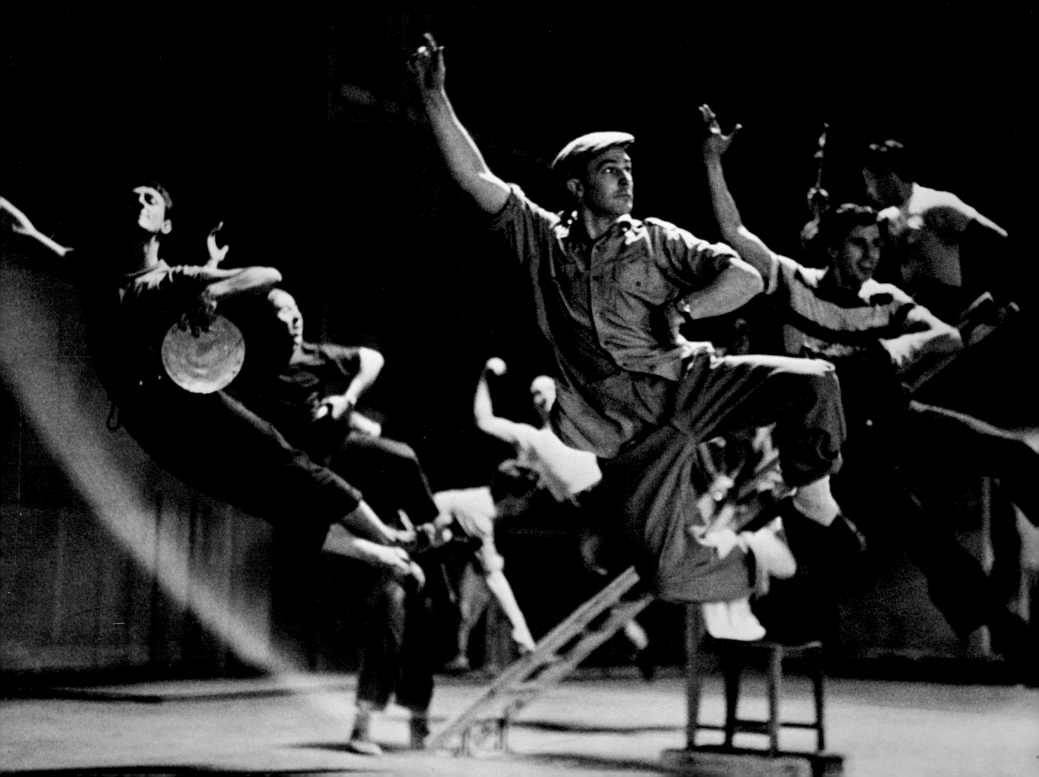

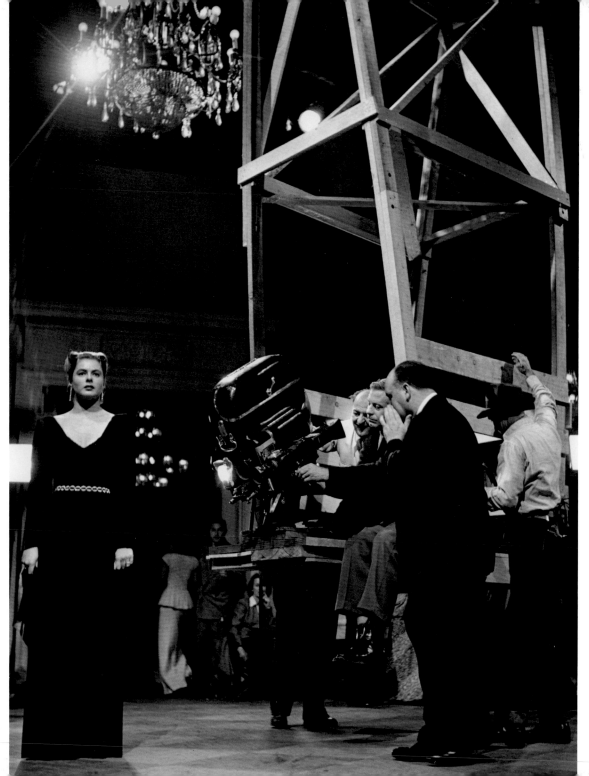

Opposite:
Gene Kelly, Paris, 1953

Left:
Ingrid Bergman
on the set of
Alfred Hitchcock's
Notorious, Hollywood,
July–October 1946

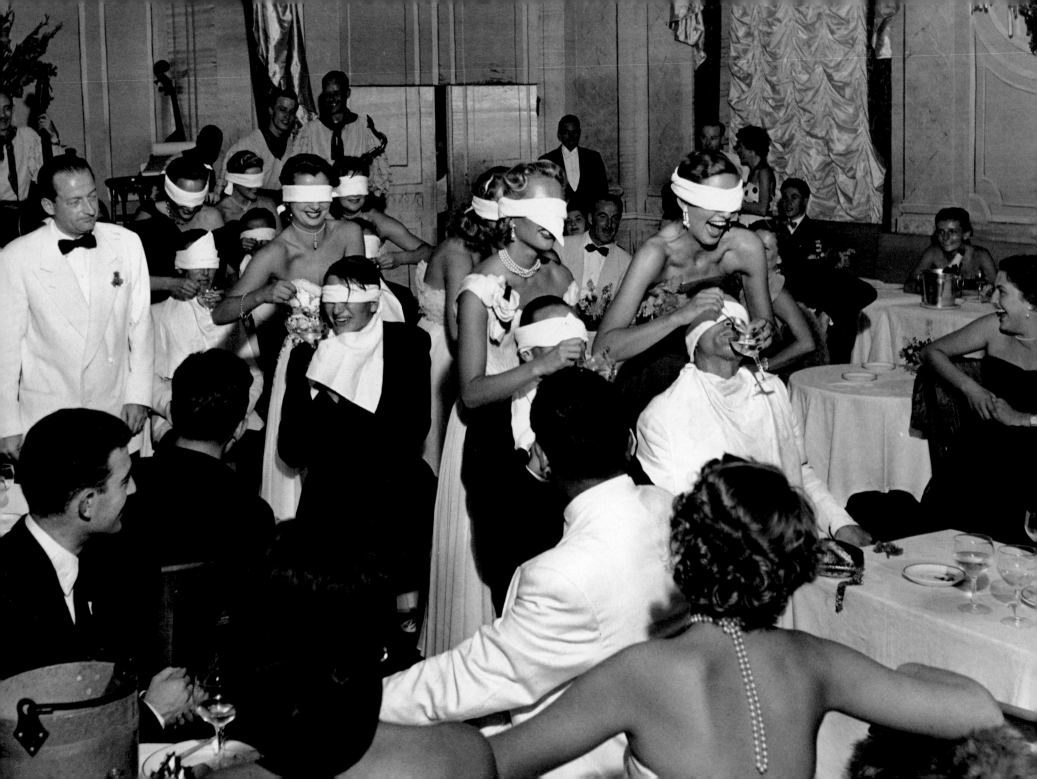

WESTERN EUROPE 1946–1954

During the late 1940s and early 1950s, Capa lived in Paris and served as president of Magnum, devoting much time to the agency's business and to the recruitment and promotion of young photographers. He enjoyed a glamorous life of afternoons at the Parisian racetracks, evenings at nightclubs with beautiful women, and skiing vacations in Switzerland. For *Holiday* magazine he wrote amusing articles—illustrated, of course, with his own photographs—about his travels to such places as Norway, Deauville, Biarritz, and Alpine ski resorts.

Irwin Shaw wryly claimed that Capa's guiding principle was to "remain debonair" under even the most terrible circumstances. "It means that one must never seem weary, one must always be ready to go to the next bar or the next war, no matter how late the hour or how unattractive the war. It means that a man must always sit through every poker pot and call every hand; must lose six months' salary and buy the next round of drinks, lend thoughtlessly and borrow ceremoniously, [and] consort only with very pretty women, preferably those who are mentioned in the newspapers...."

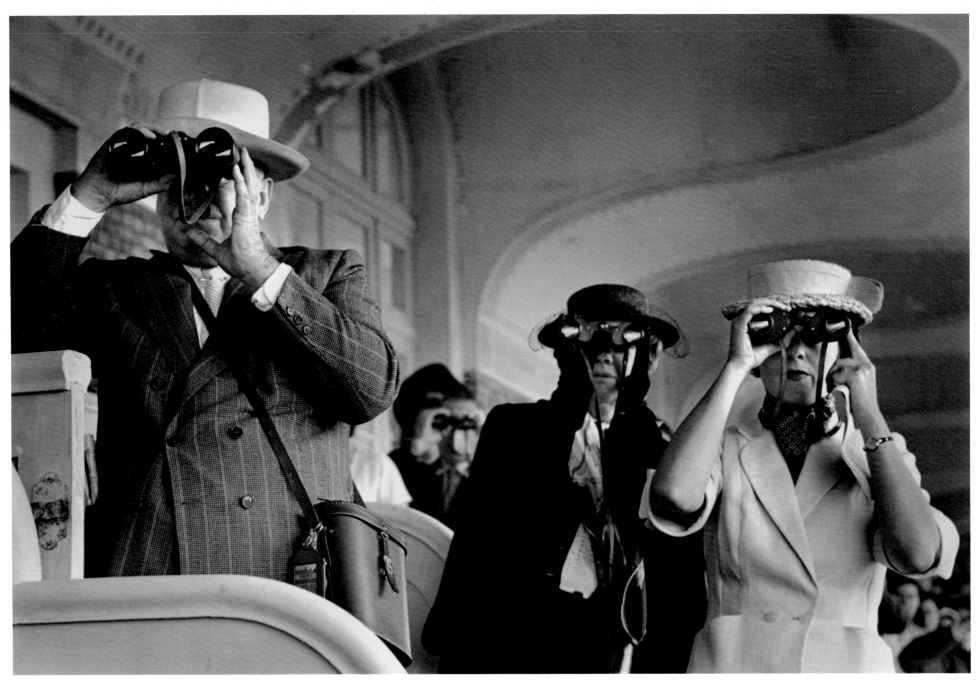

Page 160: Biarritz, France, August 1951 Above: At the horse races, Deauville, France, August 1951 Opposite: Paris, July 1952

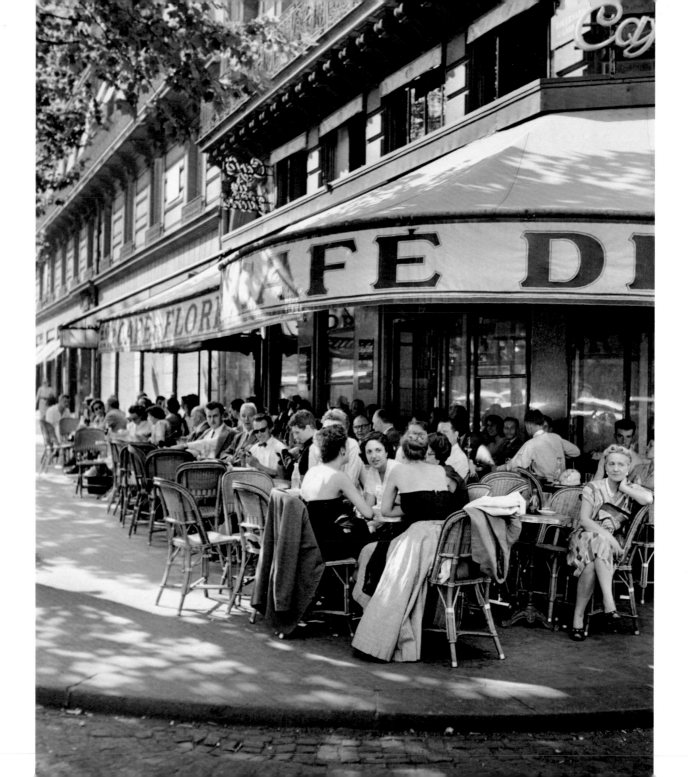

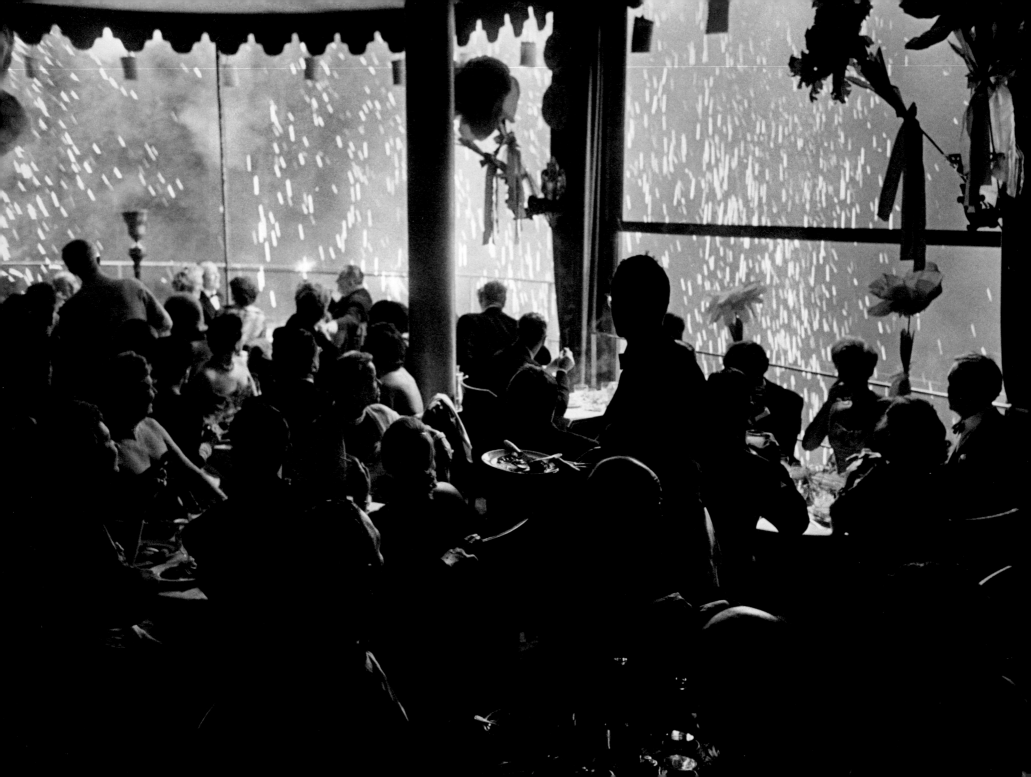

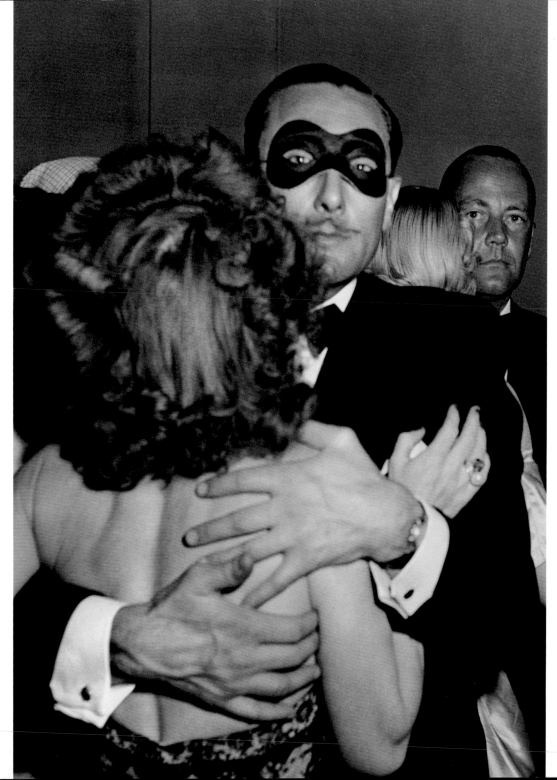

Opposite:
Watching the Bastille Day
fireworks from the
Tour d'Argent restaurant,
Paris, July 14, 1952.
Seated at the table at the right
are: John Huston (far right),
Zsa Zsa Gabor (third from
right, facing camera),
José Ferrer, and Aly Khan.

Left:
Carnival, Zürs, Austria,
February 1950

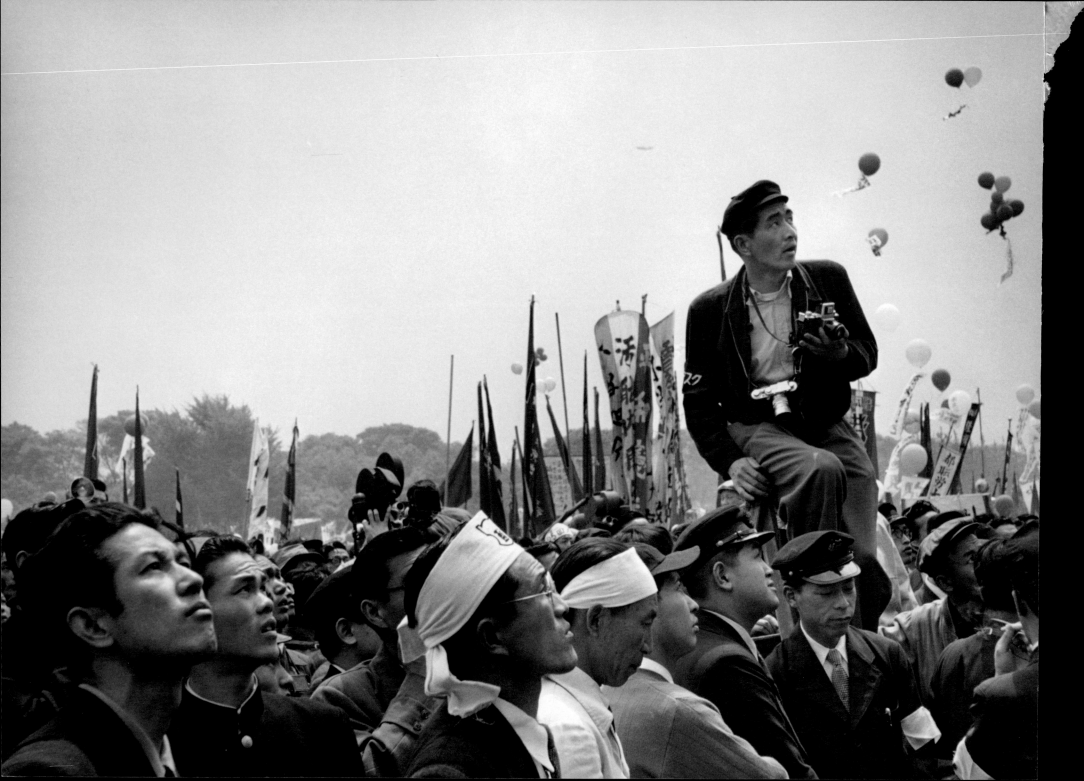

JAPAN 1954

While Capa was living in Paris in the 1930s, two of his best friends were aspiring young Japanese filmmakers, Hiroshi Kawazoe and Seiichi Inouye. Thanks to their connections, the photographer briefly worked for the Paris office of the Mainichi Press in 1935–36. Kawazoe and Inouye returned to Japan at the outbreak of World War II, but they renewed their friendship with Capa by letter after the war. In 1954 they were instrumental in getting the Mainichi Press to invite him to spend six weeks in Japan photographing for a new magazine. He arrived in mid April and visited Tokyo, Kyoto, Nara, Osaka, Kobe, and Amagasaki. Everywhere he focused mainly on children, but he also photographed other subjects ranging from geishas to a leftist May Day rally in Tokyo.

Many of Capa's photographs from this visit are infused with his delight in the beauty and grace of traditional Japan and are reminiscent of Japanese woodblock prints. Other photographs contrast those qualities with the jarring encroachment of modern Western influences. One aspect of modernity that impressed him greatly, however, was the excellence of Japanese cameras.

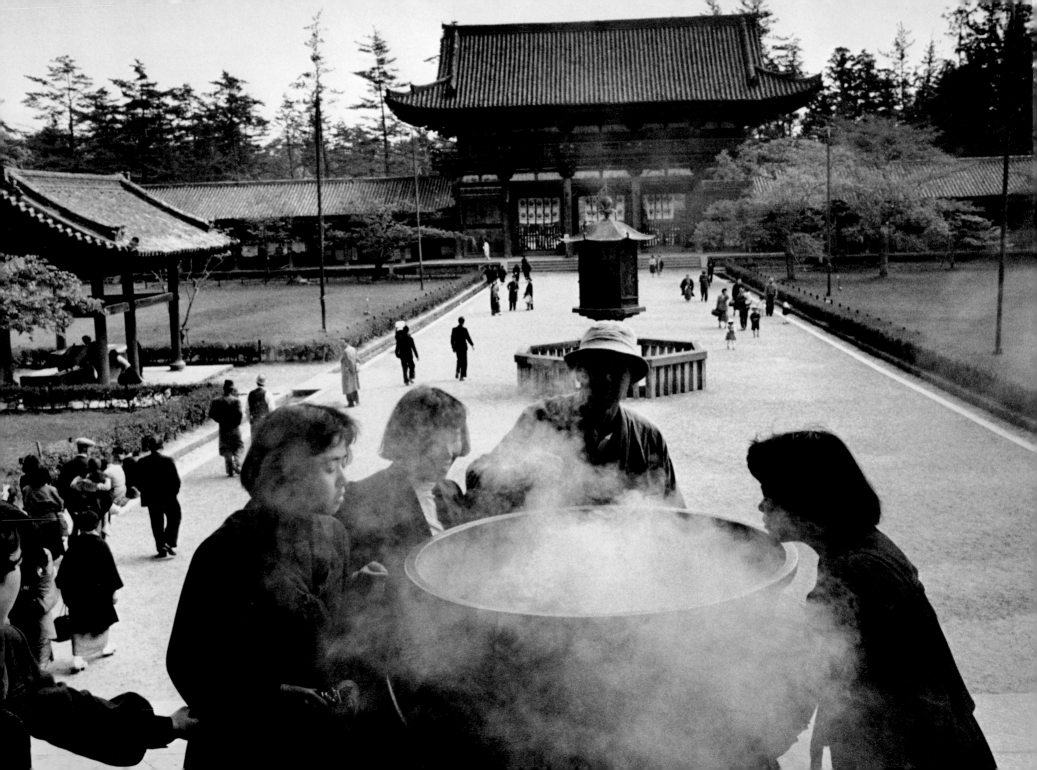

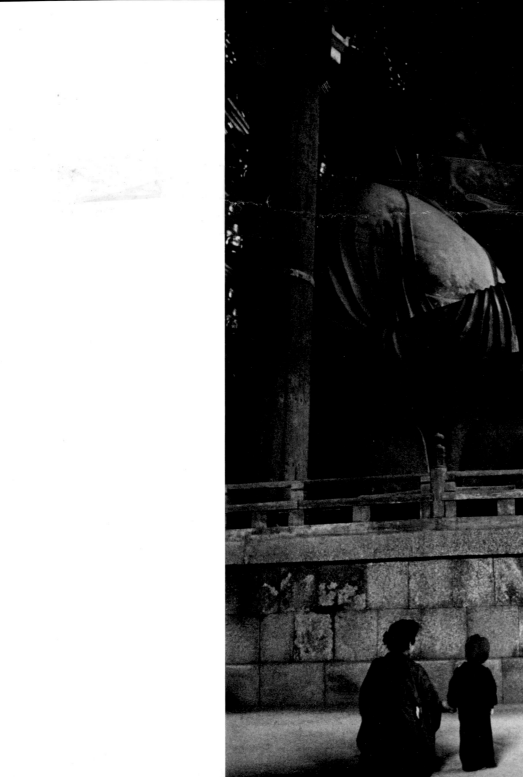

Page 166:
May Day rally, Tokyo,
May 1, 1954

Opposite:
Tokyo, April 1954

Left:
Nara, April 1954

169

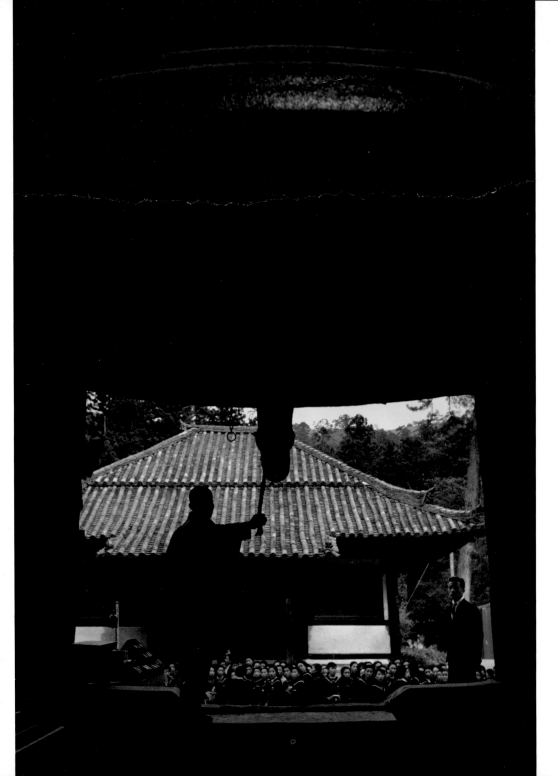

Right:
Japan, April 1954

Opposite:
Tokyo, April 1954

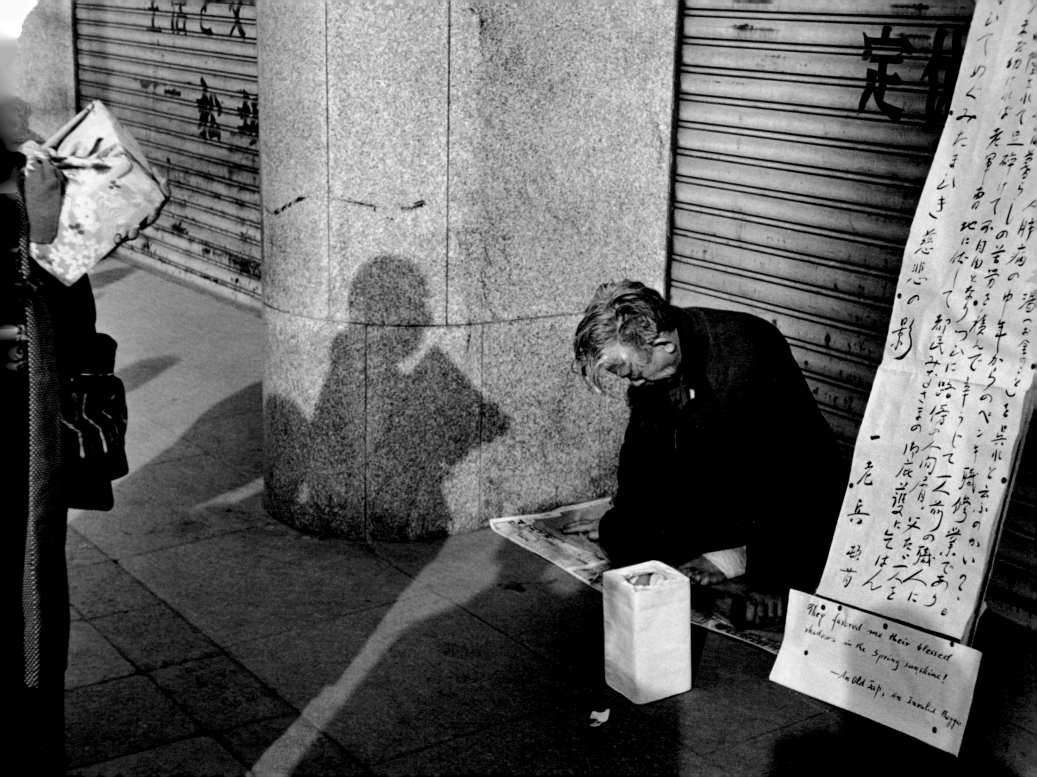

They favored me their blessed
shadows in the Spring sunshine!
—An Old Jap, An Invalid Beggar

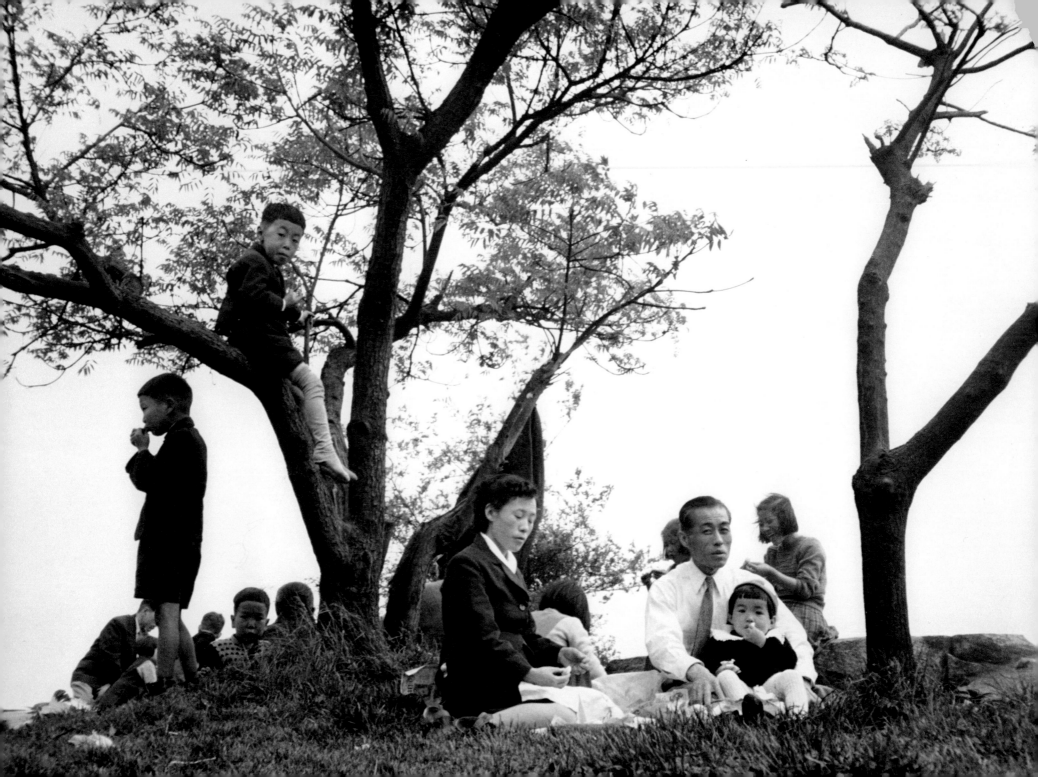

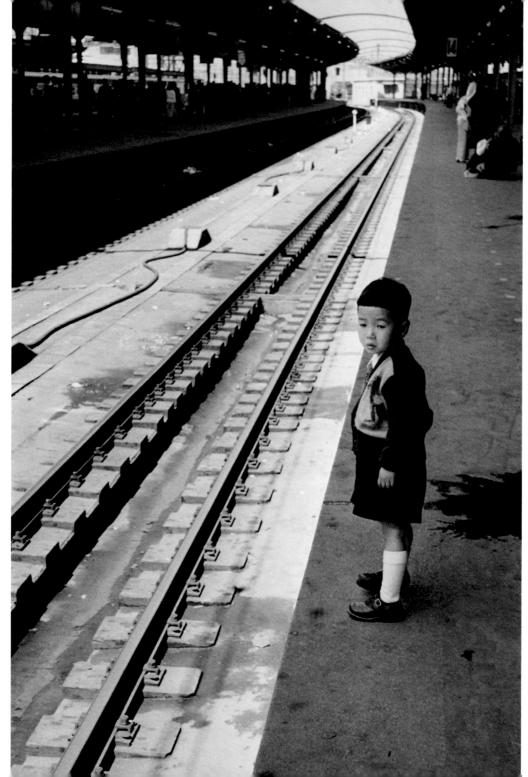

Opposite:
Osaka, April 1954

Left:
Tokyo, April 1954

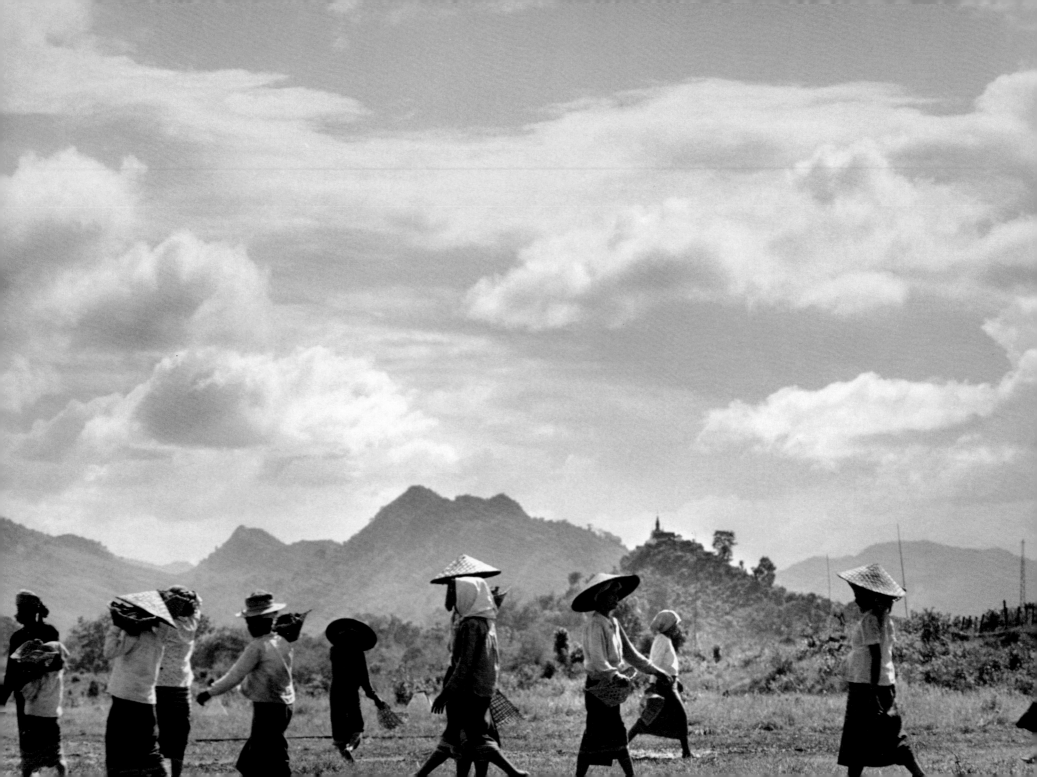

INDOCHINA 1954

Vietnamese Communists and nationalists (Vietminh) launched a war against the French colonists in 1946. The war reached a climax in March 1954, by which time 50,000 Vietminh troops had surrounded the 13,000-man garrison of the French outpost of Dienbienphu. After having spent only half of his planned six weeks in Japan, Capa agreed to replace *Life* magazine's photographer in Vietnam for a month.

On May 7, a day or two before he arrived in Hanoi, Dienbienphu fell to the Vietminh. Capa then went to Luang Prabang, in northern Laos, when the Vietminh announced that they would release there 750 ill or wounded French soldiers from among the thousands who had been taken prisoner at Dienbienphu. After his return to Hanoi, Capa began to work on a story about the military situation in the Red River delta, where Vietminh activity was increasing. On May 25, he accompanied a French mission to evacuate and raze two small forts between Namdinh and Thaibinh. While the convoy was halted at one point, Capa went with a detachment of soldiers out into a field beside the road. He stepped on an antipersonnel mine and was killed.

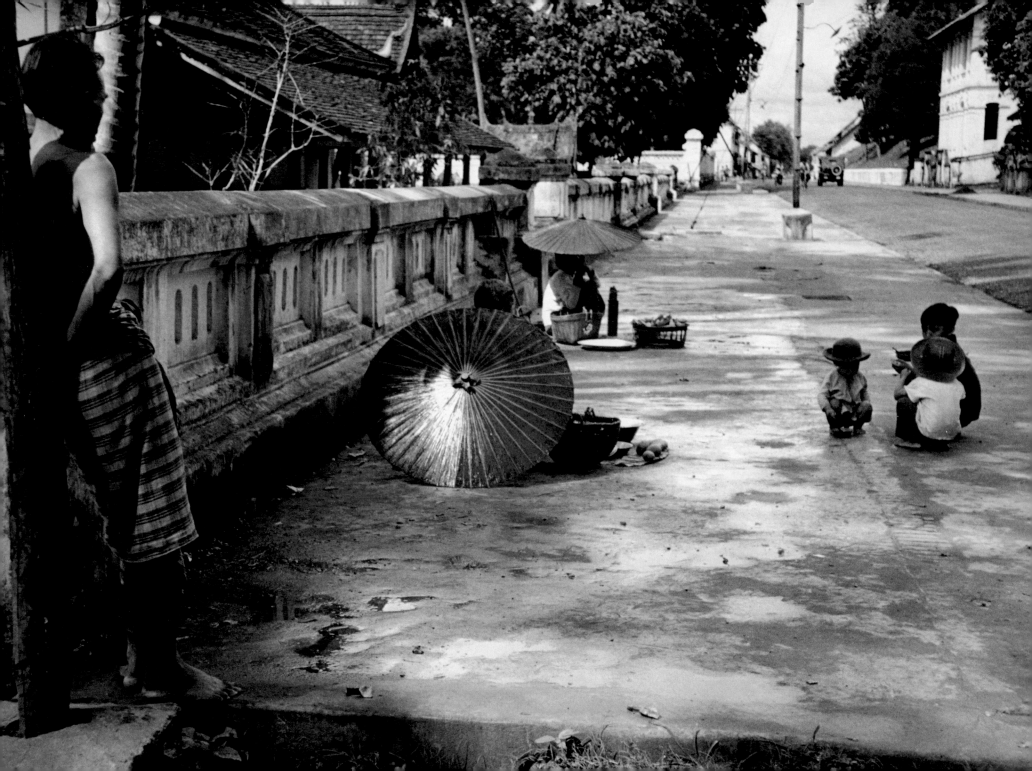

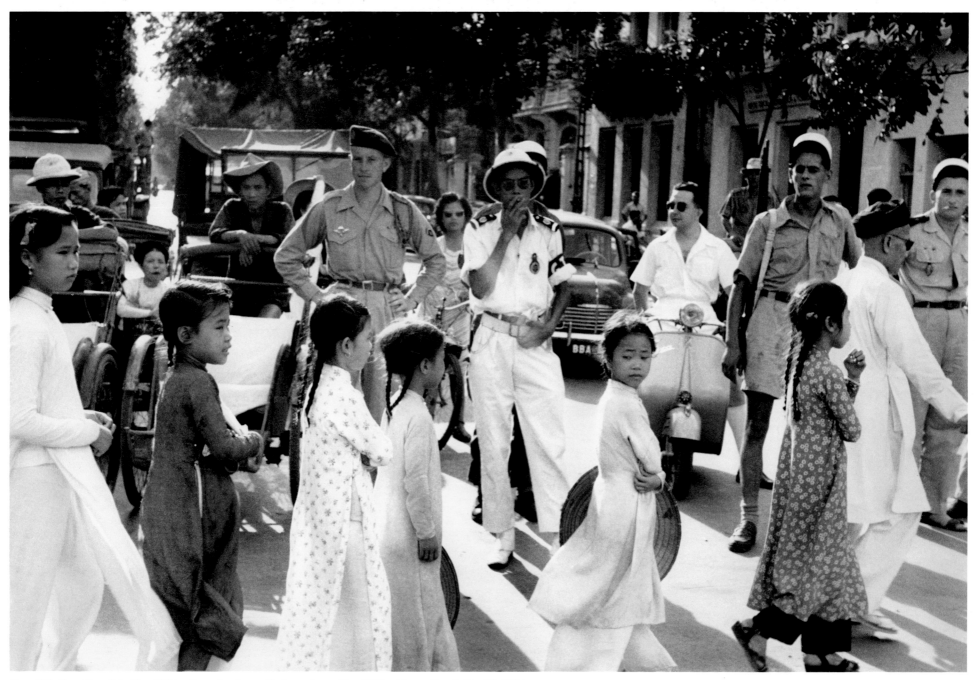

Page 174: Near Namdinh, May 1954 Opposite: Luang Prabang, Laos, May 1954 Above: Hanoi, May 23, 1954

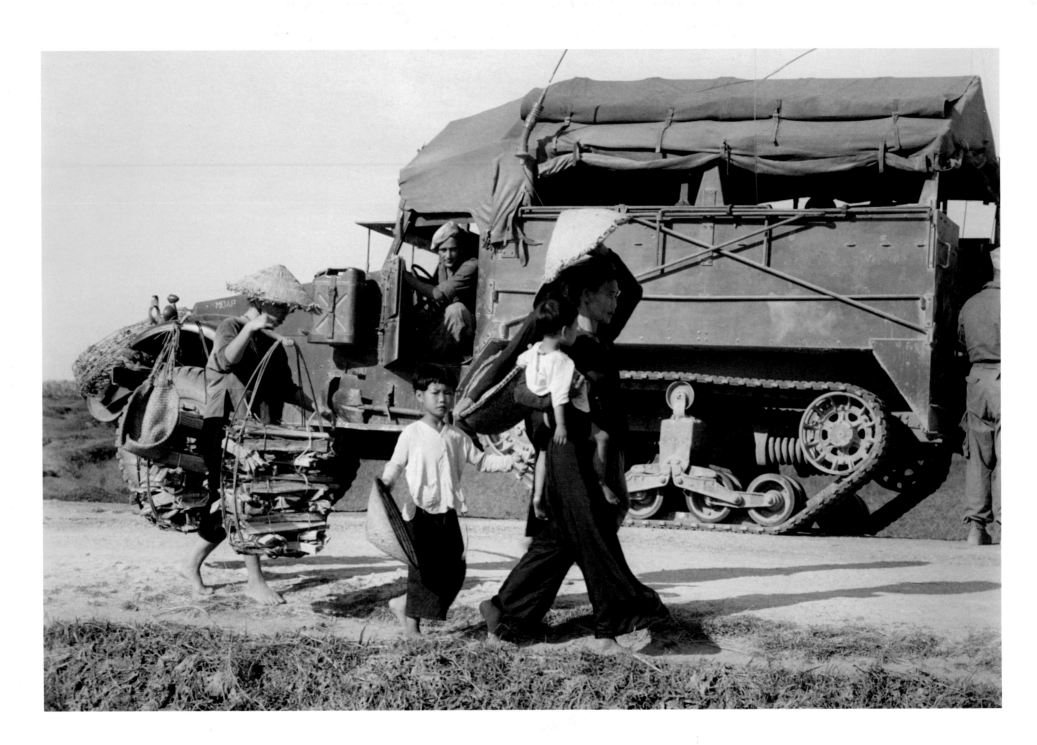

Opposite:
On the road from Namdinh to
Thaibinh, May 25, 1954

Left:
French soldier released
by Vietminh, Luang Prabang,
Laos, May 1954

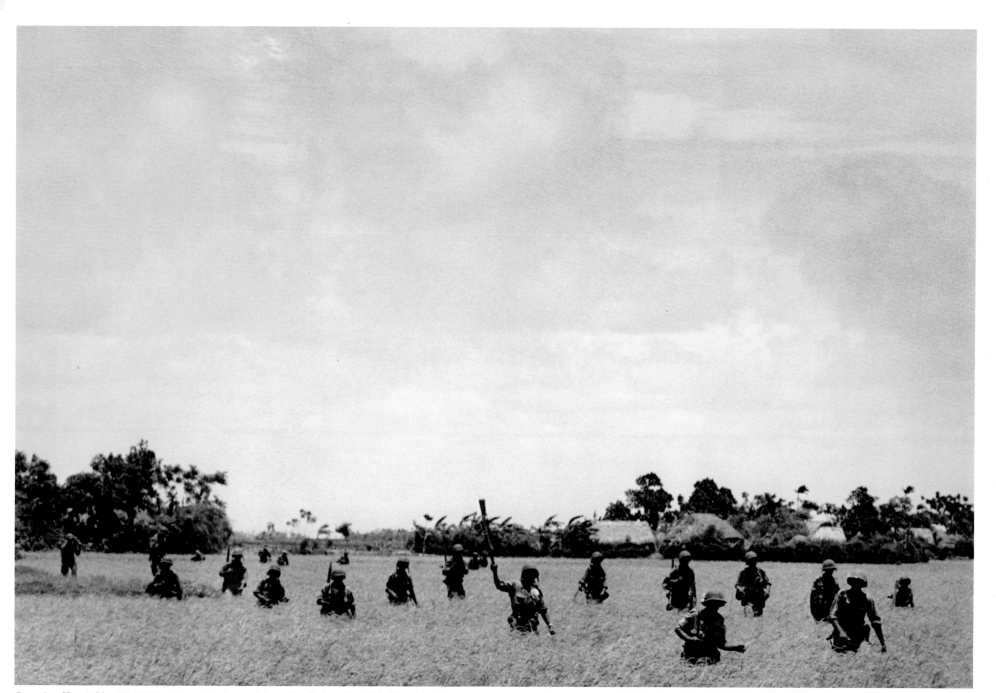

Opposite: Hanoi, May 23, 1954 Above: On the road from Namdinh to Thaibinh, May 25, 1954

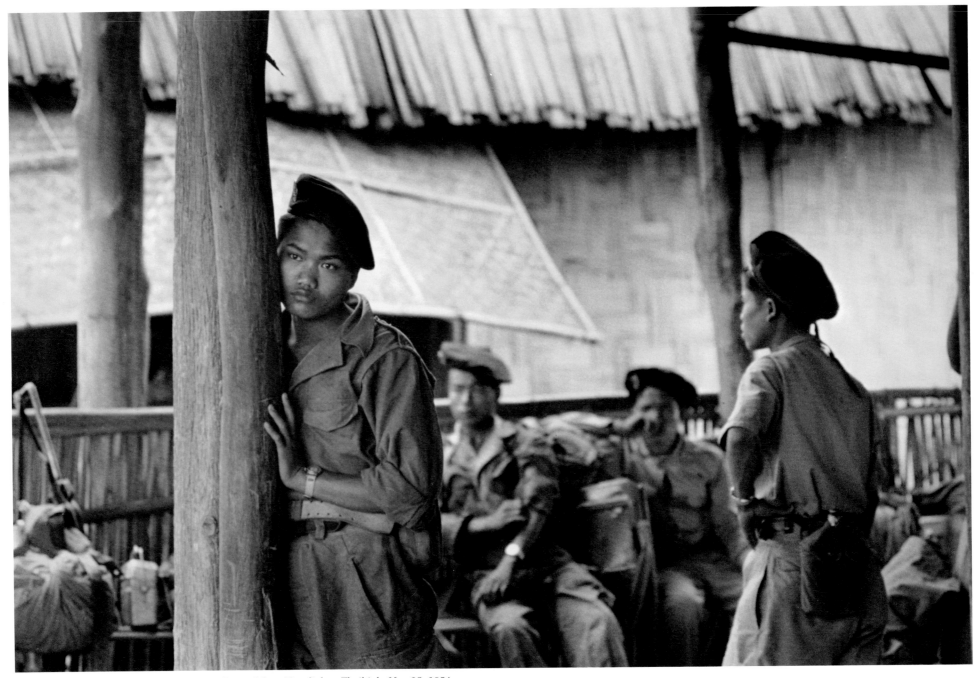

Above: Hanoi, May 23, 1954 Opposite: On the road from Namdinh to Thaibinh, May 25, 1954

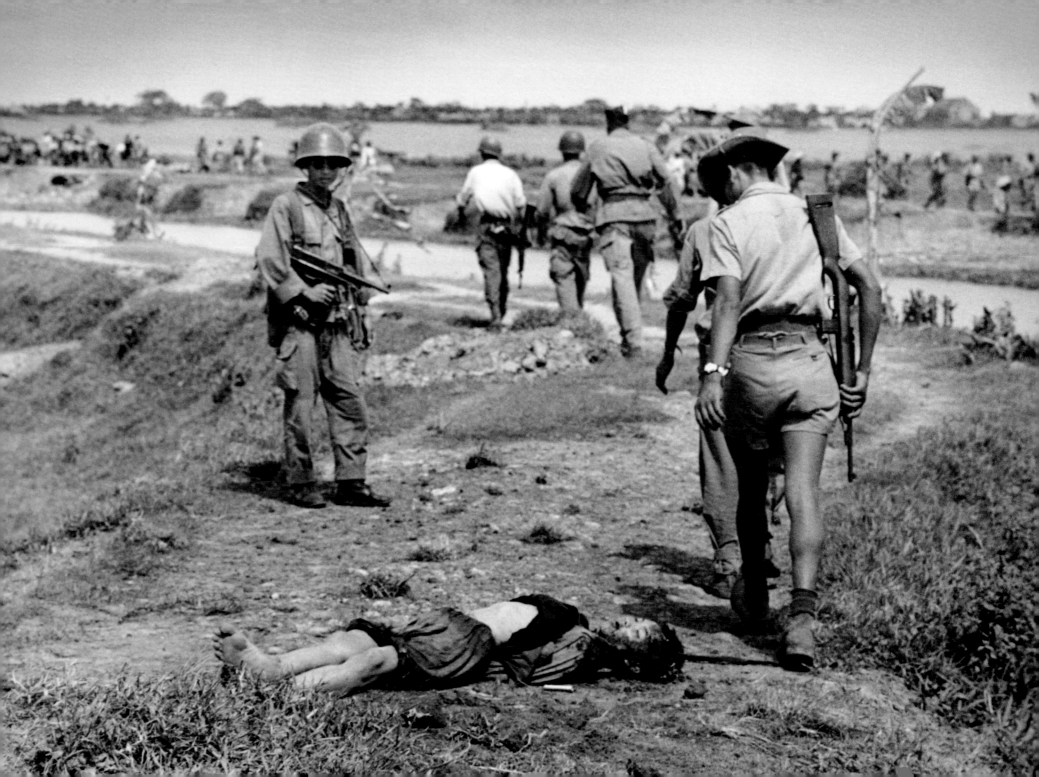

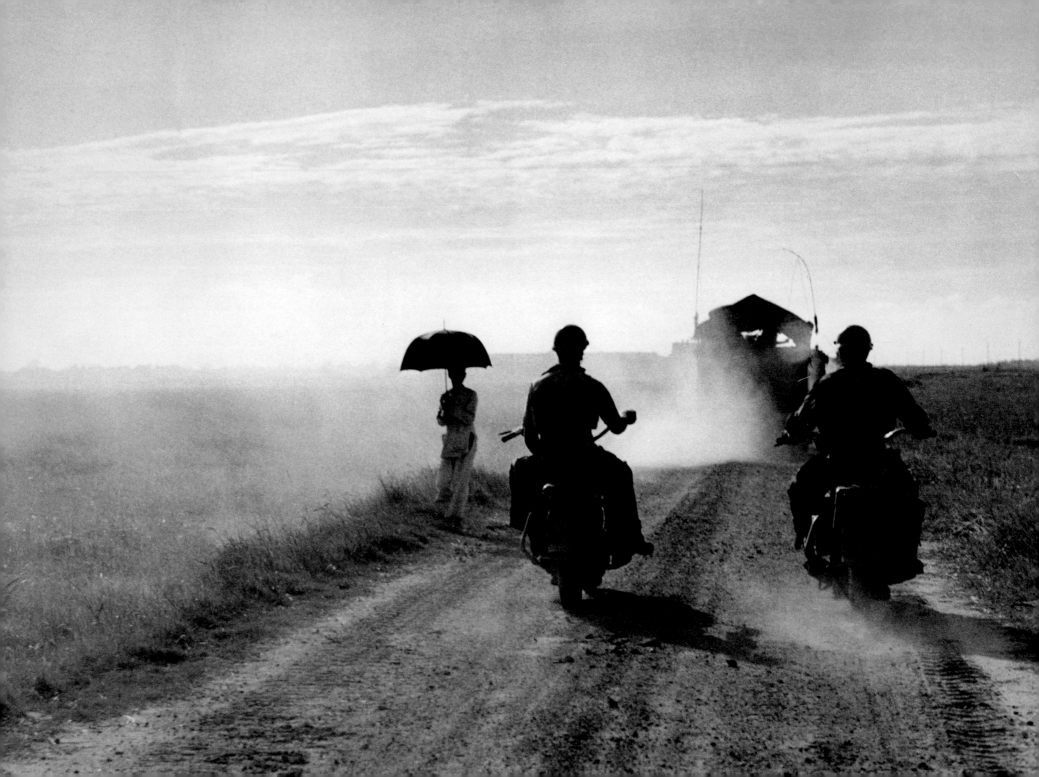

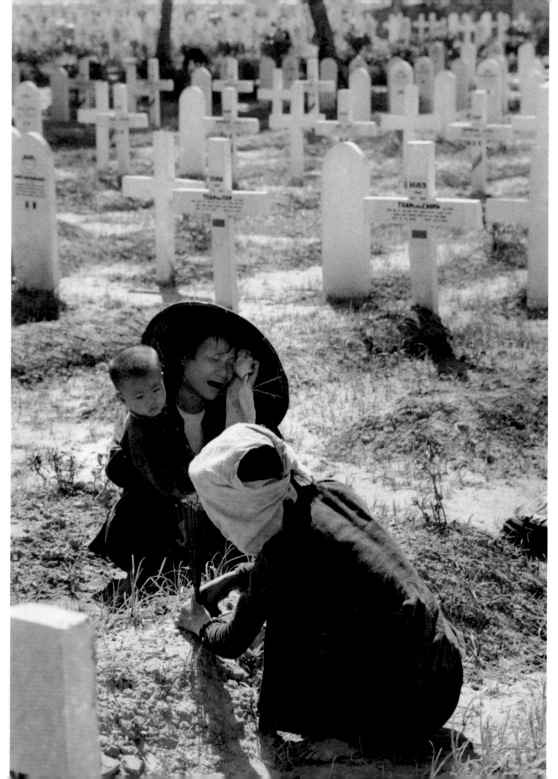

Opposite:
On the road from
Namdinh to Thaibinh,
May 25, 1954

Left:
Namdinh,
May 21, 1954

Opposite:
Along the road from
Namdinh to Thaibinh, May 25,
1954. This is the
last photograph that Capa took
before he was killed by
stepping on a landmine.

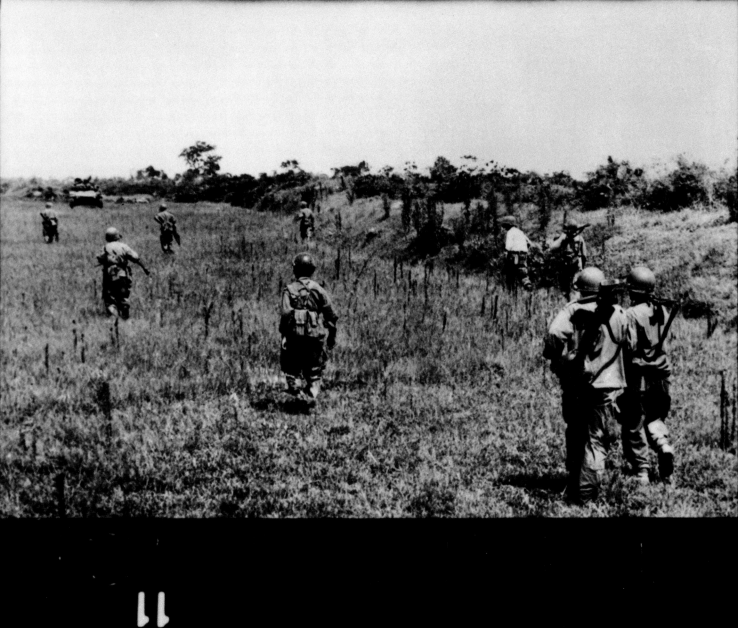

ROBERT CAPA CHRONOLOGY

1913 Born Endre Friedman, in Budapest, on October 22.

1931 Exiled from Hungary as a result of leftist student activities. Went to Berlin, where he enrolled that fall at the Deutsche Hochschule für Politik as a student of journalism. At the end of the year learned that his parents, their dressmaking business badly hurt by the Depression, could no longer send him money for tuition, room, and board.

1932 A Hungarian acquaintance helped him to get a job as an errand boy and darkroom assistant at Dephot, an important Berlin photo agency. The director, Simon Guttmann, soon recognized his talent, and began to send him out to cover minor local events. Received his first big break in December, when Guttmann sent him to Copenhagen to photograph Leon Trotsky giving a speech to Danish students.

1933 Fled Berlin after Hitler assumed dictatorial powers in the wake of the Reichstag fire (February 27). Went to Vienna, then obtained permission to return to Budapest. After the summer living at home and working on local photographic assignment, left in September for Paris.

1934 Met and fell in love with Gerda Taro, a German refugee.

1935 Went to Spain to work on several photojournalistic assignments arranged by Simon Guttmann.

1936 Invented a glamorous and successful American photographer named Robert Capa; made the photographs that Gerda Taro sold to impressed editors as Capa's. The ruse was soon discovered, and he changed his own name to Robert Capa.

Covered the tumultuous events in Paris surrounding the election of the leftist coalition Popular Front government.

In August, went to Spain with Gerda Taro, to cover the civil war that had broken out in July. Made a second trip to Spain in November to photograph the defense of Madrid.

1937 Visited various fronts in Spain, alone and with Gerda Taro, who was herself becoming an independent photojournalist. In July, while he was taking care of business in Paris, Taro covered the fighting at Brunete, west of Madrid. During a confused retreat she was crushed to death by a Spanish government tank. Capa, who had hoped to marry her, never fully recovered from his grief.

In September, visited New York. After his return to Paris, went to Spain in December to cover the battle of Teruel.

1938 Spent six months in China with filmmaker Joris Ivens documenting the Chinese resistance to the Japanese invasion.

1939 Covered the fall of Barcelona. After the end of the Spanish Civil War, in March, photographed defeated and exiled Loyalist soldiers in internment camps in France. Worked on various stories in France, including an extensive one about the Tour de France.

After the outbreak of World War II, in September, sailed for New York, where he began to work on miscellaneous stories for *Life*.

1940 Spent several months in Mexico, covering the Mexican presidential campaigns and elections for *Life*.

1941 Crossed the Atlantic in a convoy carrying American planes to England. Worked on numerous stories about the Allied war effort in Britain.

1943 From March to May, covered the Allied victories in North Africa. During July and August, photographed the Allied conquest of Sicily. For the rest of the year, documented the fighting in mainland Italy, including the liberation of Naples.

1944 In January, participated in the Allied landing at Anzio, south of Rome. On D-Day (June 6) landed with the first wave of American troops on Omaha Beach (Normandy). Accompanied American and French troops throughout the campaign that culminated in the liberation of Paris (August 25). In December, covered the Battle of the Bulge.

1945 Parachuted with American troops into Germany and chronicled the Allied capture of Leipzig, Nuremberg, and Berlin. Met Ingrid Bergman in Paris in June and began a two-year affair with her.

1946 Became an American citizen. Spent several months in Hollywood, writing his war memoirs (on which he intended to base a screenplay) and training to become a producer-director. Finally, decided that he did not like the movie business and left Hollywood. Late in the year, spent two months in Turkey working on a documentary film.

1947 With his friends Henri Cartier-Bresson, David Seymour ("Chim"), George Rodger, and William Vandivert, founded Magnum, a cooperative photo agency. Spent a month traveling in the Soviet Union with his friend John Steinbeck. Also visited Czechoslovakia and Budapest.

1948 Visited Hungary, Poland, and Czechoslovakia with Theodore H. White.

1948–50 Made three trips to Israel. On the first, photographed the declaration of Israel's independence and covered the fighting that followed. On the two subsequent trips, concentrated on the plight of arriving refugees.

1950–53 Lived in Paris and served as president of Magnum, devoting much time to the agency's business and to the recruitment and promotion of young photographers.

Because of false accusations that he had been a Communist, the U.S. government suspended his passport for several months in 1953, during which time he was unable to travel for his work. That year, he also suffered from severe back pain, for which he had to be hospitalized.

1954 In April, spent several weeks in Japan as the guest of the Mainichi Press. Arrived in Hanoi about May 9 on assignment from *Life* magazine to cover the French Indochina War for a month. On May 25 accompanied a French convoy from Namdinh on a mission in the Red River delta. While the convoy was halted at one point, Capa went with a detachment of soldiers out into a field beside the road. He stepped on a landmine and was killed.

1955 *Life* and the Overseas Press Club established the annual Robert Capa Award "for superlative photography requiring exceptional courage and enterprise abroad."

1974 Spurred in part by his determination to keep alive the work of Robert Capa and other photojournalists, Robert's brother and fellow photojournalist Cornell Capa founded the International Center for Photography in New York City.

BIBLIOGRAPHY

BOOKS ABOUT ROBERT CAPA

IMAGES OF WAR
Photographs by Robert Capa, with text from his own writings. New York: Grossman, 1964

ROBERT CAPA
Edited by Cornell Capa and Bhupendra Karia. (ICP Library of Photographers). New York: Grossman, 1974

ROBERT CAPA: A BIOGRAPHY
by Richard Whelan. New York: Knopf, 1985

ROBERT CAPA: PHOTOGRAPHS
Edited by Cornell Capa and Richard Whelan. New York: Knopf, 1985

CHILDREN OF WAR, CHILDREN OF PEACE: PHOTOGRAPHS BY ROBERT CAPA
Edited by Cornell Capa and Richard Whelan. Boston: Bullfinch Press/Little, Brown, 1991

BOOKS BY ROBERT CAPA

DEATH IN THE MAKING
Photographs by Robert Capa and Gerda Taro. Captions by Robert Capa, translated by Jay Allen. Preface by Jay Allen.
Layout by André Kertész. New York: Covici, Friede, 1938

THE BATTLE OF WATERLOO ROAD
Text by Diana Forbes-Robertson. Photographs by Robert Capa. New York: Random House, 1941

INVASION!
Text by Charles C. Wertenbaker. Photographs by Robert Capa. New York: Appleton, Century, 1944

SLIGHTLY OUT OF FOCUS
Text and photographs by Robert Capa. New York: Henry Holt, 1947

A RUSSIAN JOURNAL
Text by John Steinbeck. Photographs by Robert Capa. New York: Viking, 1948

REPORT ON ISRAEL
Text by Irwin Shaw. Photographs by Robert Capa. New York: Simon and Schuster, 1950

DEDICATION

———

To the memory of our mother, Julia.

To the memory of Robert Capa's great love, Gerda Taro.

And to my wife, Edith: I am profoundly grateful for her inspiration and

her years of dedicated care of my brother's archives. —C. C.

ACKNOWLEDGMENTS

———

Between 1990 and 1992, we meticulously re-examined all of Robert Capa's contact sheets. From the approximately seventy-thousand negatives that he exposed during his lifetime, we chose 937 images to constitute a survey of his work. Many of these images have never before been published or exhibited. Under our close supervision, an edition strictly limited to three identical sets of 937 prints was produced by master printers Igor Bakht and Teresa Engle. This project was made possible by the generous support of the Tokyo Fuji Art Museum, which has acquired the first set. The second set has been donated to the permanent collection of the International Center of Photography in New York. Because of Robert Capa's European heritage, the third set is intended for a European museum. It is from this new edition that the images in this book have been selected.

We would like to thank everyone who has participated in the production of this book, especially Michael E. Hoffman, whose vision has been decisive at every step; Yolanda Cuomo, the designer, whose layout will enable readers to see even the perennial classics in new light; and Diana Stoll, our editor, who has patiently brought the concept to fruition. We would also like to thank the staff of the International Center of Photography, especially Miles Barth, curator of ICP's Permanent Collection, and Anna Winand, Cornell Capa's associate. Beginning in 1937, many of Robert Capa's photographs were published by *Life* magazine. We would like to thank the editors with whom Capa worked, in particular Edward K. Thompson. As in any Robert Capa project, the support of Magnum Photos, Inc., of which Capa was a founding member, is gratefully acknowledged.

The Robert Capa Archive is located at the International Center of Photography. ICP's Permanent Collection contains over 2,500 vintage prints of Robert Capa's photographs, as well as more than 1,000 modern prints. Furthermore, ICP houses, on extended loan from Cornell Capa, all of Robert Capa's negatives, contact sheets, caption sheets, and correspondence. To this archive Richard Whelan has donated transcripts of all the interviews he conducted while working on his biography of Robert Capa. The Robert Capa Archive, of which Richard Whelan is the Consulting Curator, is available for consultation by qualified scholars. —C. C. & R. W.

A major traveling exhibition of "Robert Capa: Photographs" will tour throughout Europe and the United States, beginning in 1997.

Limited-edition prints of *Running for shelter during air raid*, Barcelona, January 1939 (page 5),
and of *Pablo Picasso and Françoise Gilot*, Golfe-Juan, France, August 1948 (page 150) are both available for purchase through Aperture.
Each edition is limited to 150 numbered prints and 20 artist's proofs, each gelatin-silver print bearing the authorizing seal of the Estate of Robert Capa.
This limited edition has been produced under the supervision of Cornell Capa.

———————

The authors and Aperture Foundation gratefully acknowledge the generous support of
Lynne and Harold Honickman, and of Claire and Richard Yaffa.

Library of Congress Catalog Card Number: 96-83976
Hardcover ISBN: 0-89381-675-2
Paperback ISBN: 0-89381-690-6
Exhibition Catalog ISBN: 0-89381-765-1

Design Associate: Francesca Richer
Typographic composition: Robin Sherin
Printed and bound by L.E.G.O./Eurographica, Vicenza, Italy

The Staff at Aperture for *Robert Capa: Photographs is*:
Michael E. Hoffman, Executive Director; Diana C. Stoll, Editor; Ron Schick, Executive Editor;
Stevan A. Baron, Production Director; Helen Marra, Production Manager; Michael Lorenzini, Editorial Assistant;
Charleen Chan, Nina Hess, Editorial Work-Scholars; Sherry Gerstman, Meredith Hinshaw, Production Work-Scholars

Aperture Foundation publishes a periodical, books, and portfolios of fine photography to communicate with serious photographers
and creative people everywhere. A complete catalog is available upon request. Address: 20 East 23rd Street, New York, New York 10010.
Phone: (212) 598-4205. Fax: (212) 598-4015. Toll-free: (800) 929-2323. Visit Aperture's web site: http://www.aperture.org

Aperture Foundation books are distributed internationally through:
CANADA: General Publishing, 30 Lesmill Road, Don Mills, Ontario, M3B 2T6. Fax: (416) 445-5991.
UNITED KINGDOM, SCANDINAVIA, AND CONTINENTAL EUROPE: Robert Hale, Ltd., Clerkenwell House, 45-47
Clerkenwell Green, London EC1R OHT. Fax: 171-490-4958.
NETHERLANDS: Nilsson & Lamm, BV, Pampuslaan 212-214, P.O. Box 195, 1382
JS Weesp. Fax: 31-294-415054.

10 9 8 7 6 5 4 3 2

BOOK DESIGN BY YOLANDA CUOMO / NYC